EXPLORE EVERYTHING

EXPLORE EVERYTHING:
PLACE-HACKING THE CITY

Bradley L. Garrett

VERSO
London • New York

First published by Verso 2013
© Bradley L. Garrett 2013
Individual image credits © Marc Explo (p. 82–83); Dan Salisbury (p. 88, 149,
246–247); Luca Carenzo (pp. 100, 119); Henry Mayhew, *London Labour and
the London Poor* (p. 113); Scott Cadman (p. 151); Patch (p. 156)
2013

1 3 5 7 9 10 8 6 4 2

Verso
UK: 6 Meard Street, London W1F 0EG
US: 20 Jay Street, Suite 1010, Brooklyn, NY 11201
www.versobooks.com

Verso is the imprint of New Left Books

ISBN-13: 978-1-78168-129-9

British Library Cataloguing in Publication Data
A catalogue record for this book is available from the British Library

Library of Congress Cataloging-in-Publication Data

Garrett, Bradley L.
 Explore everything : place-hacking the city / Bradley
L. Garrett.
 pages cm
 Includes bibliographical references and index.
 ISBN 978-1-78168-129-9 (hardback)
 1. Garrett, Bradley L.–Travel. 2. Urban geography. I.
Title.
 G246.G37.A3 2013
 910.4–dc23
 2013020578

Typeset in Univers by Hewer Text UK Ltd, Edinburgh, Scotland
Printed in the UK by CPI Group (UK) Ltd, Croydon CR0 4YY

For Marcia and Erpel

'But what a strange geography
lesson I was given!'

– Antoine de Saint-Exupéry

TABLE OF CONTENTS

DISCLAMER

'UE is a crime but I won't do time.'

– UE Kingz

Due to the sensitive nature of this research, certain people's names, place names, dates and specific details have been changed. This has been done to protect both myself and my project participants from social and legal implications that arose from the research, which will become apparent throughout the book. In some cases, minor fictive elements were introduced for strategic reasons related to research questions and construction of narrative arc. However, the bulk of this research remains faithful to a course of events that unravelled over a span of four years. I leave it to the reader to unknot which lines have been crossed, when, where, how and for what reasons. Enjoy the journey.[1]

PROLOGUE

'There is only one way to understand another culture. *Living* it.'

– Peter Høeg

I woke up with a start, dizzy and confused, sure I had only slept for five minutes. I was unsure whether it was the jetlag or the situation that had my head spinning. Days earlier I had been in Cambodia happily wrapping up a research project. Now I was in a police cell in north London after being pulled off a plane on the tarmac of Heathrow Airport and arrested by British Transport Police (BTP).* They wanted me to give them information about the London Consolidation Crew (LCC), a collection of urban explorers who had systematically cracked dozens of closed areas owned by Transport for London (TfL). The police were threatening to charge me with criminal damage, burglary and assisting or encouraging an offence. I had spent four years working with the LCC as an explorer and a researcher, and BTP thought my field notes and recordings would give

* Specialist terms such as this are detailed in the glossary at the end of the book.

them what they needed to stop the LCC from exploring the city and, as the investigating officer told me later, 'embarrassing the police and powerful corporations'.

Someone had flung open the metal slider on the door. They were staring at me. 'Give us the PIN to your phone', the person said. I looked at the man who'd spoken, rubbed my eyes and replied, 'I'm a researcher. I have confidential information on there. I'm not going to do that until I speak to my lawyers.'

He looked back at me through the slider, and although I could only see his eyes, I could tell he was frustrated. I was sure the tendons in his neck were taut. 'Suit yourself, *doctor*. We'll just break it.' Before the sentence had emerged from his mouth he had slammed the slider shut. I heard his squeaky boots walking away down the empty corridor and fell back on the plastic pillow, shooting out a hard breath at the ceiling. Then I rolled onto my side, grabbed a pen and paper and started writing. What I wrote was the conclusion to this book.

This book is about urban exploration. You will meet some of the world's most accomplished urban explorers through my adventures with them, and I will investigate every aspect of urban exploration, from the art of photographing ruins to details about accessing some of the most high-profile secret locations in the world's most secure cities. Some of these adventures led to incredible discoveries or uncontrollable media spectacles. Others ended in encounters with the police.

In particular, this is the story of the rise and fall of the London Consolidation Crew, the United Kingdom's most notorious place hackers. This is the story of friendships I forged over four years with a group that, despite severe consequences and repercussions, refused to let adventure, mystery and desire wither in a world rendered increasingly mundane by media saturation, gentrification, surveillance, the constrictions of civil liberties, and health and safety laws.[2]

Chapter 1

THE UE SCENE

'The Age of Discovery is not dead: it lives on through urban explorers.'

– Deyo and Leibowitz

It was a crisp, still night outside London Bridge station and our breath curled in the air. Marc Explo and I were standing on a temporary wooden walkway looking through a viewing window into the ground-level construction yard of the largest skyscraper in Europe. 'Gary' walked up behind us and, putting an arm around each of our shoulders, also peered through. 'One secca looking after the tallest building in London, huh?' he said, and we chuckled. We waited for the guard to finish his current round and go into his hut.

It took a few minutes of lingering before the walkway was clear of people, then we grabbed on to the scaffolding piping and swung off the bridge. Hanging tightly to the cold pipes, we pulled ourselves to the top of the walkway and laid down out of view, waiting for a reaction if anyone had seen or heard us. It didn't seem anyone had.

Staying low, we descended the other side of the scaffolding, right behind the security hut, where we could see the guard watching TV,

ignoring the CCTV cameras that relayed images to him from the rest of the site. Quickly we scampered across the yard and found the central staircase, again pausing to see if there would be any reaction on site, like phones ringing, doors opening or people running. All was silent.

We took the stairs two at a time. All three of us were in pretty good shape and could do twenty-five or thirty floors like that, but by the thirty-first floor, I was sweating. Knowing that the sweat would sting when we emerged onto the roof into the cold night air, I tried to pace myself and breathe. By floor fifty, my calves were burning and I needed to stop every so often to let them pulse a bit and untighten. When at floor seventy the cement stairs turned into metal ones, indicating that we were near the top, I was ecstatic. One final burst of enthusiasm took us from metal stairs to wooden ladders. We threw open one last hatch and found ourselves on top of the Shard, seventy-six stories high.

As I climbed up onto the counterweight of the crane on top of the building, my whole body tensed. It was a combination of the icy wind and the sheer weight of the moment that shocked me. I got down low, slowly pulled myself to the end of the counterweight and peered over the edge, down to the River Thames where the permanently docked HMS *Belfast*

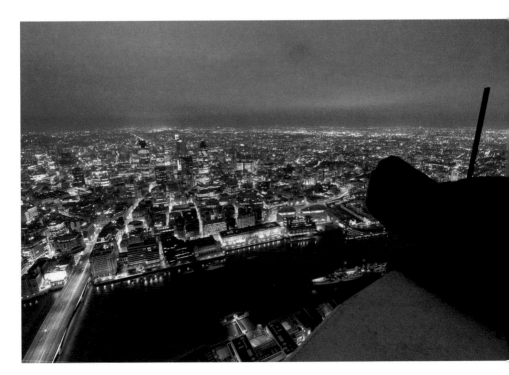

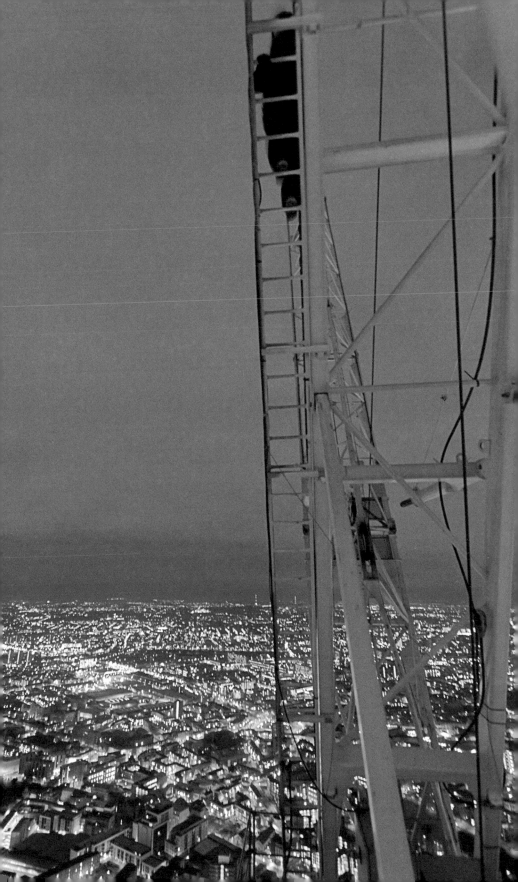

battleship looked like a bathtub toy. A ripple of adrenaline rolled up my spine, causing a full-body shiver. My hands gripped the edge of the counterweight tighter, knuckles whitening. We were so high that I couldn't see anything moving at street level – no buses, no cars, just rows of lights and train lines that looked like converging river systems or a giant circuit board. It was the first time in my life I looked at London and heard only the wind.

We found the cab of the crane open and sat down inside it. 'Gary' pointing to a glowing green button on the control panel, said, 'Watch this, I'm going to build the Shard!' and pretended to press the button.

We only lasted about half an hour on top before our muscles began to seize up from the exertion and chill. We were actually yearning for the stair climb down, which is always much easier than coming up.

At ground level, we causally walked across the yard and hit the crash bar on the fire door, home free.

Later, standing next to the Thames, staring up at the monolith and the small red light blinking on top of the crane, it seemed unimaginable that I'd had my hands on that light just hours earlier. Ever after, whenever I see the Shard from anywhere in the city, I can't help but smile as I'm reminded of the inescapable allure of urban exploration – the ability to make the impossible possible.

So what exactly is urban exploration? In his 2005 book *Access All Areas*, an explorer who wrote under the nom de plume Ninjalicious described urban exploration (colloquially known as UrbEx or UE) as 'an interior tourism that allows the curious-minded to discover a world of behind-the-scenes sights.'[3] Troy Paiva more recently wrote that urban exploration was about the discovery and investigation of 'TOADS' – temporary, obsolete, abandoned or derelict spaces.[4] More specifically, urban explorers trespass into derelict industrial sites, closed hospitals, abandoned military installations, sewer and storm drain networks, transportation and utility systems, shuttered businesses, foreclosed estates, mines, construction sites, cranes, bridges and bunkers, among other places – simply for the joy of doing so.

For the last four years I have been an ethnographer – literally, from the Greek, a 'culture-writer' – working from within the global urban exploration community. Rather than writing about events from an outside perspective, as a journalist might, I have embedded myself in the community to see how the people within it work and play, the rules they give themselves and the stories they tell. Within the community I discovered a call to adventure and a desire for personal freedom that I had never experienced elsewhere.

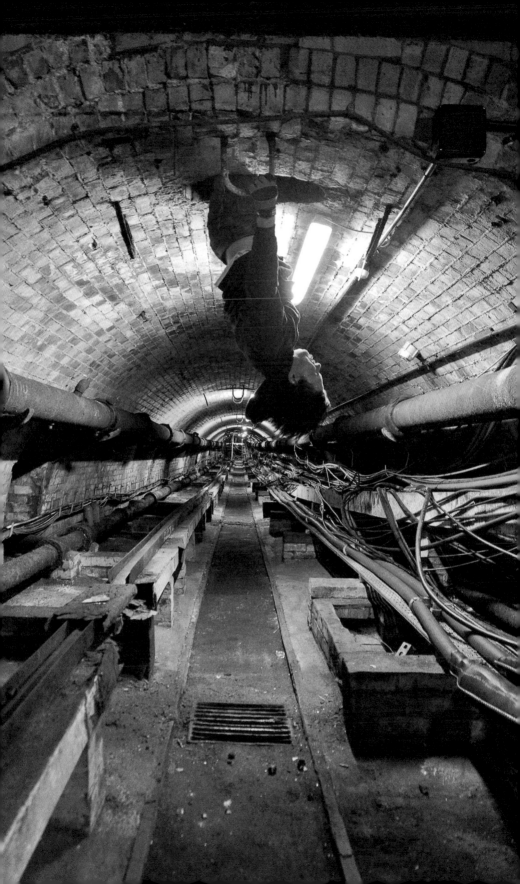

Urban explorers, much like computer hackers in virtual space, exploit fractures in the architecture of the city. Their goal is to find deeper meaning in the spaces we pass through every day.[5] Our 'place hacks' have taken us to cities all over the world, from London to Paris to Berlin and across the Atlantic to Minneapolis, Las Vegas and Los Angeles, encountering different communities of practice as well as the different security measures implemented in various places.

By sneaking into places they are not supposed to be, photographing them and sharing those exploits with the world, explorers are recoding people's normalised relationships to city space. It is both a celebration and a protest. It is a melding, a fusing of the individual and the city, of what is allowed and what is possible, of memory and place. Urban explorers make it clear that the city is not as secure as some may suggest and that, more importantly, by undertaking risks to probe those boundaries, one can create opportunities for creativity, discovery and friendship, and even uncover the places and histories that those in power would prefer remained hidden.

This book tells two stories. The first is my personal involvement in more than three hundred trespass events in eight countries with over one hundred explorers, primarily undertaken with an urban exploration collective once referred to as London Team B and later as the London Consolidation Crew (though, as I will discuss, many people involved with the collective resisted, and continue to resist, group bounding and labels). During the time I explored with them, the LCC gained an international reputation through both extensive travel into Europe to find ruins and an unprecedented level of exploration in London, with adventures down utility tunnels and bunkers, through sewers and underground railway lines and by scaling the city's skyscrapers and rooftops. The LCC, as a result, became one of the most revered and reviled urban exploration collectives in the world in the eyes of the public, other explorers and the authorities. The story of what it took to get there, and, to a degree, my complicity in those exploits as a member of the crew, make up one strand of this book.

The second strand is a discussion of why people become urban explorers in the first place, and what this might mean in the contemporary city – built around my concept of 'place hacking'. For many, urban exploration is a quest for a more personal sense of the past, one that has been steeped in the present – a kind of history work that resists nostalgia.[6] Like related activities such as parkour, skateboarding and street art, urban exploration is about temporarily occupying and reimagining the spaces of the city.[7] It is therefore not necessarily, as is commonly suggested, a mere

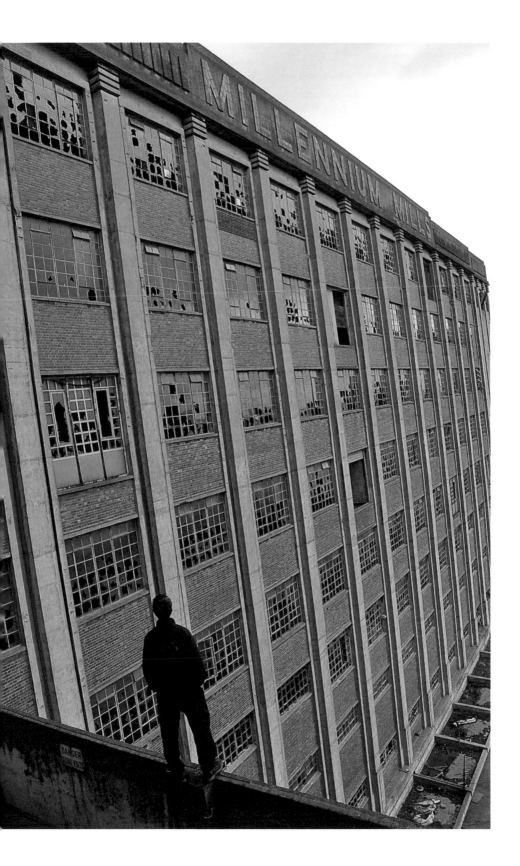

hobby undertaken by anoraks, nor is it simply what the urban explorer Bacchus has called 'victimless criminal activity'.* Rather, I see it as being about taking back rights to the city from which we have been wrongfully restricted through subversions that erode security and threaten clean narratives about what one can and can't do. Although, to clarify, most explorers would not make such claims – they simply want to learn more about the world around them through experiences they would otherwise be denied access to.[8]

By sneaking past security guards and photographing the secret city, we take back what we didn't know we'd lost, reclaiming the places hidden from our everyday view.[9] As a result, urban exploration becomes a political act, despite claims of apolitical motivations from many involved. Going beyond normally circumscribed boundaries forces one to rethink not just one's own identity but also the relationship between power and urban space.[10] It is at the same time a subversive response to the imperatives of late capitalism that encourage spectatorship over participation and, as an explorer called Peter bluntly put it, 'just a bit of fucking with people's heads to help them understand how much they're missing every day'.[11]

The most well-trodden avenue into urban exploration is through a fascination with ruins – buildings and places that have been left and are considered useless. Explorers seek out ignored and abandoned sites and photograph them as a sort of counter-spectacle to the contemporary city, where many people consider notions of 'development', construction and gentrification to be the normal course of things. A second path to urban exploration is through the systematic infiltration of secure corporate and state sites and networks, dismantling the urban security apparatus through photography of the secret city.

My role as an ethnographer, therefore, was to uncover the veiled motivations and principles of what we were doing, to trace a map of what it all meant, from urban exploration to infiltration to place hacking; to chart a politics of practice.[12]

Urban explorers have no central leadership with a list of demands. Instead, where they are not offered, rights to the city are simply taken. As London explorer Winch writes, 'Exercising access to voidspace is not a right or a privilege, it's just something that can be done. Why should we sit and wallow in the regimentation of shallow, sterile spaces presented to us as 'safe' and appropriate for use?'[13]

* Unless otherwise noted, direct quotes have been recorded in person during the course of ethnographic research (2008–2012).

On the website of Dsankt, one of the world's best-known explorers, in the place one would expect to find something to the effect of 'Don't try this at home', instead is written:

Disclaimer? There is none, do as you wish. Climb bridges, run the subways, play in sewage, go in drains.[14]

The message behind the disclaimer (or lack therof!) is clear: no one is stopping you from doing what you want but yourself. As Marc Explo, an explorer from France, told me on a trespass into the Paris catacombs: 'I don't need anyone to tell me that I'm free. I prove that I'm free every day by going wherever I want. If I want to drink wine on top of a church, I do that. If I want to throw a party underground, I do that.'[15]

This central motivation behind urban exploration has been parodied beautifully by the UE Kingz, a Stockholm urban exploration crew. They created a music video in a sewer called 'You Have to Choose', where they implore the viewer to 'live your life in a fishbowl ... or climb down in a manhole'.[16] According to UE Kingz philosophy, no person or physical barrier can stop you from going where you want to go and doing what you want to do – the choice is always yours. It is the ultimate assertion of the right of the self. As the explorer and BASE jumper Downfallen writes, 'When we see a sign that says "Do not enter", we understand that this is simply a shorthand way of saying "Leaving protected zone: demonstrate personal accountability beyond this point".'[17] Downfallen, as you will see, is one of a handful of explorers who died for that belief.

In the following passage, American explorer Youliveandyouburn highlights what he sees as urban exploration's liberating role:

[Urban exploration is] not 'safe' in the way that modern society has come to understand safety. We are not experts in our field. We don't always use tested and accepted equipment. We don't always go where it is deemed safe for us to go. The risks are plain and clear to all involved, but we face them and weigh the options. Rather than pursue solely the recreational products and services offered to us, we choose to follow our own aims.[18]

Youliveandyouburn is making clear that although the world has become sanitised in many ways to assure a safe and sometimes banal existence, it is up to us to break the mould if we find it lacking.

To give you a sense of the risk and exhilaration of this type of freedom, the bizarre twist that urban exploration puts on life, I will recall the

summer of 2010, when three other explorers – Winch, Guts and 'Gary' – and I took a two-week road trip from England to Poland, exploring more than fifty ruins, many of which we also camped in. We began that trip by climbing the Palais de Justice in Brussels, a challenging and tiring ascent that required getting over a twelve-foot hoarding and into the palace site by the scaffolding, making it first to some statues that were being refurbished and then free-climbing the outside of the scaffolding pipe, arriving at last on the crown of the building's dome.

That climb was the beginning of two weeks on the road that ended with something even more ambitious: a thirty-metre abseil down a construction shaft to gain access to the Antwerp Pre-metro, a system of tunnels and stations under the southwestern suburbs of the city, where tracks were never laid and trains never run. The underground site has been abandoned since the 1980s, and we wanted to walk its length.

It was 5 August, and although it was warm out, it was spitting rain as Guts pulled the car up to the curb next to the massive black hole we had found with Google Earth on Winch's Blackberry. Winch jumped out of the front seat and hopped over a fence to cross the street. I looked over at 'Gary' – his eyes were bloodshot, his shirt was stained with blood and mud

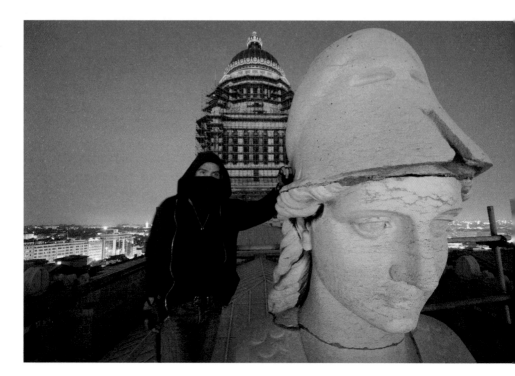

after weeks on the road vaulting barbed-wire fences, being chased by dogs and sleeping in derelict buildings, and he had a nest of petrol station food wrappers and plastic bottles around his feet. I realised with a start that I probably looked similarly run-down and thought briefly that this might all be a lucid dream, a reoccurring mental blip on the journey.

Then suddenly the car door ripped open with a sucking sound. 'It looks good, boys,' Winch reported. 'But we need to come back in a few hours, there's far too much traffic now to rig ropes.' We decided to go to the cinema and see *Inception* to kill time, which was the first 'normal' thing we'd done in weeks. Cinema employees eyed us suspiciously as we bought our tickets, probably thinking we were homeless and just looking for a place to sleep.

After the film, at about 1 a.m., Guts limped out of the theatre and told us that he was exhausted and backing out. He had hurt his ankle badly somewhere in Germany and didn't think he was in good enough shape to abseil. He dropped us off at the access point, where we chucked our rope over the fence.

We got started in what was now a steady shower of rain. Dropping in one at a time and kicking off the wall while we slid down the rope, we were shocked upon arriving at the bottom to find that the lights in the

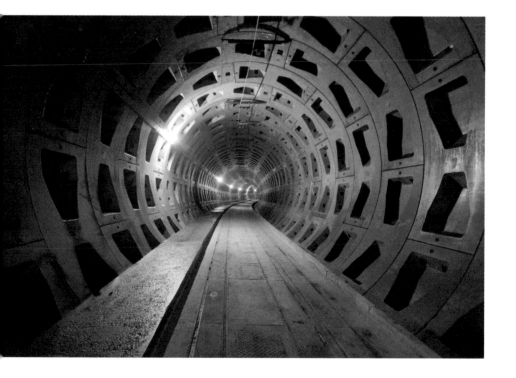

Pre-metro were all blazing. We entered the beautifully unfinished architecture and walked it for miles, taking photos in the luminescent tunnels and the never-used metro stations. By the time we got back to the rope the sun was coming up and the three of us were dragging our feet. The rain was now pouring down the construction shaft in sheets, soaking us as we tried to hook the ascenders onto the rope to climb back up.

We were so tired we couldn't think straight, and no one could manage to thread the SRT kit properly. All of our suggestions and solutions seemed ill conceived to the others, and tempers were flaring. At some point, 'Gary' even suggested we take a nap and try later. We were trapped.

Wet and frustrated, we gave up on ascending the rope and began searching for another exit. Eventually we found an emergency door out of the system and called Guts to pick us up, deciding to return later to retrieve the rope from the top. In the car, we were miserable and tired but still found the energy to chimp over the photos we'd just taken, delighted we'd got away with it and survived the night.

'Gary' said that that night demonstrated the reason we never watch films or do other 'normal' stuff – because our lives are far more exciting than anything that can be offered to us for passive consumption. We all chuckled knowingly and joked about how Leonardo DiCaprio, the star of *Inception*, probably would have soiled himself dropping over the edge of that construction shaft on a rope in the rain.

During that trip, much of which was spent drinking beer in the back of Guts' car, Winch told me that he felt urban exploration redefined the notion of 'quality of life'. When I asked him to elaborate, he said, 'Well, I think our generation has come to realise that you can't buy real experiences, you have to *make* them. Experiences like these are what quality of life is about. It has far less to do with how much stuff you own and more to do with how you choose to spend your time.'

Winch's insistence on his right to make life what he wanted it to be was felt in one way or another by everybody in the group and was revealed in increasingly unexpected ways over the next few years as our crew became more brazen and skilful at trespassing. At the same time, however, our thirst for the adrenaline rush of getting away with things became insatiable. Meanwhile, explorers constantly insisted to me that the desire to do something simply because it could be done superseded any political or transgressive impulse I might read into it.

However, when I talked with them about Winch's 'quality of life' notion, many explorers, most of whom worked office jobs, agreed that ordinary life had at some point become dull, prompting them to seek out something different. Undertaking urban exporation had made it clear that the modern global

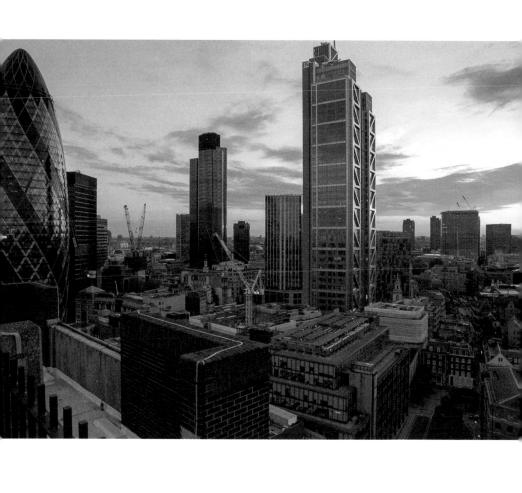

city was a place where sensory overload and increased securitisation have become the norm, where the only acceptables modes of behaviour are to work and spend money on pre-packaged 'entertainment'. These restrictions are now so ubiquitous that they're almost unnoticeable to the general population, but our adventures made them visible to us. Adventure after advernture, we revealed derelict playgrounds and infrastructure networks that were accessible to only the persistent explorer, undermining the notion that local borders, CCTV systems, walls, fences and guards could stop us from playing as we wished.[19]

London is, by many accounts, the archetypal, impenetrable fortress city.[20] The financial district is circumscribed by a 'ring of steel', a security and surveillance cordon surrounding the City of London which was constructed in the wake of the 1993 IRA Bishopsgate bombing. Heightened security measures were reinforced by 9/11 in New York and the 7/7 Tube bombings. The construction of these types of spaces has meant that the security architecture familiar in airports and at international borders – such as cameras, cordons, bollards and even biometric readers – has begun to appear in our neighbourhoods.[21] This has since spread to many other areas in the UK. The Liverpool police force even started using flying drones to surveil its own citizens in 2011, the same technology used to kill thousands of 'militants' in Afghanistan.[22]

Over the past four years, the city has seen countless reasons to increase security measures in order to match an imaginary 'threat level': the Pope's visit, the Royal Wedding, the Queen's Jubilee, the 2012 Olympics. And yet after each of these events ends, the security levels remain 'heightened'; the surveillance infrastructure remains in place.

Ironically, it is exactly these types of places that are most permeable to the urban explorer, because the more complicated a system becomes, the more weaknesses there are to exploit. As Dan Salisbury, another London explorer, told me, 'At some point you have to say: "Fuck the consequences, I *need* to connect with this city, and if I have to work a little harder for that feeling, then so be it."'

But beating the system, crossing the boundaries, making these connections – it all has consequences. Guy Debord, the self-proclaimed leader of the Situationist International, a group of radical Parisians in the 1950s who believed in taking back the city by any means necessary, writes in his iconic work *The Society of the Spectacle* that the modern world 'rigidly separates what is *possible* from what is *permitted*'.[23] The geographer Nigel Thrift further elaborated on this idea by calling the everyday city a 'security entertainment complex', that is, 'a mixture of control through surveillance and

distraction through entertainment'.[24] Urban explorers countermand those securitisation and distraction efforts through trespass, reporting back to the public with blogs, photos, videos and prose, bringing the hidden to the fore.

You likely wouldn't recognise an urban explorer walking down the street. They come from a wide swath of nations, vocations and backgrounds. Comprising loose networks of practitioners operating under pseudonyms and false identities, the UE scene is a mysterious, secretive, exclusionary and deeply rooted community full of rare camaraderie. The one thing they all share is the desire to find adventure in everyday life. This is the central foundation of place hacking.

Urban explorers, like computer hackers, exploit security weaknesses for the pure joy of doing so. Ask them why they do it and you are likely to be told that it's all in the spirit of freedom and tackling challenges. Both groups are enraptured by those moments when the seen and unseen, the possible and impossible, the self and the community fuse. I call this process the meld. Precisely because they are forbidden, these meld moments have the ability to shock and inspire, but to pursue them is also to risk crackdowns by embarrassed authorities. And urban explorers have one additional danger to face that the computer hackers do not: seeking the meld out in the physical world can also lead to the ultimate sacrifice, when explorers die in the process of discovery.

Like hackers, modern urban explorers have quickly built a rich history for themselves on web forums. Here, the community extols a kind of code of ethics, a primary facet of which matches the social expectations of contemporary eco-tourism of 'leave no trace'.[25] There is no apparent enforcing body for this code, other than the disapproval of fellow conspirators.

The urban exploration community may appear quite exclusive and cohesive to the outsider, but that unified front contains innumerable internal fractures, leading to constant assertions that there is no community and that individual explorers do what they like, regardless of any perceived code of ethics. As Moses Gates, author of the memoir *Hidden Cities*, said to me, 'The irony is, this is a community of people who by their inherent nature break rules and expectations. Expecting them to then follow the rules of a community is patently absurd.'[26]

One of the earliest stories of UE that explorers like to recount comes from 1793, when a Frenchman named Philibert Aspairt journeyed by candlelight into the abandoned quarry system underneath Paris we call the Paris

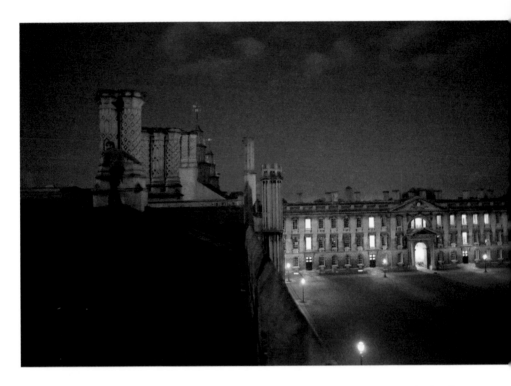

catacombs, looking for a 'lost' wine cellar, never to return. His body was found eleven years later, and a monument was erected to his memory.* Over a hundred years after that event, one week after the opening of the New York subway system, Leidschmudel Dreispul was killed by a train while exploring the freshly carved subterranean tunnels.

Of course, not all urban explorer tales have such tragic endings. In ancient Rome, Livy wrote about the Cloaca Maxima sewer, presciently suggesting that the system of drains might preserve the original layout of the city at a time when the buildings on the surface had been destroyed and ruined.[27] In 1862, John Hollingshead insisted that London sewers had 'been fruitful in furnishing antiquarian and geological discoveries' and spent time exploring them.[28] The writings of Walt Whitman, Charles Dickens, Baudelaire and many other artists and groups, including the Dadaists, Surrealists and Situationists, serve as inspirational figureheads for contemporary notions of the practice of urban exploration, with their passion for discovering dangerous, precarious, incongruous and absurd urban spaces.

* 'Philibert Aspairt' may be an anagram for a different name and/or may have been invented by cataphiles, despite the presence of the monument.

In 1939, an individual writing under the alias Whipplesnaith published a short book called *The Night Climbers of Cambridge*.[29] In the book, Whipplesnaith writes dramatic and amusing tales, comprehensively documented through photography, of being a student at Cambridge in the 1930s, spending evenings free-climbing the buildings of the city and being chased by police and porters, but eventually making it to the top of the tallest spires. When I presented a paper about urban exploration at the Cambridge Centre for Research in the Arts, Social Sciences and Humanities (CRASSH) seminar series in October 2012, the talk was infiltrated by a modern night climber called Tom Whipple, a reporter for the *Times* who has written extensively about the history and contemporary escapades of the Night Climbers, and who may or may not be related to Whipplesnaith. Whipple took me out for an evening of mischief and regaled me with buildering tales all night.[30]

In one such tale from 2009, students placed Santa Claus hats on the top of each spire of King's College. The university administration later claimed that the removal of the hats cost 'thousands of pounds'.[31] In the most famous university buildering caper, which took place in 1958, engineering students placed a car on the roof of the Senate House that could only be removed by cutting it to pieces.[32]

The first generation of contemporary urban exploration groups coalesced from the 1970s to the 1990s. These groups were (and are) known as the Drainiacs and the Cave Clan in Australia; Diggers of the Underground Planet in Russia; Ars Subterranea, Jinx Crew and LTV Squad in New York City; the Cacophony Society in San Francisco; the Action Squad in Minneapolis; Angels of the Underground in Canada; the Berlin Underground Association in Germany; and various cataphile groups in Paris, including UX.[33] Interestingly, the Cacophony Society was a spin-off of the San Francisco Suicide Club, founded in 1977. Founding member John Law later helped established the Burning Man festival in Nevada's Black Rock Desert, which now attracts ten of thousands of visitors each year.[34]

The first recorded internet-facilitated large-scale urban explorer meet-up was attended by about thirty individuals in Brooklyn in 2002. It was organised by the LTV Squad, a graffiti group turned urban-explorer crew, and was followed by an even larger meet-up in Toronto in June 2004, where sixty-five people gathered to go exploring together. Given that Ninjalicious, the first contemporary to pen a book on urban exploration, was also from Toronto, that the largest web forum, the 'Urban Exploration Resource' (UER), is run from there, and the fact the city has produced a steady stream of internationally respected urban explorers, including Michael Cook,[35] it's fair to say that Toronto may be the birthplace of the modern

urban exploration movement – though others might give that title to Australia because of the Cave Clan or San Francisco because of the Suicide Club. Regardless of where it happened, the early 2000s can be pinpointed as the time the global UE community was formed.

However, all these associations are loosely structured, much like the urban exploration practice itself. Toronto journalist Wershler-Henry has suggested that urban exploration, because it presents fractured, complicated and often contradictory stories of places, is like a postmodern Fodor's travel guide.[36] Explorers, like computer hacker groups such as Anonymous, perfectly understand that to transgress, to create a movement or narrative of resistance, is to create a target for authorities to bear down upon.[37] The fragmented urban exploration community, however – nomadically operating under aliases, with photos of blurred faces, shifting identities and constantly changing geographic locales – precludes that possibility of constructing any such grand narrative of opposition.

However, urban explorers take these precautions less, I think, because of fear of persecution and more because they don't want to be stuck with a label. Not having a specific (political) message to advance also, in a way, releases them from having to articulate their motivations for what is, in the end, a largely selfish pursuit.

UE practitioners clearly enjoy the image of the urban explorer as outlaw, masked up and sneaking about the city during the dark hours, shattering illusions of security by demonstrating that protected urban artifices can be breached by a group of twenty- and thirty-year-olds with backpacks and tripods.[38] In reality, there is nothing very alarming about urban exploration – it is certainly more quirky than threatening. Exploring places rarely leaves the city vulnerable. What the practice *does* challenge is the underlying message of constant and immanent threat promised by neo-liberalism that is used to codify the urban environment for our 'safety' and restrict the range of acceptable activities. Exploration of 'secure' sites reveals this spectacle to be, much like explorers' public anonymity, a fragile smokescreen.

As a sort of anti-spectacle, most explorers hope that their narrative is the more tantalising option that pulls people away from the mall and television screen, though most would take no responsibility for the failings of others to seek out their own adventures.[39] By creating alternative models for action, however, urban explorers undermine public narratives about what can and should be done, similar to other urban 'subversionists' like graffiti artists, parkour enthusiasts and skateboarders – though it is important to note, again, that urban explorers' response to this situation is not to blame the system, but to do what they wish regardless of the system.

Unlike, for instance, the Situationists, who participated in (and possibly triggered) riots in Paris in 1968, urban explorers aren't calling for an organised revolution; they just do what they want and go where they can. Whether or not they inspire some sort of awakening by encouraging others to engage viscerally and creatively with the world, as most people did more freely when they were children, is likely an afterthought for most explorers. The goal is more about the exploit itself.[40]

This is why I call urban exploration 'place hacking'. As early as the 1980s, the term 'hacking' was applied to physical space by the Technology Hackers Association at MIT, who learned to pick locks and infiltrate the steam tunnels underneath the university. The same students began climbing rooftops on campus, bringing freshmen on what is called the Orange Tour, where a group of hackers wearing t-shirts stating 'I am not here' circumvented campus security for unsanctioned views after midnight.[41] The celebrated hacker Kevin Mitnick used to Dumpster-dive in Los Angeles and find old bus passes, and after acquiring a punch-hole device identical to that of the LA Rapid Transit Authority, he would stamp out free bus transfers for passengers.[42]

It wasn't until relatively recently that the term 'hacking' was appropriated by the virtual computing community. As the Swedish media scholar Jonas Löwgren writes, 'the word "hack" was used to refer to . . . practical jokes or stunts. Its meaning shifted to the technology needed to perform the prank, and later came to mean a clever technical solution in general.'[43] The seventh entry under the term 'hacker' in the New Hacker's Dictionary defines a hacker as 'one who enjoys the intellectual challenge of creatively overcoming or circumventing limitations',[44] importantly pointing to the physical foundations of the art. As Dsankt suggests on his website:

Whether you're hacking transit systems or computer systems, they're all fissured, all possessing those little cracks just wide enough to wriggle your dirty little fingers into and force, to sneak a peek into what lies beneath the shiny smoothed over facade most [people] take for granted every single day.[45]

Today the most popular global urban exploration forum in the world, UER, has eighteen thousand registered users.[46] In London, there were around a hundred active urban explorers as of 2012. When I asked Methane Provider, the administrator of the UK's most prevalent forum, 28 Days Later, if he could provide me with any statistics on registered users across Britain, he responded, 'What happens on the forums has squat to do with exploring. It's not a true reflection of anything.'[47]

Methane Provider's reaction was predictable; it's the reaction proffered to any researcher or journalist wanting to approach this community, one

built around shared experiences that prides itself on a foundation of providing constant misinformation to mislead noobs and cops. Even after a year of close friendship and countless explorations together, 'Gary' told me, 'What you do, Brad, it's just words. This doesn't have anything to do with anything.'

Urban exploration, despite claims by outside observers,[48] is not a spectator sport. The beautiful low-light long-exposure photographs explorers are becoming celebrated for exist, as Dan told me, 'solely as markers to experience', even as they are 'proof of what we've accomplished', as Winch claims. When I asked a London explorer called Alex why he titled his blog residu.es, he said it was because 'the text and photos posted there are just residuals of the experience'.

Taken at a metropolitan level, the urban exploration community is tenuous, competitive and contested. However, despite practitioners who assert that they have nothing to do with other crews, there clearly *is* an urban exploration community. Explorers like the group I ran with are, on some level, quite tribal in their affiliations,[49] but we often communicated, traded information and visited other explorers in Minneapolis, New York, Milan, Stockholm and Paris.

Within London, the community structure was rather unique: four distinct but overlapping crews were in operation when I arrived in 2008, and many explorers were not connected to any particular group. Most of the London 'teams' operated outside of the public forums or on secret forums requiring personal invitation, which people often join or create after being banned from 28 Days Later by Methane Provider, who asserts brisk authoritarian control over the forum.

It has been suggested by academics that urban explorers are all white and middle class.[50] But here again the community is less homogenous than it appears on public web forums and in the media. While it is the case that this is *largely* a group of white, middle-class men[51] – Abdul Greaze, a London explorer, once told me, only half joking, that he was 'the wrong colour to be an explorer' – urban exploration is, in my experience, not exclusionary. Anyone willing to take responsibility for themselves and step up to the challenges the community tackles will be welcomed. Though long-term friendships, and therefore group affiliation, may be difficult to forge, once you are offered a place in the crew and taken in, you are quickly shown secrets, supported (even when wrong) and expected to participate. The organisation of urban explorer groups, again, mirrors that of computer hackers, which in turn, as journalists Arthur and Halliday wrote about the now-defunct hacker group Lulzsec, 'mirror those of street gangs, where the talk is of respect, attacks, who can be trusted, who the

enemies are (usually law enforcement and rival gangs), whose ground belongs to who, and who has accomplished what'.[52]

Explorers I met from the UK, United States, Sweden, France, Australia, Italy, Belgium and the Netherlands include a number of people with various jobs – a social housing worker, a manager at Asda, a bus driver, a church leader, an exotic dancer, a cleaner, film and music students, an owner of a construction company, a few professional freelance photographers, a joiner, a banker, a call centre worker, a lighting engineer, a special constable, a dentist, a geography teacher and, unsurprisingly, a number of people working in software, IT and web design, who might also be considered hackers in the virtual sense. Obviously, in order to have the opportunity for these sorts of engagements with the city, one must be secure enough financially and have enough free time that investing the hours necessary to research and explore sites can be accomplished. More importantly, one also has to view these spaces as primarily areas for play and not, for instance, potential housing.

There is, in addition, a clear imbalance in the ratio of women to men involved (approximately 10 to 15 percent of London explorers are female). While accusations of sexism have been levelled against explorers themselves – probably due to the masculinised edge to the images they produce and obvious links to the male-dominated historical foundations of exploration in a broader sense – there is nothing explicit in the exclusion of women, and in fact, women explorers tend to be very highly regarded. However, the community's inclination to valorise risk and technical skill, within closely knit explorer cliques with competing egos, certainly does seem to appeal to a traditionally masculine way of seeing the world.

When I initially posted on the public forums, late in 2008, I was trolled by explorers who would later become close friends. On the thread, I posted photos of a derelict brewery I had explored in Wandsworth alone, writing that I wanted 'to get footage of exploration and do some "in the field" ethnographic interviews about the motivation to explore in the city'. Nicholas Adams wrote back saying 'your location in wandsworth looks awfull I will do the documentary if u show me a photo of you stood on top of Battersea Power station'. Zero then responded, 'Jesus talk about a guy who clearly HASNT done his research'.[53] The vetting process eventually operated on two fronts – connecting first online, where Facebook worked better than forums for meeting people, then proving my mettle as an explorer on a mission.

It was January 2008 when a guy called Neil J. rang to invite me out for my first exploration with London explorers. We agreed to meet at 9

a.m., but then that morning he texted to ask if we could meet an hour earlier. I raced out of the house, crossing London to Tottenham Hale. Once there, he told me they had already driven past and I had better meet them at Ealing Broadway – over an hour away on the other side of the city. Upon arrival, sweating and panting, I jumped into the car next to a girl called Agent M, who was fiddling with a film camera. Neil was sitting in the passenger seat chain-smoking and gesticulating his way through stories, while Popov drove like a madman.

I was nervous and excited as we cruised down the motorway towards a mental health hospital called West Park that had been derelict for almost a decade. We were caught almost immediately upon arrival by a security guard the explorers called The Hammer, who threatened to phone the police while Neil argued with him.[54] Amid the commotion, Popov quietly disappeared down a tunnel and went exploring without us.

This was the beginning of my life as an urban explorer. That day I also met Winch, who was roaming around a different hospital in a tweed coat and glasses, carrying a large tripod and talking excitedly about the history of the location. By 2011, long after the day we abseiled into the Pre-metro together, Winch would be one of my best friends as well as a founding member of the London Consolidation Crew.

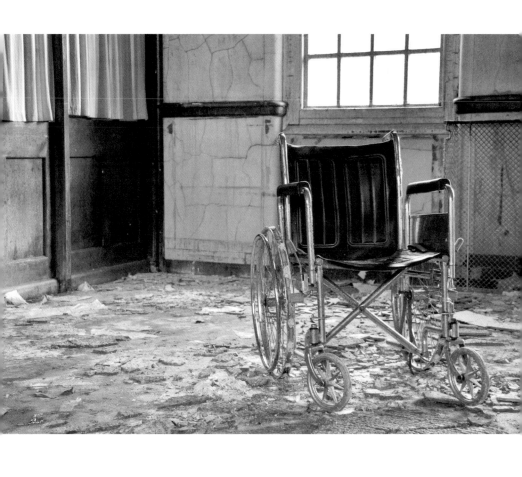

Chapter 2

THE RUINS OF HISTORY

'Understanding the past embraces
all modes of exploration.'
– David Lowenthal

We were hiding in the bushes, covered in mud, watching the security patrol walk past on their rounds. I could hear the gravel crunching under their boots as they talked about the latest football match. Beyond them, Battersea Power Station sat empty, with its beautifully grim brick walls and creamy smokestacks jutting into the slow clouds. Finally the guards turned the corner, and without a word we ran, crouched low. We went over the Heras fences: two to get into the courtyard, one more to get to the walkway entrance. The last fence was broken and made an incredible metallic shriek as we tried to get over it. We held the fence for each other, sweating and shaking, then entered the roofless central hall, falling into the grass, trying to suppress our laughter and excitement.

Lying there, catching our breath, inside one of the most iconic derelict sites of London, we stared up at the massive chimneys we would soon touch. I felt an immense sense of freedom. Rouge turned to me and said,

'Should we go see what else we can find in here?' and I felt the tension release from my shoulders. I knew that I was in love with this. I never wanted this feeling to leave me.

Pulling ourselves up over some rotten iron girders and then through a small crawl space, fending off flapping pigeons, we emerged into Control Room A, a chamber with a long panel of wheels, switches, clocks, dials and levers that had been used until the 1980s to regulate electricity to different parts of London. Everything in the room was covered in dust. It felt like a movie set as we pretended to shift power to different areas in London ('Goodnight, Wimbledon' – *clang!*). Then we climbed onto the roof and up to the base of the chimneys, where we opened drinks and watched the lights of London twinkle below, rubbing the texture of the smokestacks so few had ever touched and wondering how much longer they would last.

Later, with the sun coming up, we beat a hasty retreat back out into the neighbouring (and far less interesting) riverfront housing development next door. We guessed that many of the people living there had most likely purchased those properties for the views of the power station and found it bizarre that most of them had probably never thought to see what was inside.

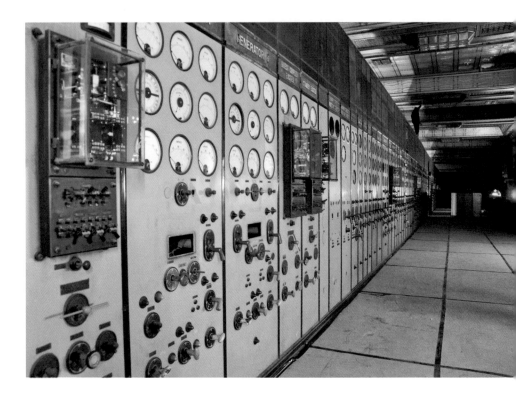

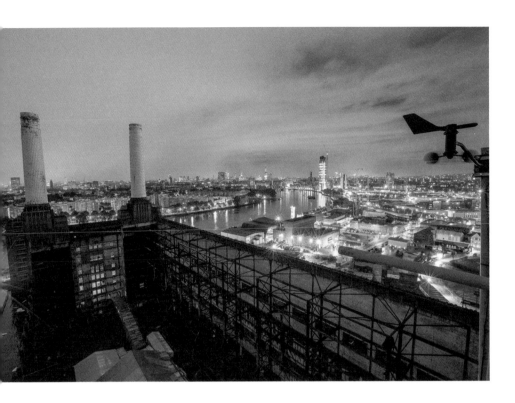

Battersea Power Station and Millennium Mills, a derelict turn-of-the-twentieth-century flour mill in East London, are considered by the urban exploration community in London to be the last great industrial ruins in the city and, as such, have taken on an almost mythological status. When explorers from other cities visited our crew in London, both of these places were usually on the list of attractions – like the catacombs of Paris and Odessa, New York City bridges, drains of Las Vegas or the ruins of Chernobyl in Ukraine.

When I first met the explorers in 2008, the global financial system was imploding. As a result, the city seemed to grind to a halt, and many architectural projects and plans to redevelop derelict spaces were suddenly shelved, leaving broken-toothed building sites and decaying ruins empty and open. As the language of media pundits, bankers and politicians slowly slipped from the reality of a recession to the possibility of a depression, explorers' eyes lit up all around the globe.

Most of the ruins we explored together, such as Battersea, tended to be at least a few decades old, steeped in the enticing aesthetics of decay.[1] However, on more than one occasion, as UK businesses fell victim to the collapse, we read of their shuttered doors in the headlines and then snuck

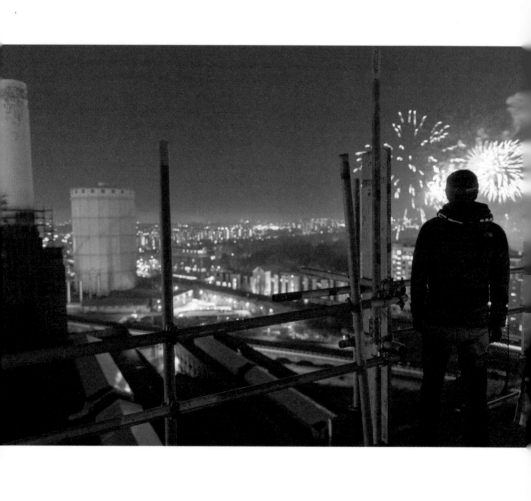

in soon after to rummage through the remains, documenting archaeologies of the future.[2]

Most urban explorers begin their passion for place hacking with an interest in exploring derelict and disused space. These spaces are appreciated for their aesthetic qualities, for their possibilities for temporarily escaping the rush of the surrounding urban environment and their ability to hint at what the future might look like, when all the people have disappeared – a visceral reminder of our own mortality. This fascination with decay is becoming more prevalent, even if explorers themselves have a difficult time articulating the urge to visit and document it.[3]

After a year of exploring decaying architecture in and around London, including Battersea, Mills and various derelict hospitals, our geographic imaginations inevitably expanded into other places, and our desire to move farther from our experiential comfort zones became irresistible.

In October 2009, we had spent a long weekend in the Belgian countryside exploring derelict castles, asylums and factories. This was the first

time we slept in a ruin. Hunkering down in ruins was terrifying – there was always a chance of being awoken by police, security guards, property owners or other nomads with less benign intentions than exploring. After weeks of living that way on multiple trips, the group began to feel our lives back in London slip into the ether, a satisfying disconnection from obligation and a reorientation of priorities to the immediate present at all times. Our intrepid planner and navigator on those trips was Winch, a well-known, well-respected camera nerd from London Team B with a propensity for telling off-colour jokes with just the right demeanour to get everyone laughing hard enough to cry.

It was the end of 2009 when Winch, Dan, Guts and I found ourselves once again speeding down Highway A18 over the French border into Belgium as the sun set. In the backseat, I stared out at the passing land-scape as we cruised towards Liege in a small green sports car, Guts behind the wheel, the boot overflowing with camera equipment, food wrappers and empty beer bottles.

The landscape, a murky grey split by beams of orange as the sun disap-peared for the night, seemed to contain more derelict buildings than living ones. Sitting in the backseat, I read aloud Rose Macaulay's thoughts that 'above and under the earth [there are] far more ruined than unruined buildings',[4] and everybody nodded knowingly. After sneaking into hundreds of decaying structures together, we were all aware that each new building constructed is another that will one day slip into ruination. It's the moment between life and ruin, the fragile point when a place could crumble with just a look, that we search for.

With every derelict factory that we passed in a blur of untamed foliage, rust and jagged metal, the energy in the car increased. Dan Salisbury, sitting next to me and on his first trip to the continent, started jumping around and clapping, saying, 'Let's go climb that!' and 'Ooh, that looks old!' Winch and I were drinking Chimay that we'd picked up at a petrol station, and Winch, as usual, was perusing photos on the Internet and scrolling around on his cracked Blackberry, looking at an aerial view of our next location on Google Earth, trying to find a possible entry point. He turned to us slowly and said, 'So, you guys, we're staying in a hotel tonight' – everyone looked stunned – 'that closed in 1996!' And we all erupted in riotous laughter.

Urban explorers are fascinated by the flotsam of the built environment, locating sites of haunted memory, seeking interaction with the ghosts of lives lived.[5] When these places are located, their fragile deteriorations are captured in photos, the snap of the camera shutter like an exploding chem-istry experiment where past, present and future are fused.[6] Taking the

photograph creates a moment of temporal juxtaposition, giving us, as the artist Robert Smithson once wrote, an 'illusion of control over eternity'.[7]

In abandoned bunkers, hospitals and industrial sites, we found moments caught between the present and the past, confrontations that flared up with unexpected material traces. Often we felt like archaeologists, assaying surface material without deep excavation to analyse the character of places; researchers conducting a survey of affectation. These are some of the things that are uncovered through the little cracks we can pry open: pictures, personal notes, clothing, toys, computers, tools, furniture and equipment. Sometimes even whole buildings are hidden from plain sight, well buried behind the urban façade. The cracks we can access them through – what the urban explorer Michael Cook has called 'vanishing points' – reveal the city less as a solid entity and more as a collection of fluctuating particles constantly swirling as people attempt to stall the natural collapse and decay of the built environment.[8]

Urban exploration is a shallow form of discovery, but it is often a more encompassing way of working through places. It's about space as much as time, about the event of discovery as much as the accumulation of knowledge, about things as much as people.[9] In contrast to a historian working

deeply on one topic or site, urban explorers have mental and virtual data-bases of hundreds of sites, connected though experience. Luke Bennett, a geographer who did research into urban explorers in the UK interested in Royal Observation Corps (ROC) monitoring posts (a type of subterranean military bunker), notes that 'participants appeared to be working something through, either a retained childhood instinct to explore, an obsessive desire to catalogue, or some form of a veneration process'.[10] The dissected, dete-riorating and confused narratives these places offer can indeed provoke self-reflection and satisfy a desire to accumulate vast amounts of knowledge, to catalogue our always unresolved relationship to space and time.

Urban exploration gives life back to a building after it has been aban-doned, with an acknowledgement that while the primary use of a space – factory, house, asylum, hotel – may have passed, and therefore it could now be considered useless, places do not 'die'. They are in transition, mutating in form and meaning. Explorers do not see wasted space, or non-places, just places cared for and remembered in different ways. Where and how to interpret these post-abandonment stories, regardless of who 'owns' them in an economic sense or whether they are 'true' in an empirical sense, is up for grabs. These places are in the hands of those who have made the effort to rediscover them, with or without invitation. Photographer RomanyWG writes that 'to be that explorer at that moment is to be given back the power to tell those stories for yourself'.[11]

In contrast to the curated management of recognised heritage sites – think of the level of care and control exerted over Stonehenge or Ellis Island, for instance – urban exploration appreciates history in different ways and does not offer the promise of preservation. Places are experi-enced, enjoyed, recorded and loved in the present, but material remains are not prevented from continuing their mutations towards inevitable obscurity.[12] Nonetheless, in many cases, steps are taken by explorers to minimise their impact on a place so as not to impede its decay or alter the sanctity of the experience for future visitors. Some explorers even attempt to impose this through the enforcement of a code of ethics that impels explorers not to affect sites by damaging, taking or even moving material traces, enforced through threat of community disapproval or banishment.

In our relationship with historic places, we often ask, 'Why is this place important?' and rely on the voice of a guide or an expert to medi-ate our relationship to it, to explain its significance. Less often do we let places speak to us directly. However, as London popular historian Raphael Samuel writes, 'History, in the hands of a professional historian, is

bound to present itself as an esoteric form of knowledge.'[13] When I worked previously as an archaeologist in Australia, California and Hawaii, I was always uncomfortable with being put in a position of authority over other people's histories and memories, and so I resisted much of that work.[14]

In the practice of urban exploration, it is not the philosopher or the scientist who interpret spaces but the often underinformed wanderer searching for knowledge as it presents itself.[15] If, as Dsankt tells me, we 'do it because we want to do it, not out of a grand sense of preservation', what then can we learn from taking the unguided tour, where the important historical attributes of a place are overwhelmed by the sensory, emotional, affective experience of simply being there?[16]

Physical exploration of space stretches the stories of these encounters into the histories of the location.[17] These experiences add to, rather than subtract from, the heritage landscape, which in contrast is rendered increasingly banal because of its reliance on the marketplace, creating pasts that are not allowed to be altered.[18] When I asked Dan, on the way out of an abandoned factory called Sinteranlage in Germany, whether he felt he had learned anything about the place, he told me that 'exploration is, on some level, always a process of becoming less ignorant. You can't have an experience like that and walk away with nothing.'

At last we found the hotel Winch was looking for. It was called Kosmos, and it indeed looked as if it had been abandoned since 1996. At 10 p.m., in a light rain, we climbed around on the tin roof hanging over a cliff on the back of the place, our shoulders piled with sleeping bags, cameras and torches, looking for a broken window, as the first-floor entrances had been boarded up tighter than expected. We eventually located a smashed-out window and climbed through, the point of entry also a portal into the past. Inside, we found a few old vinyl couches covered in pigeon faeces and set up tea lights in musty bookshelves, sipping whiskey obtained on the ferry to Calais, thankful to have found shelter for the night.

As we sat together, listening to the wind ripping broken glass out of the twisted window frames, the peace was destroyed by the sound of some bit of metal smashing over and over again against a part of the roof we couldn't reach. In this punctuated calm, Dan told us that never before had he felt so wrapped up in the fabric of a place, and we all agreed. Temporarily living in ruins – what the urban exploration community calls 'urban camping' (or going 'pro-hobo') seemed to fold us right into the very materiality of the place.

In the morning we walked out over the cracked tarmac of the parking lot, weeds grabbing at our trouser legs, and headed to the car to speed

to the next location. We briefly stopped to look back at the Hotel Kosmos and consider our night there. I asked Dan if, after his experience, he would like to see it preserved in some way. He laughed and said, 'Hell no, that place is a shithole – look at it!'

I thought as we drove on that explorers are less attached to the places themselves than to the history, memory and experiences of these places, which often linger after the material remains are gone. Nobody was nostalgic about the material remains of the Hotel Kosmos, but we felt that all of us, and perhaps even the hotel itself, had enjoyed our experience there.

Kosmos is the kind of place that might be dismissed by historians, who would see it as being too new to have heritage value. Urban explorers, by contrast, harbour no such restrictions to an appreciation of the past. An explorer may find as much significance in an abandoned grocery store that was just closed down last week as in a derelict eighteenth-century castle in Belgium. Places with beautiful, amusing, disturbing and dark histories are all given space for recognition, exploration and appreciation.

Urban explorers are omnivorous; they quarry and store both material and immaterial records, functional and fantastical memories, rational and irrational histories of places. They create myths about places that, through retelling, become embedded in the places themselves. The stories of a night spent sleeping on the decrepit vinyl couches in the screeching winds of a cold Belgian winter in Kosmos become just as much a part of the place as the stories from its life as an everyday hotel.

Sometimes we encounter other people in abandoned places, especially when we get farther from areas of relative economic prosperity. Those encounters – sometimes consisting of an apology while turning to leave and other times resulting in small conversations about the place we have found each other in – also remind us that buildings continue to be useful even when their primary function has dissolved. Later, on a different road trip in Poland, we encountered a tent clearly being used as a home inside a derelict Soviet military troop barracks. We took in the scene for a moment, snapped a photo and left quietly. Later we wondered what kind of relationship, if any, the person living there had to the base, and we regretted not speaking to them.

The English Heritage website proudly proclaims that it 'exists to protect and promote England's spectacular historic environment and ensure that its past is researched and understood.'[19] Meanwhile, on the US National Park Service website, they declare their willingness to work with those 'who believe in the importance of our shared heritage – and its preservation'.[20] When you

visit historic sites like Dover Castle in the UK or Bodie Ghost Town in California, what you will encounter embodies the keywords outlined in these statements: preservation, research, understanding, heritage.

These concepts are valuable, and the research that stems from them is important. But those sites have also been turned into government property, working in the interest of national agendas and motivated by economics.[21] These places are then used by the state to assert a moral right over place, and can be interpreted as part of a campaign to impose a prescribed heritage that dictates the 'official' history, to the exclusion of alternative stories.

This can, at times, incite populist reactions against what is seen as a homogenisation of cultural identity, particularly in cases where visitors realise that representations of history presented as singular narratives are in fact more complicated than they are presented. Preserved Spanish missions in California, for instance, say little to nothing about the murder, rape and enslavement of indigenous people that took place within their walls, despite Native Americans' demands for 'other' histories to be remembered.[22]

Public reaction to state-mediated historical interpretation is, in many cases, disdain. In the course of geographer Dydia DeLyser's work at Bodie Ghost Town in California, she spoke with two visitors, a husband and wife. The wife told her, 'We were just in Virginia City and Bodie is so much better. This isn't commercial. Over there, every time you walk into a building, somebody's trying to sell you something.' Her husband concurred: 'This is so much more authentic.' On the other hand, other visitors DeLyser later spoke to deemed Bodie 'inauthentic' when they found out that 'modern' materials had been used to stabilise buildings onsite.[23] A few years after DeLyser, I visited Bodie and saw a young girl standing behind a rope that was preserving a room in a state of arrested decay. The girl was clearly frustrated by the barrier, and asked her father, 'But who decided I can't go in there?'

DeLyser's work at Bodie suggests that, while many people want a sense of history, some are also looking for more than a passive idea of the past constructed through a scripted narrative. These individuals are looking for some level of authorship over and engagement with that history, whether that calls for an engagement with a physical place, a more interactive experience or even an opportunity to take part in its interpretation.[24] As the photographer Wolfism writes, urban exploration gives you 'the opportunity to feel you're in close touch with history, up close as opposed to in a glass case, [in places] completely forgotten by history books'.[25]

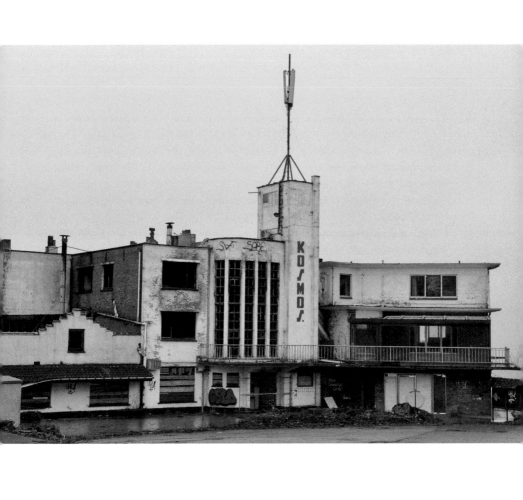

Thinking, the only route to the past, transforms the city into an ever-changing story. In *Civilization and Its Discontents*, Freud writes about a dream of standing on the Palatine Hill in Rome and imagining the city as a palimpsest, an architectural parchment on which many series of inscriptions can still be detected below the most recent text written upon it, all available for psychological delving, regardless of their material or immaterial state.[26] This type of layered memory is as much a freedom of action as thought. As Patch told me during an exploration, 'What I choose to do here doesn't belong to anybody; it's mine.' Urban explorers insist on the right to enter places, to enjoy them on their own terms, and to create counter-topographies that playfully undermine the conventional narratives of history.[27]

This delicate understanding is described by geographer Caitlin DeSilvey, who invites us to 'imagine a place where the past lies thickly under a layer of dust, and where the simplest act of retrieval kicks up clouds of uneasy speculation. Junk or treasure? Waste or artefact?'[28] In DeSilvey's world, the dreamlike qualities of the fragile ruin and irresistible material resonances contained within excite our imaginations.[29] With that in mind, the thoughts of urban explorer Jeremy Blakeslee become even more poignant:

> **These places become like a drug for some reason. Places of this magnitude get you high, a combination of the history, the architecture, the light moving through, the smell of one hundred years of motor oil in the internal combustion blowing engines all over the floor like blood. And you are just another layer in the history of the place.[30]**

I got a call from Rouge in the summer of 2009, saying she'd heard there was a derelict Soviet submarine, a U475 Black Widow, sitting in the middle of the River Medway somewhere near Rochester. The sub had been converted into a floating museum and then, at some point, abandoned. She had purchased an inflatable dinghy off eBay for twenty quid and asked me if I wanted to come along and see if we could get inside.

I arrived in Rochester at about 11 p.m., stepping off the train to find an unexpectedly sleepy little Dickensian town. We made our way to the riverbank around midnight and found a small set of wet stairs covered in green slime next to the waterway, out of sight of passing drivers. Thirty minutes of absurdly loud dinghy hand-pumping ensued, leaving my arms completely sore and limp, not just from pumping but also from fending off the trash washing up onto us as the tide rippled against the stairs. Finally the boat was pumped. We loaded it with our camera equipment in gaffer-taped bin liners. Rouge sat down in the front as I shoved off the river wall and then plunked down in the back.

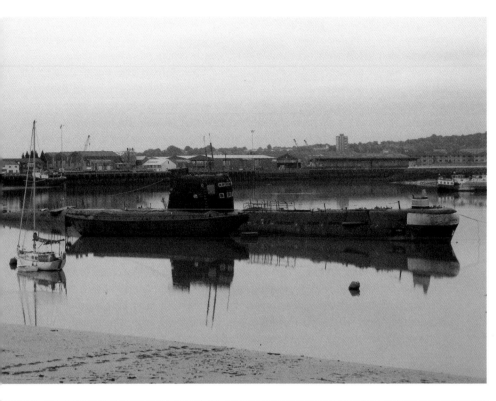

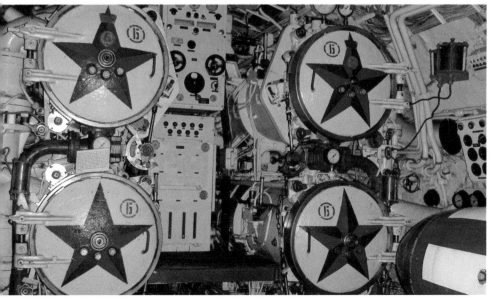

In the silence of the night, floating into the middle of the River Medway, the first thing we noticed was a terrible hissing coming from the boat. We were sinking. In a panic, we decided to quickly try to reach the sub, about a hundred feet away, and then repair the boat. I paddled fast and hard, working against a strong current. When we sped into the hull, Rouge tried to stop us with her oar – snapping it in half in the process. We both watched solemnly as the broken paddle was swept out to sea with the current. Then I grabbed a mooring rope and tied off the dinghy. Once we'd both climbed out and scaled the side of the sub, the hissing stopped.

Up top, we found the hatch held closed with an electrical cable inside the fin. I untied the cable and, holding my breath, slowly wrenched the handle. The hatch opened with a horrendous sucking sound, and an oily olfactory cocktail of mould and crusty pigeon hit us full in the face. We descended.

Inside, the air felt compressed, with a thick, vile aroma of oil and machines, rust and decay, driftwood and dead bird. The sub was resting unevenly on the hull, so walking required using an off-kilter sense of balance, and the space was very tight, so setting up photos was almost pointless as they all turned out wonky. We played with the defunct radar, used the periscope and telephone and had dinner in the bow. It was unclear which parts of the sub were original and which had been installed later for visitors to the museum. After a good five hours in the boat, both our heads began to hurt, possibly from breathing the stale air. We decided to leave.

Rouge was first up the ladder to the hatch. As she reached the top, enveloped in darkness above me, I heard a horrible thud followed by a blood-curdling scream. She came down the ladder in a limp pile, falling on top of me, holding her head. The hatch, just as she was poised to emerge, had swung shut, the sealing wheel hitting her hard. After she took some time to recover – both of us becoming increasingly paranoid about our headaches – we worked together to get out.

With the swirling black-and-tan river around us, Rouge dizzily wandered towards the dinghy on the slippery hull. I ran to grab her, and at the moment I did so I realised with horror that the tide had gone out. With no other option, I helped her into the boat, got in myself and paddled as fast as I could towards the shore, the hull continuing to hiss all the while. I beached the dinghy at speed and jumped into the mud, sinking up to my knees. We were at least fifteen metres from the slippery stairs.

Dragging the dinghy full of our kit, I held Rouge up and we slowly made our way to the shore, step by step, with the horrible stinking sucking sound announcing our progress to a dismayed early-morning jogger watching with

his mouth open. Finally on the shore, we fell to the ground panting, but also laughing like mad, celebrating escape and good fortune.

Urban explorers seek to celebrate the vernacular past that history books overlook.[31] In these forgotten places, history is a social form of knowledge, crafted by the multitude.[32] Exploration, urban or not, is defined primarily by the spontaneous search for and discovery of the unexpected, finds you didn't know you were looking for.

The architect Le Corbusier found it ironic that while we piously worked to preserve the Coliseum, we allowed a locomotive to rust in a scrap heap.[33] Today we may revere the locomotive, yet label the pile of old printers or stacks of floppy disks as 'trash' or 'waste'.[34] As Geoff Manaugh of 'BLDGBLOG' notes,

Wordsworth could very well have gone out at 2 a.m. on a weeknight to see the cracked windshields of car wrecks on the sides of desert roads, new ruins from a different and arguably more interesting phase of Western civilization.[35]

How much time must pass to appreciate a place or the artefacts within it? For urban explorers, the answer is not much. Part of this appreciation lies in the idea that, by visiting places that have been recently abandoned, we encounter artefacts of abandonment that are familiar to us and invoke spectres of unexpected and involuntary memories, conjuring intersecting temporalities where the past becomes the same time as the present.[36]

In one instance, London Team B first explored the Courage Brewery in Reading just days after its closure. It became, by all accounts, a favourite site that the group revisited many times. Dan, climbing the brewery tanks that first time, declared, 'This place is still alive – it's still humming!' Eighteen months later, it was demolished. For all we know, the pictures the explorers took (illicitly) are the last extant documentation of the place before it was materially obliterated.

In 2009, I accompanied a spiky-haired urban explorer called Vanishing Days on a trip to Gillingham. We visited four sites in one day, from a Napoleonic-era fort to a World War II battery to an equestrian centre closed down in 1986, all of which he had visited frequently. When we stopped and sat on a small crumbling brick wall in the equestrian centre to catch our breath towards the end of the day, I asked him why he came to that place when we were clearly surrounded by many more historically 'significant' sites.

He told me that he loved the story of the place. It was about an eccentric old millionaire who had begun building the centre and who

consistently made impossible demands for permits and strange architec-
tural components, causing both the local council and the construction
company to balk. Finally, after years of endless building and rebuilding,
the millionaire ran out of money. The best part about the equestrian
centre, Vanishing Days told me, was that it had only been open for a
few months before being shut down again. He was enchanted by the
ridiculousness of it all.

As we entered one of the rooms of the building – careful to avoid the
nails sticking out of the floor where people had been ripping the copper
piping out of the planking – we saw a wallpapered mural of a horse half
peeled off and flapping in the wind above us. We found a stack of
pamphlets published by the Kent Visitors Bureau from 1985, which included
the failed equestrian centre in the list of top ten attractions. Vanishing Days
shined a light on the pamphlet so I could film it and told me, 'I just love
how sad this place it. Can't you feel it?' In fact, I had felt it since we first
squeezed through the fence and into the grounds. The place was sodden
with a prevailing comical tragedy.

The equestrian centre is now more memory than history. Its 'official'
history, wherever it exists, is of course important, but the oral traditions

and folklore that urban explorers (amongst others) have built around the site add another layer to the story.[37]

Between 2008 and 2012, we visited many recently abandoned places, from empty cinemas to collapsing shopping malls to empty hotels. Fascinated by the aesthetic qualities of the architectural remains, we were also attracted by the impossibility of separating the places from the people who had lived and worked within them.[38]

As we walked around the Soviet Military Base Vogelsang near Berlin one day, Winch said, 'Can you imagine this place swarming with Soviet troops, doing parades around here and ferrying all this food and materials deep into a German forest so far from home? Mental.'

Guts responded, 'Mate, if we were seeing that, it would be the last things we saw, I assure you.'

Often, exploring reveals things we never expected. Journalist Tom Vanderbilt tells a story of his myth-infused expectations being shattered as

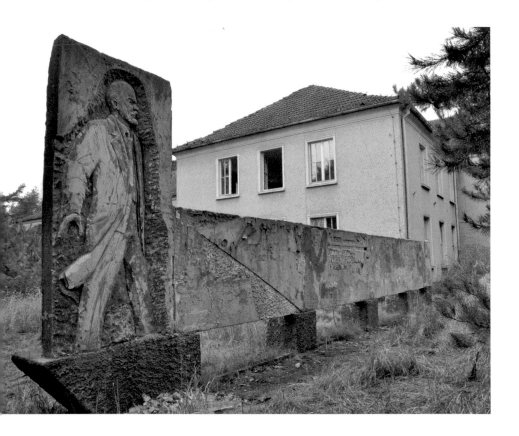

he climbed around what he thought was a set of abandoned atomic
bunkers in the American Southwest:

> As we explored the area around the bunkers, a collection of wood structures over-
> seen by a rickety observation tower, we would occasionally find scraps of wreckage
> jutting out of the pale white sand. It seemed a trove of modern archaeological history,
> and as we climbed the tower we imagined ourselves gazing on the site the way some
> sentry must have once done. As I found out later, however, [these] were traces of not
> Cold War history [but] of the film *Con Air*. We could still find scatterings of weathered
> Hollywood paperwork in the various buildings.[39]

Vanderbilt's experience led him to invest his own meaning into the place,
for which he is given back a different story. Thus it can be seen how the
many possible histories of a place are constructed though experience,
memory, forgetting, political agendas, spontaneous encounters and myth-
making processes. When we allow a place to teach us about itself, when
we give it agency, we begin to build rich tapestries that enticingly rear-
range images of the past. Perhaps most importantly, as urban explorers
teach us, it is our responsibility to take control of these narratives, to
create the constellation of meaning that we would like to see created,
rather than waiting for those narratives and experiences to be offered.

Chapter 3

CAPTURING TRANSITION

'Any order is a balancing act
of extreme precariousness.'
– Walter Benjamin

Late in 2009, Marc Explo invited me to undertake an exploration of the abandoned West Park Mental Hospital in Surrey, the same place where I had been caught by The Hammer on my first exploration. West Park had been closed down by the Thatcher government in the 1980s through the implementation of the 'Care in the Community' policy of deinstitutionalisation, shifting the mentally ill from institutions to private homes, leaving behind a number of stunningly derelict, often Victorian hospitals that retained equipment, documents and patient records.

Marc Explo and I crept through the bushes outside of the site early one morning, hunting for a window that was not boarded up. We found one

and crawled through it, into thickened air. Tables and chairs were stacked up behind the front door, obviously placed there to keep people like us out. As we roamed from one section of the hospital to another, we began encountering more personal areas and artefacts. We found a padded cell, which we entered and sat in for a while. It almost felt like it was bleeding with half-congealed horrors. Next, at a slow and respectful pace, we moved into the hospital's crèche.

Marc disappeared down a corridor as I sat down on the bent and broken floorboards, looking at a pile of decaying toys. It reminded me that this had been a workplace for some and a site of childhood memories for others, and I wondered where those children were today. Were they my age? Were they okay? Were they dead? Did they ever think of this place? Were their memories inscribed in the walls, peeling off with the puke-coloured lead paint? Would these artefacts that I was photographing be important to them?

When I stumbled across a pair of tiny shoes, I almost had a panic attack. All I could think, over and over, was, 'Whose shoes are these?' Soon after, I found a charred doll with mouldy skin sitting in a small chair (likely placed there by another explorer). The moment burned slowly as the wind whistled through the broken panes of glass and the light in the room slowly shifted with the passing clouds above. It felt like someone had increased the existential volume of the place. Though the history here was spectral and my curiosity perhaps a bit morbid, the impact of that moment was revelatory.

But these moments are fleeting as they must be to remain significant. When demolition at West Park began in 2010, Patch said, 'Good, now we can stop photographing that fucking place.' Winch later told me, as we were standing at a fence around the empty lot that used to be another hospital, Cane Hill, 'Look, these places are probably better-documented photographically than most heritage sites. It's sad [when they are torn down], but we can let them go. There will always be new places to explore, new experiences to be had. And hey, if they turn this into social housing or something, that would be great for the community, too.'

Every time you logged on to urban exploration web forums, there seemed to be some new 'breaking news' about one of the derelict asylums around London being demolished, trashed or set alight. United Kingdom explorers, some of whom are flippantly called 'asylum seekers', love these places for their unique and sad histories, their aesthetic and affective qualities. Often on weekends you can find multiple groups roaming the same corridors, taking the same pictures. The mourning process that explorers go through when sites are lost (Patch later said that he wanted

the hospital to 'die in a dignified way') indicates their deep attachment to these places.

After the destruction of Cane Hill and West Park, I began to consider the seriousness of the urban explorer's role as historian, especially when these places disappear with little or no formal documentation.* I also began to consider how the inevitable destruction of these places affects the experiences explorers have inside them, harnessing glimpses of the past onto an imagined future when the places no longer exist.[1]

In our visits to derelict asylums, factories, power stations and military bases, we have found countless ledgers, notepads, pamphlets, medical records and newspapers, giving us personal recollections and story fragments from the people who dwelled in these places. Images of bodies are often conjured up in ruins, particularly by people's jettisoned clothing or empty chairs and beds. These artefacts remind us that the 'ghosts' thought, interacted, engaged.[2]

In this past-informed present, we might begin to think about our own experience, not in contrast to, but interwoven with these residual emotions and fleeting memories. We go to these places to attempt to read the inscriptions, to imagine the shared moments of fear and excitement that are left floating in corners like twisting smoke in a room full of stagnant air. A security guard at West Park told London explorer Scott Cadman upon catching him in the ruin, 'Every time I enter the asylum, I say a prayer.'[3]

Winch, in his free time, maintains a website devoted to the Cane Hill Hospital, canehill.org. The site, which contains many archival photographs as well as Winch's own pictures of the place during serial trespasses over many years, has received thousands of visits. He has also received thanks from workers and patients of the demolished asylum, some of whom suggested that neither the National Health Service (NHS) nor the government had much interest in preserving the hospital's history. Recently he was contacted by the British Library with a request to archive the site in its entirety. Despite Winch saying that he was okay with letting the hospital go, he was clearly pleased that these glimpses of the place would be preserved, placing the urban explorer in the rare role of the respected amateur archaeologist.

Another part of explorers' enjoyment of these abandoned places is a regard for their mutable qualities – every time you go back to a place in decay, it is different. The *how* is generally unknown: an explorer may have moved an old typewriter over a centimetre to get better lighting on it for

* To see and hear the actual demolition of West Park recorded by urban explorer Gina Soden, go to youtube.com/watch?v=qwEgaAz6uFQ ('The Sounds of Demolition').

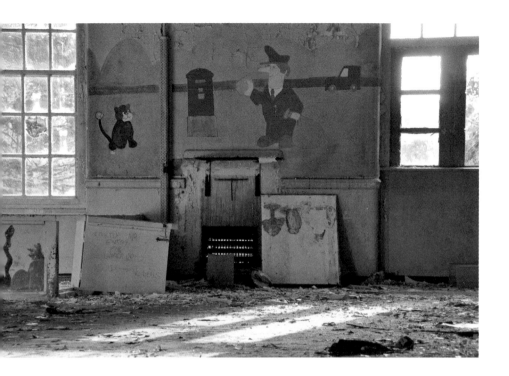

a photo, some kids might have tagged the walls up, a group had a party here, a security guard put a new board on a window, a fox dragged the outside in, the rain finally saturated the roof beams to the point of collapse. We get glimpses of nature doing its slow but relentless work: ivy creeping though windows, mould taking down walls, trees pushing through floorboards, rain slowly pecking at roof tiles or snow piling up until the whole thing slumps over in an architectural cardiac arrest.

The places urban explorers go lack the textural smoothing that is generally in evidence in maintained areas of the city. In ruins, artefacts are sometimes coated with what looks like hundreds of years of grime. Finding an old bottle that is thickly layered with time's dust, you can get close to it, zooming in on it with your camera lens and watching the light refract in different patterns as you shift your stance, seemingly revealing layer after layer of active life taking place. When you quietly sit down on the creaking floor, feeling like an out-of-place thing – the only thing not covered in dust – and listen to the pigeons coo above you, the eerie ceaseless scratch of a branch rubbing against a broken pane, the desire to inscribe yourself into the place becomes unbearable. The existential tension stacks until it pops. Slowly you lick your finger and reach out, rubbing it

down the side of the bottle. And you take all those years of history into your body, watching your salival DNA glisten in the broken sunlight, a new layer cut right into the old. These are the ways in which a body might react – the only ways a body *can* react – in space where time seems to slow or stop. These are the moments to pay attention and, as Bekah suggested to me, 'just be still'.

The camera sits still as a totem in a derelict corridor. A few seconds of light, carefully measured by the eye, break through a missing tile in the roof and are captured by the camera. Soon enough the lucent resonance is sucked out of the air by a passing cloud. The explorer whispers a curse, as if voicing it loudly will exacerbate the loss. He waits for another shaft of light to emerge but it never does, and the coldness and shadows of the abandonment close in and are ingested by him corporeally, incrementally. The moment falls flat. With a shiver, he puts the camera back into its case, shoulders the bag, saunters yonder. The light must now play with the building alone, though whether it does we will never actually know, because without the meld the architecture performs in unrecorded language.

Those who look after historic locations and managed heritage sites that are dutifully maintained in a state of arrested decay can learn this from urban exploration: something is missing when we cannot anticipate transience, when material and memorial trajectory is regulated. We cannot see ourselves written into the futures of these places because we are not allowed to inscribe ourselves there. The act of preservation of a ruin is ultimately self-defeating, because the essence of decay is lost with the effort to stall it.[4] Arrested decay is misinterpreted love for the ruin when it becomes nostalgia for a cryogenically frozen past.

In opposition to the commonly held idea that urban exploration is an act of destructive trespass, that explorers 'break in' and disrupt derelict spaces, urban explorers also protect and document fragile sites so that secret histories can continue to be revealed in whispers and through spontaneous discovery. The explorers act as keepers of extraordinary affects in a world rendered increasingly mundane.

As we anticipate their transience, ruins, like dreams, pull us both towards our innermost yearnings and towards a life beyond the constraints of the material world.[5] In that tension we find a darker component of an imagined ruined future, a Ballardian formulation of urban apocalypse where the remains of our everyday existence become the archaeology of the future.

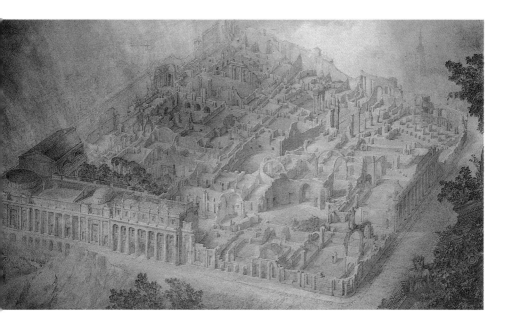

Romantic accounts of ruin exploration in the last two thousand years abound. Many eighteenth- and nineteenth-century depictions of ruins were built around the ethos of artists like Giovanni Battista Piranesi, Hubert Robert and Giovanni Paolo Panini, who painted European dereliction with a healthy dose of dark nostalgic romanticism, evoking the perceived grandeur of the Roman ruin. Famously, in 1830, the artist Joseph Gandy was commissioned by John Soane, the architect of the Bank of England, to create a painting of what the bank would look like in ruins – before it was built.

In the late twentieth century, Hitler's architect Albert Speer wrote *Theory of Ruin Value*, in which he sought to manufacture the greatness of the Third Reich through the construction of buildings that would decay beautifully.[6] Speer was assisted by the political geographer Karl Haushofer, who insisted that the German imperial imaginary would be bolstered by 'ruin gazing'.[7] In the book, Speer writes:

> **It was hard to imagine that rusting heaps of rubble could communicate these heroic inspirations which Hitler admired in the monuments of the past . . . By using special materials . . . we should be able to build structures which even in a state of decay, after hundreds or . . . thousands of years would more or less resemble Roman models.[8]**

These representations have deep connections to people's perceptions of what the 'use' of ruins might be and have fuelled many contemporary perceptions of ruin aesthetics, an imagination that retains an Imperial taint. These examples, despite not necessarily being common knowledge, have resulted in a situation where the aesthetic power of ruination is as relevant today as it was in an ostensibly more romantic era.[9]

We can look to a juxtaposed frame of reference in Speer and philosopher Walter Benjamin to elucidate some of the motivations of the contemporary ruin explorer.[10] Benjamin saw historical truths revealed in ruins – he contended that the romantics had draped the world in a façade of eternal perfection that displaced the anguish of life, the natural state of humankind. The ruin, to Benjamin, is that vision stripped back, laid bare, ripe for rereading against the grain of History with a capital H. Residing in the ruin, or even the construction site, triggers affective associations, leading to a crisis of memory as one realises that everything is always already being lost. The reliance on photography, then, is an effort to capture not that transition, but the experience of being present in the flow of time.[11]

Speer, on the other hand, contemplated building an eternal Third Reich that would defy even nature. He saw the ruin as a container for tradition, an embodiment of mythology that harbours only the truth imbued into it by the builder, the historian, the mythmaker. He was specifically interested

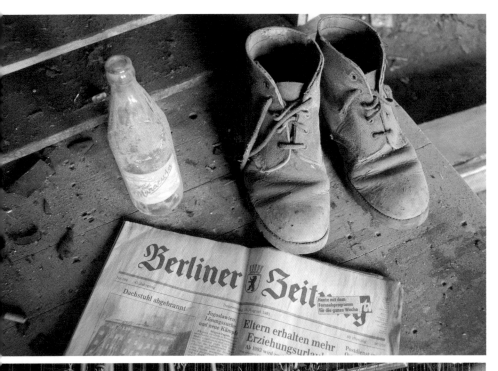

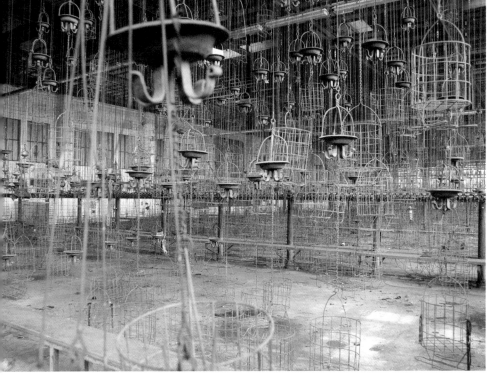

in the ways in which certain materials decayed, and in building a material fetishism into a future memory.

The motivations of urban explorers today sit at the crossroads of thought between Speer and Benjamin, driven by a fascination with the world laid bare, ready to confront the emotional flood that taking in the ruin will cause, anxious to find those histories untold, yet at the same time engaged in mythmaking through preservation photography, depicting a history of decay. This role positions the explorer-documentarian as a guerrilla preservationist, conserving, through video footage and photographs, a record of a particular time and place – preserving what will inevitably change and braiding themselves into those transitions.

Friedrich Nietzsche contends that this type of nostalgic longing is emotionally crippling, creating a society so rooted in preserving some legacy of itself that it fails to appreciate moments of existence in the present. As a result, Nietzsche quips, 'every past is worth condemning'.[12] Critic Brian Dillon follows Nietzsche, suggesting that the contemporary ruin gaze of urban explorers and artists is a nostalgic quagmire.[13] However, given many explorers' willingness to let places go, are they really nostalgic for a past now gone? Is that Nietzsche's 'crippling nostalgia' or is it a more

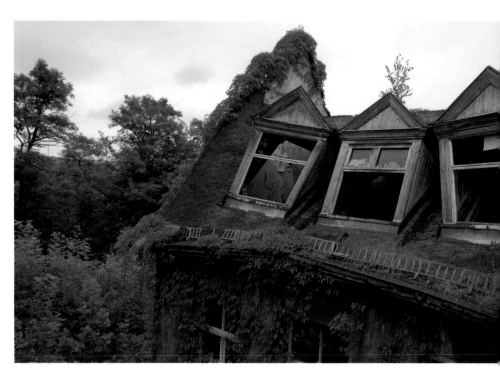

controlled form of remembering, one that augments perception rather than distracting from it?

Urban exploration offers an important model for the intersection of history, present-day experience and the future. As Ninjalicious argues, in a post-apocalyptic future, what we need are not *wilderness* survival skills but *urban* survival skills: fence climbing, lock picking, breaking and entering, wall scaling, trap detection, building-navigation and the like. He asks: 'Where better to foster such skills than in abandoned buildings?'[14]

Historian Paul Dobraszczyk took a trip to the exploded nuclear reactor at Chernobyl, a trip which, he writes, 'incorporated elements of both dark tourism and urban exploration', digging through the radioactive rubble of 'inconceivable terror'.[15] Dobraszczyk suggests that after a century of being subjected to incredibly realistic images of ruination and apocalyptic futures through films, video games and literature, it's no wonder the line between fantasy and reality is blurring.[16]

This meld of the real and imagined, as Dobraszczyk found, is an undeniable part of the allure of urban exploration. We can find resonances in the prose of W.G. Sebald, a writer who spent a great deal of time thinking about memory and decay. In this passage he explores the derelict Orford Ness military installation:

> **The closer I came to these ruins . . . the more I imagined myself among the remains of our own civilization after its extinction in some future catastrophe. To me too, as for some latter-day stranger ignorant of the nature of our society wandering about among the heaps of scrap metal and defunct machinery, the beings who had once lived and worked here were an enigma, as was the purpose of the primitive contraptions and fittings inside the bunkers, the iron rails under the ceilings, the hooks of the still partially tiled walls, the showerheads the size of plates.[17]**

In a similar vein, historian Jonathan Veitch, in the compilation *Ruins of Modernity*, writes about his tour of the Nevada Atomic Test Site. He expected his response to the ruins to be one of melancholy or nostalgia, but instead finds Baudelaire's Satanic laughter, a terror so visceral that the only possible response is humour, as if the emotions have been short-circuited by the horror.[18]

Explorers develop these notions through new image-making techniques. Other crews, especially the explorers on the 'TalkUrbex' forum, whose exploits were published by RomanyWG, began experimenting with High Dynamic Range (HDR) photography in ruins.[19] HDR is a technique of taking multiple identically

framed pictures at different exposure levels and layering them to produce a picture that is equally representative of both dark and bright areas. Some of the results can be 'overcooked' and reveal too much – too much colour, too much vibrancy and saturation, too much technological dependency. When the pictures work well, however, HDR shots make these surreal places look even more fantastical, otherworldy, uncanny and post-apocalyptic.

Images like these blur the line between reality and fantasy, moving towards digital singularity, where the digital and biological feed each other.[20] HDR photographers fetishize dark materiality by making it hyper-real, but the technique also brings that sorrow to bear on the witness, making it clear that these spaces, places, times and people do exists, that life is never a simple case of clean, clear narrative templates. Many of RomanyWG's more recent photographs – female models, often nude in ruins, Photoshopped to include aesthetically effervescent, beautiful and smooth fictive elements of light, plants and fabric – also work to compli-cate supposedly objective spatial and aesthetic relationships even if they appear, at times, fetishistic and exploitative in other ways.

The experience of being overwhelmed by an environment or situation that is clearly 'out of control' is becoming less and less prevalent in a

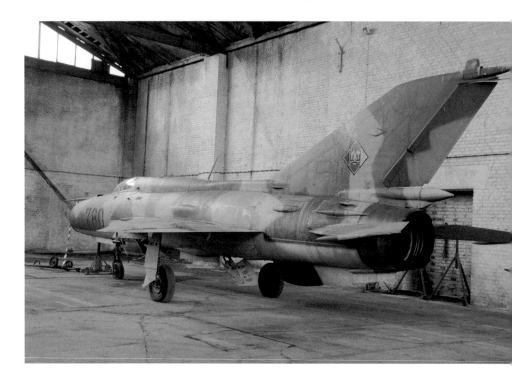

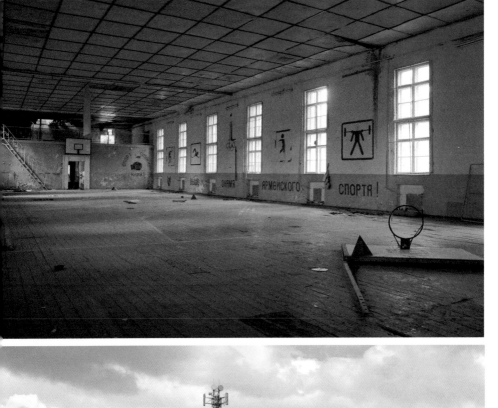

society that prides itself on maintaining order, robbing the individual of agency over his or her existential trajectory in the same way that the regulation of ruins often precludes the possibility of writing our own stories into them. Because we lose control over our actions on an everyday basis, sociologist Stephen Lyng suggests that increasing numbers of people in modern society feel threatened, 'both physically and mentally, by forces entirely beyond their control, for example, threats posed by toxic chemicals in the environment, nuclear war, financial instability, the general instability of personal relationships, and so forth'.[21] As a result, developing tactics for coping with a dystopic future seems like a logical extension of the inability to contend with the apparent alienation and apathy modern society inspires.

Clearly, part of the reason explorers enjoy sneaking into decaying architecture is rooted in an imagination of a post-apocalyptic future. These places are viscerally enticing in their wretchedness, in part because we sometimes imagine ourselves populating them during futures filled with heroism and adventure, where the explorer is the auteur of his or her own mythology.

In our explorations of the ruins of Eastern Europe between 2008 and 2010, we all took guilty pleasure in witnessing the remains of the failed Soviet

Union and Nazi Germany, reacting, at times, absurdly.[22] On the trip I took to Poland in 2010, with Winch, 'Gary' and Guts, we encountered an eight-foot statue of Lenin at an abandoned Soviet base in Germany called Nohra. I felt an inexplicable need to climb it, and did so. Looking back on my reaction, which the other explorers seemed to find reasonable, I realise that I desired an embodied exchange with a Cold War history that meant so much to my parents and so little to me. We all laughed, slapping and assaulting Lenin, taking photos, and then sped off into the forest. On some level, this was just what we needed in the moment – and something that clearly would not have been encouraged inside a heritage park.

Not all explorations of the past are playful, though. Some places are more challenging to keep in sight and memory, and some contain a darkness that incites calls for their destruction.[23] Other places seem culturally or socially vacant, leaving one with little to process. Many people seek to erase these places from memory, including those who interacted with them during their use-life.

When asked about the notion of industrial heritage in 1973, Theo Richmond, a developer from New Hampshire, was quoted in the *Guardian* as saying, 'Preserve a steel mill? It killed my father. Who wants to preserve that?'[24] High and Lewis write about the spectacular, explosive destruction of industrial spaces in the American Rust Belt and adjacent Canadian factories. In April of 1988, over 28,000 people gathered to watch the Montreal Miron quarry smokestacks be demolished. The event, in the words of the authors, became a sort of 'secular ritual', a blast against the past to heal the wounds inflicted by the corporate entity that ran the factory until its doors were shuttered, and at the same time a celebration of the memories from years gone by that still filled the place.[25]

It is in these moments, like my reaction at Nohra, that we might make the decision to leave our mark, to take more than photographs, to inscribe a place with our own feelings and memories. Importantly, it is our choice to do so while we are trespassing in ruins, and although many urban explorers aim not to alter a site in an effort to preserve the liminality of decay, sometimes this is just what one feels is required. The artist and urban explorer Lucy Sparrow told me, 'Exploration is what we want it to be – I don't remember signing a contract about how I should respond to places.'

Explorers venture into derelict places despite (or because of) the danger or horror of the experience; poignancies and fallacies of sites are given equal attention. Practitioners also interrogate their own praxis with similar self-awareness. 'Gary', inside a factory in Germany, called out to me across a room and said, 'Hey Brad, watch this, I'm going to document some "history,"' making scare quotes with his fingers. He then took a photo of

a broken window, laughing. Reactions to encounters with these places might appear uncouth or even dismissive at times, but in the absence of mediating external forces like preservation expectations, visceral interactions materialise. By the end of our second trip to Europe in 2009, we found ourselves encamped near Berlin barbequing dinner over broken doorframes from an abandoned Soviet military hospital, a place we never could have seen twenty years ago. The irony was lost on no one.

These experiences left us in a distinctly different state than our ruin explorations in the United Kingdom. The reverence for dereliction and failure on a state-wide level, rather than just one business or building, made our explorations both more poignant and more guilt-ridden. If, as philosopher Dylan Trigg writes in *The Aesthetics of Decay*, a derelict factory testifies to a failed past but also reminds us that the future may end in ruin, what do the ruins of an entire failed state say?[26]

On those explorations of economically disadvantaged areas in Poland as well as in the drains of Las Vegas,[27] we found our relative affluence uncomfortable when we encountered other people who, by necessity, had made the ruins their home. On our European tour, the farther East we went, the more crippling our uneasiness became. As we crossed the border into Poland on the same trip that took us to the Antwerp Metro in 2010, the car was filled with excited cheers that were quickly followed by confused murmurs. While the landscape here offered what we had come to expect from the remains of the Soviet Union – endless ruins – we found ourselves confronted with a place in which the relationship to derelict space was entirely different. Here, ruins were not just spaces for trespass and adventure, but of necessity to locals looking for free shelter and goods to sell.

After driving for hours through a forest hunting for a Soviet base called Keszwca Lesla, we arrived at 10 p.m. to find rows of buildings, clearly Soviet-built, surrounding an undecipherable war memorial. It looked like standard Eastern European fare, but with the addition of satellite dishes hanging off the sides. It seemed the local population had turned this place into a summer holiday encampment after the collapse of the USSR and the abandonment of the base. Gangs of teenagers roamed the streets in tracksuits and mullets, running in and out of the derelict buildings and bunkers. Even the inhabited buildings looked derelict. There were no fences or security to be found, and no rules, boundaries or exclusionary practices in evidence.

It should have been paradise for us, except that things felt different. And then the difference hit me – there wasn't a hint of nostalgia to be found. Locals likely rather enjoyed stripping Soviet blocks of all they were worth, because people here were still in pain. It was probably a delicious

catharsis to smash out those windows and excavate the rusting hunks of artillery from the ground to sell to scrap yards.

There was a specific guilt that came with exploring Eastern Europe, arising from the clash of different value systems in regard to derelict space. Perhaps this is an indication of a larger continued tension between capitalism and communism: where East meets West, desire meets utility, nostalgia meets expectation and mobility meets place-making. We knew we were bringing the West with us, and we also knew, deep down, that the social conditioning that resides in those templates could never be completely erased, much as we tried. As Winch said, on our way out of Poland, 'I felt just as likely to get my head kicked in and my camera stolen out there than to get a good photograph . . . and I couldn't blame them.' Eventually we returned home, determined to get underneath the skin of our own city instead.

In explorations of subterranean features such as utility tunnels, catacombs and bunkers, even if we never lived in them in the way people might in other parts of the world, there was a certain fantasy being played out of someday taking refuge, whether from drought, famine, nuclear attack or

even a zombie infestation. The specific reason was never articulated, yet it was often implied that this sort of scenario would almost be a blessing, as the explorers could then exert the full force of their knowledge and skills, finally becoming the superheroes they believe they are.

Susan Buck-Morss writes, in *The Dialectics of Seeing*,[28] that, throughout Walter Benjamin's *Arcades Project*,[29] the image of the 'ruin' is emblematic not only of the fragility of capitalism but also of its inevitable destruction. Even when trespassing in construction sites, explorers love to imagine that we are seeing ghosts from a future yet to come.[30] In exploring the ruins of a failed past after hearing the stories of workers being shut out of factories following thirty years of dedicated corporate service,[31] explorers don't just experience the surreal collapse of time and space that exist within the ruin – they remind themselves that everything is transience, that anything we think we can hold on to is an illusion.[32]

Post–climate catastrophe and post-apocalyptic imaginaries permeate popular culture, from films and television shows like *Mad Max, 28 Days Later* and *12 Monkeys* to books like Cormac McCarthy's *The Road* and even video games such as *Bioshock* and *Rage*. In all of these depictions, though the future may be bleak and dystopic, there is an underlying euphoria: the freedom that comes with being released from the state, social life and cultural expectations, and having to rely on and worry about only oneself.

The urban explorer's interest in post-apocalyptic imaginations, therefore, is nothing less than an interest in trying to get back to what we have lost: a sense of place, a sense of community, a sense of self – as Marc Explo told me, 'We want to be a part of a tribe again, where relationships matter.' And although urban exploration passes through places rather than staking them out in any permanent way, it can also act as a vital bridge, a gateway, because it makes the move from imagination to action.

Urban explorers are interested in quarrying spontaneous finds through embodied experiences in derelict and abandoned places to create time fusions. Explorers are aware that, every time they crack a new location, they become one of the ingredients of the mixture of the place, melding themselves into its fabric and capturing transitional moments within it.[33] Explorers are prepared to care for historic sites but also to let them disappear. Nonetheless, explorers don't argue that their view of the past is more valid; what they want to relay is that there is a place, a need and a desire for experiences of the past, dreams of alternative pasts, for localised historic interpretation and for unregulated decay. This is because unregulated experiences in ruins tell us as much about ourselves as about the places we explore, and this at a time when fewer people then ever feel a sense of place.[34]

Ruins may be decaying, but they are not dead, they are filled with possibilities for wondrous adventure, inspiring visions, quiet moments, peripatetic playfulness, dystopic preparation and artistic potential. Derelict spaces inspire creativity through their pace but also because process can be privileged over production in them. Since ruins don't lend themselves to seamless narratives, they are slippery and contested, and that indeterminacy invites playful, probing attempts to make some sort of sense of their complexity.[35] The urban explorer becomes a time alchemist in these places, creating transitions that are not supposed to be possible, that would have slipped by unnoticed.

Explorers are interested in small stories and local, immaterial, fantastic and whimsical histories. Exploration fosters an imagination of the past and an experience of the present that are informed by a cautious curiosity about what the future may hold as people begin to lose faith in the powers of the modern world. Perhaps this is the reason urban exploration is taking on a rapidly increasing social relevance. As people become more curious about what a post-capitalist world would look like, urban explorers can supply imaginative depictions.[36]

Chapter 4

THE RISE OF AN INFILTRATION CREW

'There is no one hacker ethic. Everyone has his own. To say that we all think the same way is preposterous.'

– Acid Phreak

It was the beginning of what was to be a long, cold winter in 2009. Team B explorers received information that a mothballed thirty-five-acre Ministry of Defence (MOD) nuclear bunker had been breached. Burlington, known as Britain's 'Secret Subterranean City', had been constructed inside a deep abandoned Bath Stone quarry at the height of the Cold War. It was the place where the British government was to be rebuilt in the event of nuclear attack. Maps of the facility, which were declassified in 2004, showed a telephone exchange, a Royal Air Force operations centre, offices,

kitchens, a BBC studio, water treatment facilities, a canteen, workshops and accommodation. The site has been disused since the 1980s and was, by the accounts we received, full of beautifully preserved artefacts of immense historical value. One person had even reported a room full of stacked-up rotary telephones, each embossed a royal emblem, still wrapped in plastic as if sitting on a shop shelf.

Eight of us arrived in two cars at about 10 p.m., to be pointed in the right direction by a local explorer called Timmy. We passed our bags through a hole in the gate to an adjacent quarry, an abandoned system that, we could see from the maps Patch had obtained, abutted the underground MOD base.

We worked well into the night, checking the walls for newly dug tunnels to gain access to the bunker, finally coming to the conclusion that the only viable entrance was though a massive sealed blast door. Either we had been given bad information or the bunker had been re-sealed before we got there. We checked the door and found it had a bit of give. Peeking through the side, we could see that it was latched closed by a threaded wheel on the other side that we couldn't reach.

The eight of us took a brief moment to discuss our options. If we were to subscribe strictly to the UE code of ethics, the trip would be over. This was a crossroads that, I would later realise, changed the way our crew operated. We voted to gently pull back the blast door and try to turn the handle on the other side without damaging anything.

We found two large metal bars in the quarry and wedged them into the edges of the blast door at the top and bottom. We were able to open the gap enough that one person could get his chest through, reach up and spin the wheel on the back of the door. The wheel fell to the ground – along with the two explorers holding the door back, which flew open with a rusty scream.

We stood at the entrance of the freshly cracked MOD bunker in plain view of a very large security camera.

A panicked discussion ensued. Figuring we had already been seen and hoping that no one was actually watching the cameras, we pulled masks over our faces and pushed forward into the UK government's underground city, scared witless but determined to discover what was inside.

What we found within Burlington was not just a fantastic material discovery, but also a reconfiguration of our boundaries as explorers. We had already bent the UE code of ethics to gain access; when we found a set of electric carts in the base we decided to push the code even further. We started them up and drove around the city all night long, skidding around turns, taking photographs and laughing, everyone terrified and utterly drunk on the fear.

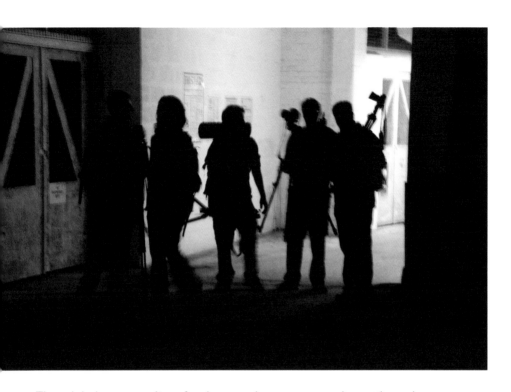

The global community of urban explorers, as much as there is one, records and often defends marginal and ruined spaces to preserve 'authentic' essences and experiences. Individual explorers as well as groups of explorers rise to prominence by being the first to breach 'new' and elusive locations, undertaking the most difficult and often dangerous explorations of urban environments, and striving for the discovery of 'holy grails' or 'epics' – sites of unparalleled historic value and aesthetic appeal that may never have before been seen publically. Often, in order to get to grails, the code of ethics has to be bent to particular needs. Many of the world's most well-respected explorers find themselves at odds with the Internet forum community when the desire to reveal new locations surpasses the desire the seek popular approval. For Team B, the crew I had chosen to embed myself with, that's just what occurred inside Burlington. The desire to see a ruin of unparalleled beauty motivated us, but the adrenalin rush of pushing the boundary was the real reward.

Architect Alan Rapp writes that the practice of urban exploration

provides a tart reminder that the areas that we have regular access to are not just quotidian, but also normative, if not repressive. The patterning that we can infer from

the sanctioned environment is absent from the spaces that urban explorers go; they
have been deprogrammed.[1]

In the same way the Situationist *dérive* offered a new way of exploring
places, allowing people to break out of everyday aesthetic frameworks,[2]
urban exploration offers practitioners a chance to take over a place and let
desire run wild, even if it lasts only for a night, as it did for us in Burlington.[3]

There is a strong strand within mainstream urban exploration of right-
eous preservationism – a sense that, without the help of urban explorers
documenting these underappreciated places, they would slip into oblivion
without notice. Behind the scenes, though, almost all infiltration and explo-
ration of 'new' locations is led by those who are willing to transgress the
code rather than wait for somebody else (kids, graffiti crews) to crack a
location so explorers can follow. Only once its boundary has been breached
can a space be documented.

Although every explorer is aware that this is, or at least may be, the
case, it is not to be spoken of. Hypocrisy abounds in the UE community.
Access All Areas, the seminal urban explorer text, focuses almost entirely
on infiltration and includes passages on disabling alarms, wearing costumes,
picking locks and 'door manipulation techniques', such as removing them
from their hinges.[4] As Methane Provider, the administrator of the 28 Days
Later forum, wrote in a hidden thread:

> Everybody from the DP [Dark Places] / early 28DL [28 Days Later] days knows the
> score. We just decide not to say anything and toe the public image line. It's the HDR
> kiddies and noobs that don't know what really happens out there.[5]

Two months after (re)cracking Burlington, I posted the photos on my blog.[6]
I mainly did this to test the boundaries of individual freedom within the
community and to probe the power of the supposedly informal code of
ethics, given that the people who gave us the lead must have known the
site would be sealed when we got there. Essentially, I wanted to know
who would attempt to enforce the code. I also, of course, wanted Team B
to get the recognition they deserved for putting in the effort required to
access the sealed bunker, taking the greater risk for the greater reward.

The ethnographer's dilemma was in effect – I often oscillated between think-
ing it was my duty as part of the crew to promote our exploits and thinking
that as an ethnographer I had no right to make such decisions on behalf of
my peers. Soon after, however, Dan Salisbury told me that I needed to 'stop
thinking you have to be one or the other. You will always be both now.' The
thought of playing this double game was both exciting and frightening.

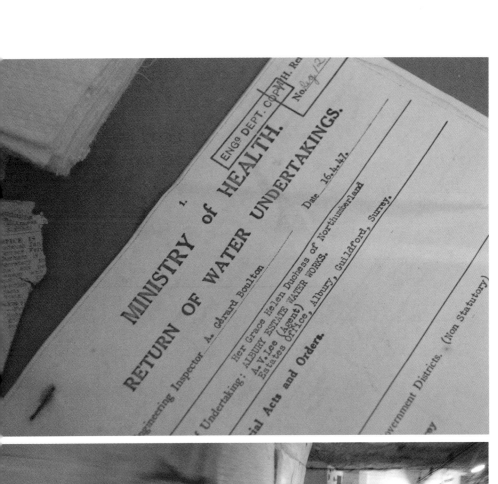

1.

ENGᵍ DEPT. COPY

MH. Re...

No. Aug/2...

MINISTRY of HEALTH.

RETURN OF WATER UNDERTAKINGS.

Engineering Inspector A. Gerard Boulton Date 16.4.47.

Undertaking: Her Grace Helen Duchess of Northumberland
ALBURY ESTATE WATER WORKS.
A.V.Lee (Agent)
Estates Office, Albury, Guildford, Surrey.

ial Acts and Orders.

rnment Districts. (Non Statutory)

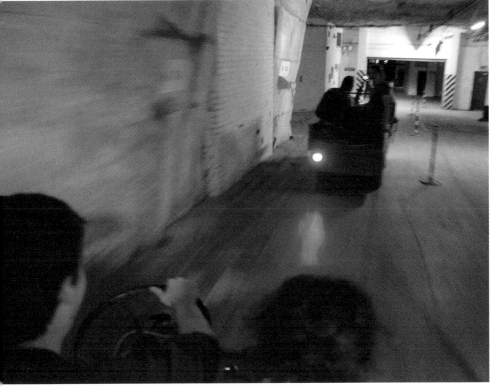

The Burlington blog post indeed became a target of rage for members of 28 Days Later and Dark Places, who claimed we had exploited information they'd 'handed to us on a plate'. Lemonhead wrote on my blog, 'You make it sound like you are pioneers. Many of us have been in and out of here for years. The only difference is the rest of us haven't crowed about it in a way that ensures increased security (and probably official interest). Well done you pretentious prat. Place-hacked? Well yes, hacked, damaged, ruined.'

Methane Provider, whom I had never met, banned me from 28 Days Later for life after he saw my post. He even called me on my mobile phone, telling me that if I didn't take the post down I would 'fucking regret it' and that he would 'sick the MOD Squad on us'. When I refused, he mobilised people on the forum to attack me in the comments section of the blog post. It became clear, eventually, that his primary motivation for the ban and threats had less to do with the code breach and more to do with the fact that we had taken credit for our success-ful exploration of a site that the denizens of the 28 Days Later forum felt was 'theirs'.

My effort to find out who was enforcing this code and why proved fruit-ful, as egos were evidenced in a dramatic way.[7] A few months later, Marc was also banned from 28 Days Later, after being accused of leaving some-one for dead in the Paris catacombs. (In reality, the person had told him she could find her own way out when Marc wanted to leave.)

The Burlington episode revealed the pretensions and politics involved in the UK urban exploration scene, a testosterone-laden competiveness fuelled by feelings of ownership over places (the preservation instinct). As I stead-ily received phone calls and messages of support from other explorers, it was obvious that many people in the community, not just Marc and I, had at some point or other become the target of a mob attacking them for an ethics 'breach'. The thread on 28 Days Later turned into a heated battle between those attacking and those defending me.

Luckily a number of people came to my defence while I monitored the discussion via an alter-ego and a VPN client that hid my IP address. The mob eventually lost interest. Dsankt emailed me in the meantime, writing, 'There's something just so inherently cowardly about the lynch mob that forms whenever someone gets their hate on.' He went on to say that the possibility of 'reasoned logical resolution of problems doesn't even seem to occur to them'. As much as the episode served to sever us from the rest of the UK scene, it also solidified us as a crew.

While it would be easy to link the community's attitudes towards control over information sharing to the mostly male demographic and an associ-ated competitive alpha-male complex, it also has just as much to do with

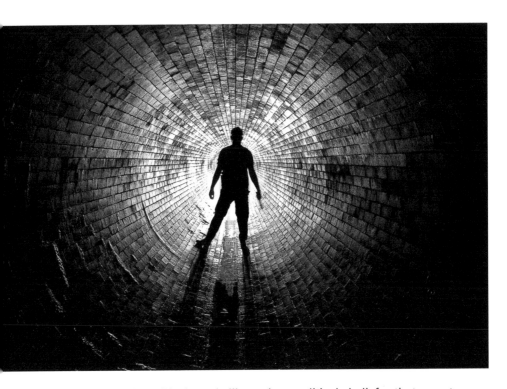

the existential philosophical and libertarian political beliefs that most explorers subscribe to. In other words, rather than this episode serving as an example of the potentially exclusionary nature of the practice, it shows that the scene really only becomes insular when a possibility for individual and group gain is threatened.

Bacchus, who was originally from Australia, later told me, 'Shit doesn't operate like this with the Cave Clan in Oz. You guys in the UK are weirdly competitive.' Although I never had a chance to explore in Australia, I don't doubt for a minute that the internal political turmoil caused by our 'breach' went hand-in-hand with the deeply political nature of social life in the United Kingdom. (I have since been made aware of similar situations arising in the United States.) As Patch said later about our success at Burlington, most explorers 'didn't understand it being hypocritical to tell people off for breaking rules when our shared pastime revolves around breaking rules'. He talked about the way urban explorers defend themselves from accusations they engage in vandalism: 'They don't condone causing damage or committing criminal offences to gain access, and they don't do it themselves. But they also refuse to admit that if it wasn't for *someone* tankcatting their way around and no "explorer" being willing to

do it, then basically none of the classic asylums or industrial sites would have ever been done.'

Our night in Burlington, and the drama that followed, brought renewed vigour to the group and created an even more intense bond between friends, now that we were liberated from association with the greater community of UK explorers.

It seemed Team B was now on its own. After years of shedding one set of rules only to feel we had adopted another (the UE code of ethics), we finally started writing our own. It was the rebirth of our rebellious selves that triggered an ever-increasing tolerance for 'Action!' as Marc yelled when we walked out the door each night to go exploring. These events would also ultimately take us farther afield and connect us to the wider global community of urban explorers.

In time, our now vehemently cohesive crew became more adept at locating, sneaking into and even temporarily residing in marginal spaces, cracking those places that hovered between urban exploration and infiltration, like stalled construction sites and sewers. Truth be told, we didn't really know what we were doing in the sewers; we just opened lids in the street and descended into them. Often we'd get stuck in a small pipe, turn around and leave. However, not knowing what was going to happen each night was a major part of what made the whole endeavour interesting.

While we were trying out new ways of exploring the city, we were all aware that Snappel, Bacchus, Zero, Dsankt, Loops and a few others had already been sneaking into the city's infrastructure. These explorers were all vaguely part of what we called Team A – the top tier of London explorers. They had been the first to crack many of the sites across the city prior to 2008 and had become global stars of urban exploration. The only one of us who really knew them well was Marc, who, with his easygoing Parisian style and relentless pursuit of adventure, managed to hang out with just about everyone at some point.

The infiltrations being undertaken by Team A consisted of five primary types of places – construction sites, electricity and cable tunnels, deep shelters, drains, and what many of us saw as the most daunting challenge of all: the transportation network, including the London Underground (Tube).

The Burlington episode earned us some admiration from Team A – perhaps as much for the lifetime ban from 28 Days Later as for the success at accessing a sealed location. Months later, I and a few other explorers threw a party for Marc Explo's twenty-ninth birthday on the top floor of King's Reach Tower, a derelict thirty-storey tower block on the South Bank of the Thames, and prominent members of Team A who were mutual friends of Marc's showed up.[8]

I had been running around all day collecting various things for the party – tea lights, balloons, a helium tank, alcohol, snacks and, of course, loads of fireworks. Winch picked me up and we headed to King's Reach Tower. In the street we met Guts, Peter, Dan and Patch. Dan slipped away as we were talking and went over the hoarding in front of three disabled security cameras. Moments later, he opened the fire exit and I walked through dressed in a high-visibility vest and hard hat, lugging a helium tank over one shoulder and a duffle bag full of fun in the other.

When we reached the twenty-ninth floor, we spent hours blowing up balloons, lighting candles and drinking Red Stripe. By the time Marc showed up, we had assembled a few dozen people in a derelict penthouse with the most spectacular London view one could imagine. Neb had lugged a sound system, hooked up to a car battery, up all twenty-nine floors. We danced, drank, laughed, screamed and set off fireworks, the city below us completely oblivious.

Somewhere around 2 a.m., Dan and I slipped out to the park below. Borrowing some traffic cones from the street, we arranged a dazzling array of exploding rockets for everyone to see. When the police arrived to tell us they had seen the explosions from the street, the partiers in the penthouse laughed uncontrollably, silenced by the distance and unnoticed at street level, as Dan and I apologised and then snuck back up to the party after they left.

The party in King's Reach Tower was liberating – to be childish and free, to let desire reign in a Dionysian frenzy.[9] It was a night when our freedom became an embodied awareness, just like at Burlington.[10] Many times, these events led to encounters with authorities, as in the park under King's Reach Tower, but we also played with the fear of being caught, which added another enticing layer to the embodied experience.

At some point in the night, Bacchus, one of the members of Team A, made a grandiloquent drunken speech. He told us he was leaving the UK and suggested that we all start exploring together, now that those of us in Team B had taken our first public bruising and begun carving out our own path outside of the restrictions of the forums. What followed was the merging of the two top London crews, rechristened London Consolidation Crew or LCC, an infiltration crew intent on cracking all of London's infrastructure and sneaking into the city's most notable construction projects and landmarks.

Skyscrapers were a solid proving ground for the new crew. My first exploration with Zero from Team A was in Canary Wharf. Marc and I met him at about 11 p.m. We were carrying bin bags filled with fishing waders from being in the sewers earlier, and stashed these in the bushes. Zero then led us to a small brick wall, which we jumped over. Behind the wall, we were

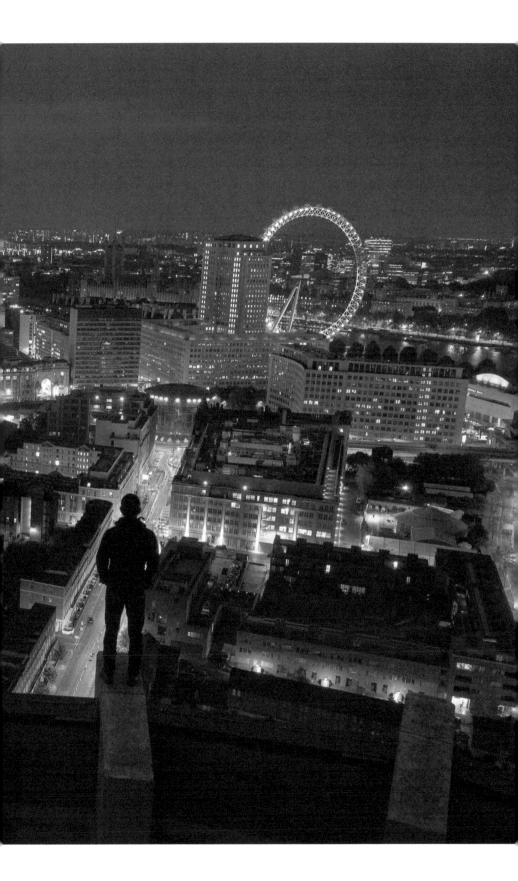

out of sight from the street and could grab hold of some scaffolding on the under-construction Lantern Court high-rise apartment complex next door. Once inside the scaffolding, we took the stairs at a leisurely pace and popped out of the top onto a skyscraper with an incredible view of the Isle of Dogs. Looking across, Zero spied another skyscraper with a crane on it and suggested we try to get on to that one.

Thirty minutes later, we were shimmying up a light pole and clambering over the hoarding into the site. However, this time we were all a bit more on edge for some reason. Then we heard walkie-talkies and a dog yelping. We were back over the fence and running away in seconds, splitting up to sprint down three different streets so the seccas would have to pick one of us to chase. We reconvened in a children's playground and sat on the swings for a while, laughing about our failure. I asked Marc if he was disappointed we got chased off the second site and he said, 'If we knew what was going to happen it wouldn't be exploration.'

When I asked 'Gary' about our move into infiltration he told me, 'Ruins are great and keep exploring them, but they are kind of "outside" the city. I like doing construction sites because they're inside the city.' Construction

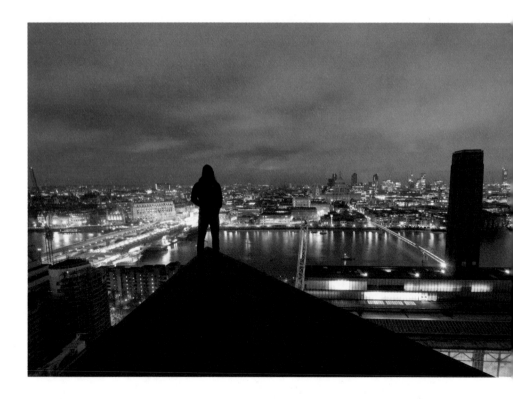

sites, like ruins, were largely hidden, opaque, rendered invisible behind barriers. Although they were many times right in the heart of the city, they were sites of a marginal, exclusive city-in-the-making.[11]

The musings of Ninjalicious, during an interview with philosopher Dylan Trigg in 2005, made much more sense now when he said: 'I wouldn't say what [urban explorers] are looking for is the beauty of decay so much as the beauty of authenticity, of which decay is a component.'[12] Seeing skyscrapers half complete, covered in cement powder and sawdust, fresh wires dangling from the ceilings, ready to be stuffed into the building's façade, held that authenticity.

Using infiltration as a medium to transmit a message of quiet social subversion, the explorer softly insists on the right of the individual to decide to engage with urbanity in different ways. Ninjalicious writes that, while some curious people are content with a peek at a construction project, others 'need to touch it, climb it, smell it and examine every minute detail in depth and figure out how everything works'.[13]

Revealing those places was part of locating that urban authenticity we sought, a way of connecting ourselves to the city through nightly sorties.

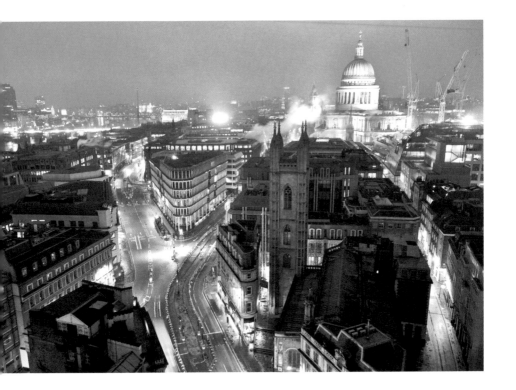

As the security in these locations was more formidable than in ruins, we were more willing to non-destructively pick locks, copy keys, subvert alarms, climb with ropes, wiggle into ventilation systems, carry hex and drain keys, scale barbed and razor wire, lift-surf, climb through air ducts and generally think of the city more as a puzzle to be taken apart piece by piece and then reassembled once access was achieved.

Once we moved beyond ruin exploration, exploring was no longer simply a matter of climbing through an open window or avoiding a lone security patrol in a massive derelict site. It now required more effort and more risk, and it also yielded far better rewards.

As the LCC coalesced, I was reminded of Debord and the Situationist International, who also worked to counter non-participatory aspects of the city by moving from looking to acting. Infiltrating the places that give people space and make the city work made us feel we were building a deepening relationship with London.[14] Instead of searching for alternative histories in known places, we began a process of revealing histories and places no one had ever publicly documented.

Ironically, it often felt far more like we were finding what was lost in the city than it had out in the urban margins, and I felt that what we were doing was not taking things off in a novel direction but, in effect, bringing urban exploration back to its roots. Urban exploration is about going places you're not supposed to go, seeing places you're not supposed to see. Some of the earliest popular accounts of urban exploration are about sneaking into hotel pools, climbing bridges, going into city infrastructure and exploring construction sites. And we were carrying on the tradition.

The question of 'securing' the modern city is one of volume and dimension.[15] The highest reaches of skyscrapers, the domain of the most wealthy individuals and corporations, are both the most difficult places to access and the most likely targets because of their imposed visibility. The Shard was an obvious example. It is the exclusivity of the views these structures provide that make them of interest, but getting to those vantage points is tricker in the UK than in many other places.

Britain is obsessed with CCTV. There are more cameras in the UK than in the rest of Europe combined.[16] We wanted to prove to ourselves that London, the most 'secure' city in the world, was still full of opportunities for adventures and awe-inspiring experiences for those who make the effort to find them. As Dan told me, it was the desire to 'find something to be passionate about again'.

* * *

Walking around one night in the City after checking some leads, Winch spied a hole in a breezeblock wall that looked like it led to a construction site. With a mischievous grin, he turned to me, Gina and 'Gary' and said, 'Shall we give it a go?' We nodded and looked left and right down the street. It was empty, as the square mile usually is after working and drinking hours.

Slipping through the wall, we found ourselves in an empty construction site with a giant red crane situated right in the middle of the yard. We ran low over to it, grabbed the rungs, and started climbing. Up top, the view was breathtaking, and we took turns hanging off the side over the rooftops of the city.[17] After posing for a group photo on the top floor, we headed back down to street level.

In our excitement coming back through the hole in the wall, we forget to check first whether anyone was on the street and emerged in full view of a man in an expensive business suit, tie loosened, who stopped in his tracks. He raised a finger, pointed and screamed, 'What the fuck?' When he came stumbling towards us, we realised he was almost too drunk to walk and skirted around him, thinking he might try to grab one of us. As we turned the corner onto King William Street, I looked back and the man was climbing through the hole, in his suit. I was shocked and strangely

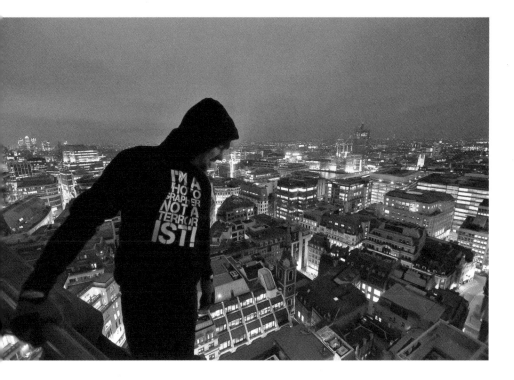

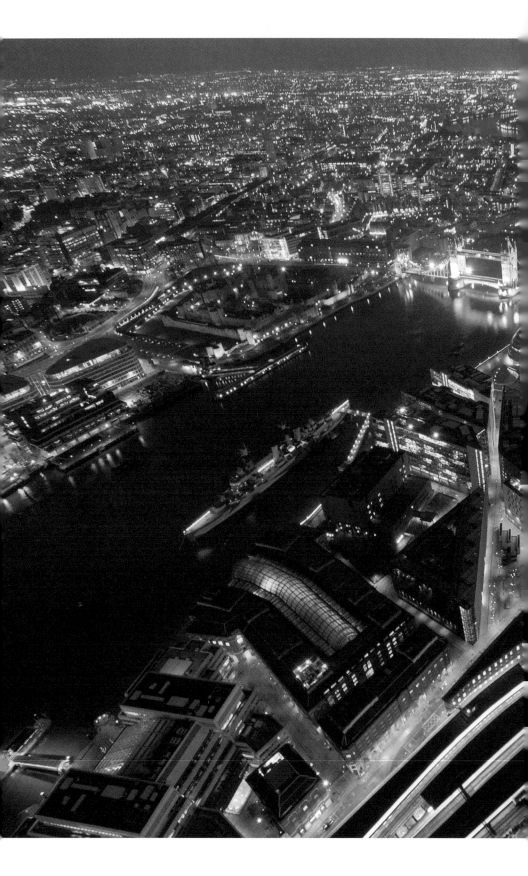

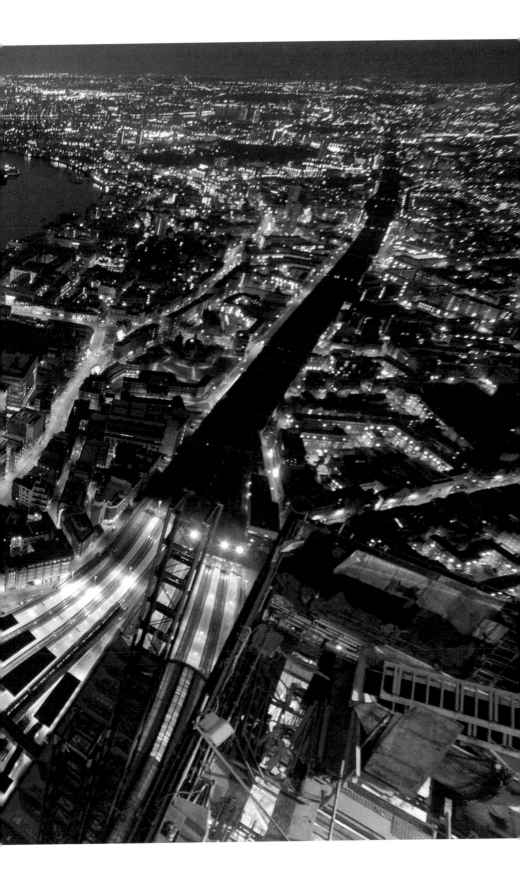

honoured. He just wanted to be involved. I found out months later that the building going up was the new headquarters of the Rothschild Bank.

Like the famous Night Climbers of Cambridge in the 1930s, the LCC took to the tall structures, scaffolding, rooftops and skyscrapers of London and, following Marc back to his old stomping ground, to the churches and cathedrals of Paris for unsanctioned views. Heron Tower, Barbican Towers, Strata, King's Reach Tower, Temple Court, New Court, the Canary Wharf skyscrapers and eventually the Shard, perched over the Thames on wind-swayed iron cranes and cement counterweights, all became our nocturnal playgrounds. Dusk was another dawn for those of us whose work depended on darkness.

Our adventures became increasingly intoxicating: far above the city's skyline, on top of derelict tower blocks or on cranes where a slight wind caused the jib to shake seductively, hundreds of metres above the city, where there was always a light mist as we floated in the clouds, causing camera autofocus problems. These were certainly sights most people would never see. But also, as Peter said, these spaces, where one is not allowed, are often where one has the most freedom: 'We were all climbing on a crane on a building and Nicholas Adams was down on the pavement taking photos of us with a telephoto lens. We saw the cops pull up and ask him why he was photographing the crane, oblivious to our presence. We laughed but it did actually prove to me that we are safer up here than in the street.'

The more time I spent climbing skyscrapers, churches and cathedrals, learning to use ropes and picking up new skills, the more our conversations convinced me of the similarities and overlaps between these seemingly disparate interstitial spaces, ruins and construction sites.

As a crane operator points out in the 2010 Channel 4 documentary *The Solitary Life of Cranes*,[18] it's incredible that so few people ever look up in the city, aside from children. From the perspective of the crane, people on the street blur into an urban flow, and the rhythm and sounds of the city, often so intrusive and abrasive, are attenuated to a subtle drone.[19] When we were sitting on top of the Shard, which was at that point seventy-six stories tall, Marc said, 'At this height the train lines going into London Bridge begin to resemble the Thames. It's all flow.' We understood these experiences were not isolated events: we were building completely new urban assemblages where connections, rhythms, flows, boundaries and potentiality were foregrounded. It felt increasingly like we were an integral part of London, witnesses to all its connections.

Dan, sitting on the edge of the King's Reach Tower, watching the new Crossrail construction at Blackfriars, told me, 'I keep coming back because I feel so alive up here. It's more real than real life.' This sense

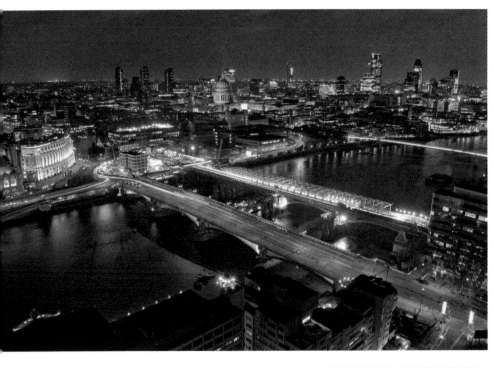

of overcoming the 'futile' daily grind in the city impacted the way we interacted with one another as well. We trusted each other with our lives while climbing buildings, but we also, more personally, fed on the adrenaline rush of living dangerously together. On the rooftop of Temple Court, an abandoned office block that has since been knocked down, when we heard the laughter of pub-goers returning home at 3 a.m., Tigger told me, 'If they only knew how good they could feel climbing this building they have probably never noticed before, they might never go to the pub again.' After that building was gone, whenever I walked by the empty lot I recalled that conversation, floating in the sky where we would never sit again.

These shared discoveries and feelings bonded the crew in an emotive embrace. Tendrils of affect conjured by collective fear and excitement arose as we melded into the city's fabric, one rooftop at a time.[20] Although we were more 'in' the city than ever before – literally inside its most prominent and costly construction projects – we could sit quietly and talk together, paradoxically more capable of having an intimate conversation there than we were on the streets. 'Gary' later said, 'It doesn't matter if you're not doing anything up here; even boring stuff is fun sitting in a crane cab.' I even wrote part of this book in a crane cab on a mothballed construction site above the Aldgate East Tube station, twisting my everyday life as a researcher into a hybrid formation as I reclined there with a beer listening the Mission Control Radio, watching the lights twinkle and typing away on my laptop at my own pace.

The trade-off, however, came at a high price. Once we realised what we could get away with, the adrenaline addiction became completely debilitating to everyday life, and many in the group found themselves becoming increasingly distanced from friends who did not explore. I became the worst dinner party guest imaginable, opening conversation with lines like, 'So yesterday we snuck into this construction site . . .' Yet it was the first time I'd ever felt that life was as it should be: every day was more exciting than the last, and I had never been so close to a group of friends. We had formed a tribal mentality.

Increasingly, I didn't care about social expectation outside of our group and embraced this tribal mentality, dedicating almost all my time to learning infiltration techniques, taking photos, exploring and writing our stories. The lifestyle satisfied my compulsive nature and brought out a side of me that I hadn't known existed, one that was, as Marc Explo said, all 'Action!'

At the height of activity, we were going out almost every night. Zero, originally from Team A and now a principal member of the LCC, told me at one point that he 'just fucking gave up on a normal life and became nocturnal'.

We also started taking more trips to Paris to visit places Marc knew about or wanted to try to get into. It was far easier to get away with things there than in London. Explorers had even climbed Notre Dame in the dead of night. Marc was particularly interested in climbing churches, something he reckoned 'should be an Olympic sport'. I didn't get his drift until we climbed Saint-Sulpice. To get up, we had to put our backpacks on backwards, push our backs up against a wall, brace a foot on a pillar, and chimney-climb our way up using alternating pressure on hands, knees, feet and back on the surfaces of the building. One slip would mean at least a broken leg. When we got to the top, we found six well-dressed college kids drinking wine, which they kindly shared.

While we were up there, I asked Marc why he felt drawn to these building and renovation sites, pointing out that this was just somebody else's workspace the majority of the week. He responded, 'Brad, a construction site is like a ruin because it's in a constant state of transition, and part of the enjoyment of the experience comes from being witness to that in-between moment. It's all about getting a glimpse of places normally not seen by the majority of the city's inhabitants.'

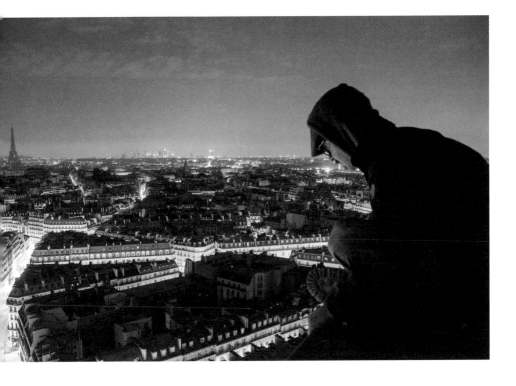

By the end of that particular trip, we had explored a host of places, from cranes to churches to catacombs to utility tunnels to metro to drains, staying up for almost three days straight. At that point, I was broken. I threw myself on a road island in the middle of an intersection while Marc was dragging open yet another sewer lid, and cried, 'Please, I have to sleep, I can't do this anymore!' and sobbed into the grass.

We were becoming ever more socially marginalised, even within the wider UK explorer community. Important intersections were emerging in the literature I was reading about the politics of space and the ways our actions were linking theory with practice. We were discovering Debord's 'internal separation' through an embodied investigation of the city's most high-profile construction projects, the archetypal spectacle space. We were splicing the 'in-between' into the fabric of the city by blurring the boundaries of seen and unseen, can and can't, imagined and experienced, done and not done, every time we posted a photo online and people realised we had cracked another site, solved another urban puzzle, together. Those feats never could have been accomplished alone. In other words, the tribalism, while exclusionary, was also cathartic and vital to our continued success.

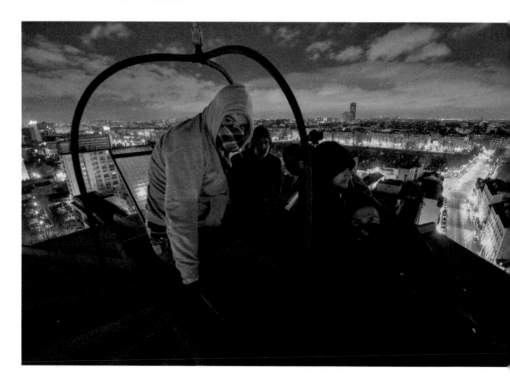

Despite the ways in which urban explorations may be seen as transgressive, viewed from a computer, they may also, in this sense, be seen as another kind of social 'authenticity'.[21] Our experiences built stronger community bonds through collaborative risk-taking, what I came to call 'edgework'.[22]

Here again, urban exploration's lineage stretches back to those Surrealist experiments in Paris that sought to release the marvels they believed were buried within the everyday. The Situationists also valorised sites that were out of sync with the spectacle of the city and contained hidden meanings and associations.[23]

The desire to explore for the sake of exploring, to take risks for the sake of the experience, with little thought to the 'outcome', is something that flows deeply through us as children. Urban explorers are, in a sense, rediscovering and forging these feelings of unbridled play: staying up all night, wandering, plotting, having significant conversations during spontaneous encounters, all of which lead to the creation of very strong bonds between fellow explorers where being playful in the city stands in contrast to the importance of work and consumption.[24]

After balancing for a photograph on a girder in an icy wet wind atop London's Heron Tower at 1 a.m. with a deadly two-hundred-metre drop below him, Dan wrote on his blog, 'Sometimes I just desire the edge. It's not about adrenaline or ego or any of that bullshit; it just happens, as if drawn by the reins held by some deeper level of consciousness.'[25] In the moment the photo was taken, it seemed Dan was issuing a challenge to those who would seek to disembody, sanitise and commodify his personal experiences, those who would turn the city into a mausoleum of sights to be seen rather than places to be touched. He had hacked reality and found his edge.

The term 'edgework' was first used by gonzo journalist Hunter S. Thompson in his book *Fear and Loathing in Las Vegas* to describe the necessity some people find in pushing boundaries for fulfilment. The idea is to work as close to the 'edge' as you can without getting cut (or at least not too deeply). For Thompson, this meant doing ethnographic research with the notorious Hell's Angels biker gang or taking drugs of unknown origin in unexpected combinations.

When Thompson tried to describe 'the edge of edgework' in his 2003 autobiography, he wrote:

> The Edge . . . There is no honest way to explain it because the only people who really know where it is are the ones who have gone over. The others – the living – are those who pushed their luck as far as they felt they could handle it, and then pulled back, or slowed down, or did whatever they had to when it came time to choose between Now and Later.
>
> But the edge is still Out there. Or maybe it's In.[26]

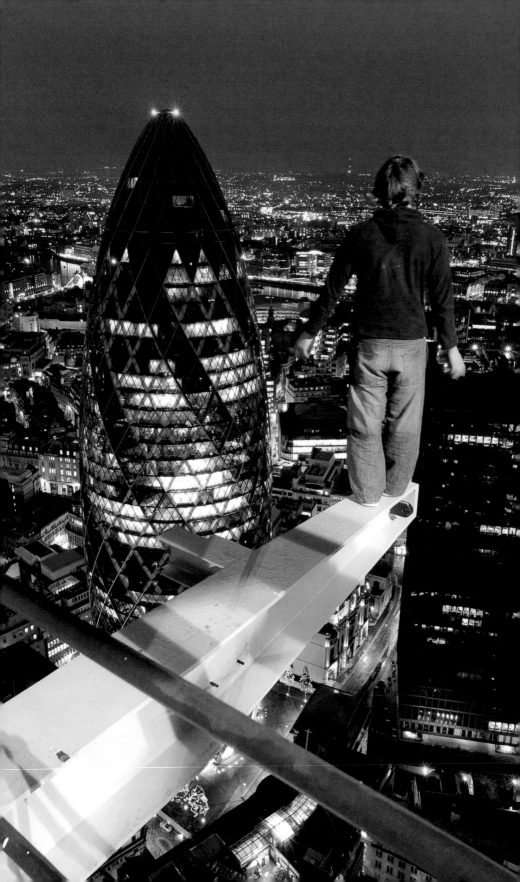

Sociologist Steven Lyng appropriated 'edgework' as a blanket term for any activity undertaken by someone who actively seeks experiences that involve an abnormal potential for personal injury or death. He explains edgework as a negotiation between life and death, consciousness and unconsciousness, sanity and insanity.

> **The mundane everyday world provides the boundaries and edges that are approached. And it is the very approach to the edge that provides a heightened state of excitement and adrenaline rush. The thrill is in being able to come as close as possible to the edge without detection.[27]**

Many place hackers not only feel the need to constantly test those limits, but want to actually change the collectively perceived limits, to move the edge. Edges are found in drain systems, where the obvious risk comes from flooding, drowning and (less likely) cave-in; they're found in abandoned buildings, which can have perilous impacts on our bodies both in the short term (collapse) and the long term (respiratory problems, cancer); and they're definitely found in high places, where falling is always a possibility.[28]

In these locations, unregulated by health and safety or rules of engagement, infiltrators are free to do edgework, finding boundaries by hanging from cranes, balancing on the edges of long drops, precariously tiptoeing over weak floors and scrambling under collapsing structures.[29] When I asked Neb why he insisted on swinging from every high thing we climbed (including jibs of cranes) with ropes and a harness, he told me, 'Well, I want the rush. And I figure, if I fall at least I'll be dead and not disabled.'

Author William Gurstelle writes, 'Done artfully and wisely, living dangerously engages our intellect, advances society and even makes us happier.'[30] While creating strong bonds of trust between exploration partners, edgework also reaffirms individual subjectivity and creative potential. Where often we fear that our individual selves would dissolve without 'normal' structure, when we become part of what constitutes the city, we tend to become dependent upon those connections, rather than being concerned about what it is they sever in 'normal' life.[31] Where we spliced self and place, with camera, body and architecture, where we invoked the meld uninvited, we created new vibrant urbanisms the likes of which we may never have known existed otherwise. Often these splices come through doing what had never been done before.

I had always wanted to explore with Moses Gates. Along with his partner in crime Steve Duncan, Moses had cracked some of the coolest stuff New York City has to offer, making him comparable to the legendary Jinx Crew,

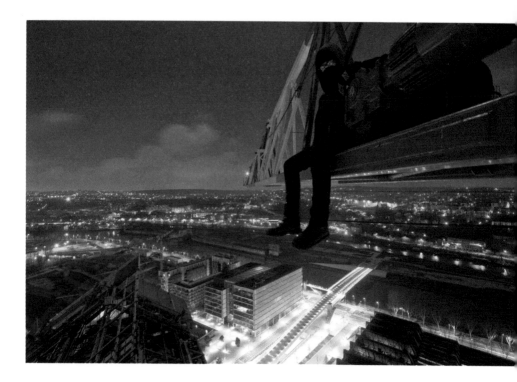

New York rooftoppers and pranksters active a decade earlier. Moses and Steve then travelled to explore places all over the world.

Marc, Helen, James and I had been planning a trip to Scotland to climb the Forth Rail Bridge, and as it turned out, Moses was going to be heading to Scotland to go hiking with his dad and brother at just the right time to meet us. We called him and asked if he wanted to climb the bridge. He responded, 'Yeah guys, climbing it would be cool, but what would be *really* cool is if we climbed the whole thing – like go up the north end and crawl across all the cantilevers to get off on the south end.'

The Forth Rail Bridge was constructed in 1883. It's built from ten times as much steel as the Eiffel Tower and stretches twenty-five hundred metres across the Firth of Forth. It's not a great distance to walk, but it *is* a great distance to traverse across steel beams while trespassing on National Rail property, not to mention a UNESCO World Heritage site.

The plan was mental and everybody loved it.

We arrived at 11 p.m. on a Friday night. North Queensferry, the town under the north end of the bridge, was dead quiet. Moses, having just left a local pub, had no backpack or camera and was wearing a leather jacket. He had a bemused look on his face as he watched us strap microphones

to people, sling cameras around our necks, and fill bags with batteries and torches for filming and photography of the expedition. Kitted up, we walked down the road towards the bridge, sticking to the shadows.

Hopping over a small fence, we made our way to the bottom of one of the pylons and looked for a way up. I spied an electrical cable running out of a hatch; I tugged it and the hatch swung open.

Helen said, 'Surely it can't be that easy?' and we looked at each other. Marc shrugged and replied, 'It doesn't have to be difficult to be interesting.'

We squeezed through the hatch and found ourselves inside the base of the pylon.

Flipping on torches, we found a ladder. The inside of the pylon was filled with pigeons that flap-attacked us as we climbed. The air was thick, laden with faeces and feathers. In contrast to the near-freezing night outside, it was blistering in the pylon, and we were all soon sweating. Reaching the top, relief washed over us when a hatch popped open and cool air rolled in. After we squeezed through the hatch, the most incredible sight unfurled before us like a cosmic tapestry.

We were on top of the bridge, engulfed by orange floodlights breaking through stagnant fog. The quiet town of North Queensferry was just visible

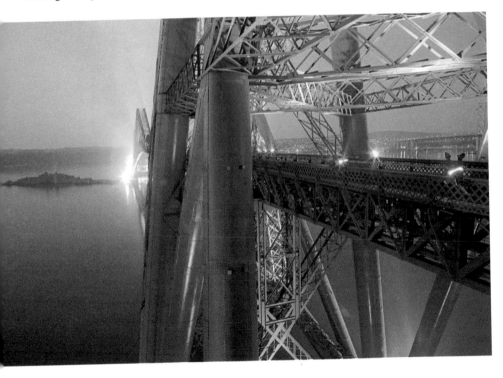

through the vapour, and the sky was a beautiful shade of purple. It was quiet – not even the sound of the sea reached us – until the first sleeper train came flying underneath us at incredible speed. As the structure shook and screeched, I felt like I was riding a dragon.

Single-file, we began the slow traverse across, climbing down off the first platform and balancing precariously on beams just wide enough to support us, then shimmying down at a snail's pace. My heart was pumping furiously. A small list to the right and I would fall 110 metres into the Firth. I knew that sixty-three men had died building this bridge, and I couldn't help but imagine their ghostly bodies plummeting through space and the feeling of helplessness I would experience if one of my friends fell. These thoughts were causing my whole body to burn with fear and excitement. This was serious edgework, and I was high on it.

We climbed for hours, and a steady rhythm began to take form as we crossed two of the three massive four-tower cantilever structures, ripples rising from the cold grey water far below.

And then it started to drizzle. This was not part of the plan.

James, straddling a beam on the other side of the bridge, screamed across to us, 'If we don't start crawling really fast *right fucking now* we are

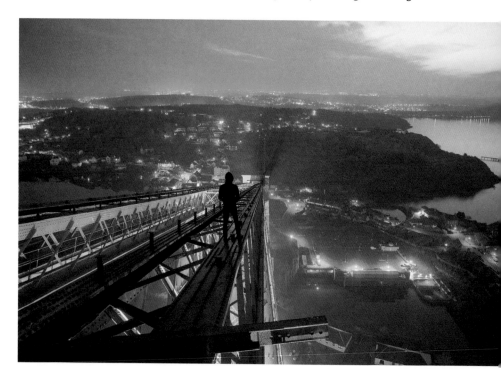

going to die on this bridge!' Despite our better judgement, some of us started standing up on the beams, crawling on all fours like bonobos, speeding down the last cantilever structure before the beams got too wet to hold on to.

By the time we climbed down from the superstructure and onto the track level, the sky was getting light. Our last challenge was a run down the rail tracks to make our escape. It was a run that might take about five minutes at top speed, and if a train came, we would certainly be seen and trigger a serious incident involving a herd of British Transport Police and an uncomfortable review of our video footage and photos.

We ran fast, and I could not help but be reminded of the scene from the film *Stand by Me* where the kids ran from the train down a bridge, jumping off at the last possible second before being hit. Luckily, no train came and we avoided such a scenario. An hour later we were speeding back down the A1 with Marc at the helm of his Twingo, our energy levels dropping rapidly, while James stared at our video footage in the back-seat, reliving every moment with a glazed look in his eyes. Moses was headed back to New York City, and the rest of us had to go to work in the morning.

Urban exploration, like street art, skateboarding and parkour, is a practice that reappropriates urban space for an unintended or unexpected use that may result in bodily harm.[32] One of the common reactions to people choosing to take unnecessary risks is, of course, suspicion that these people are somehow deviant.[33] But as social theorist Christopher Stanley has written, these points of 'alternative' social connections could also be seen as moments of community-building, rather than narratives of dissensus.[34] Moments of both individual accomplishment and collective identification come from the notion that explorers are doing work for each other, by ourselves, as free beings.[35]

Skydivers have espoused similar notions. During an interview conducted by Steven Lyng, one jumper said:

> While we're riding in the airplane on the way to jump altitude, I always feel scared and a little amazed that I'm fixing to do this bizarre thing – jump out of an airplane! But as soon as I exit the plane, it's like stepping into another dimension. Suddenly everything seems very real and very correct. Free-fall is much more real than everyday existence.[36]

The release of adrenaline becomes addictive, causing participants to spend an increasing amount of time and energy chasing the release. Lucy Sparrow told me a story of a night she and two friends decided to sneak into a live factory outside of Manchester.

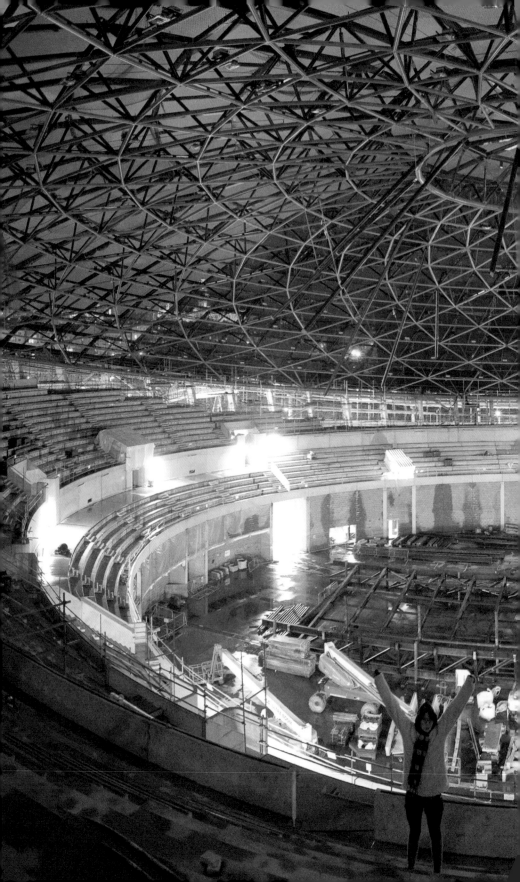

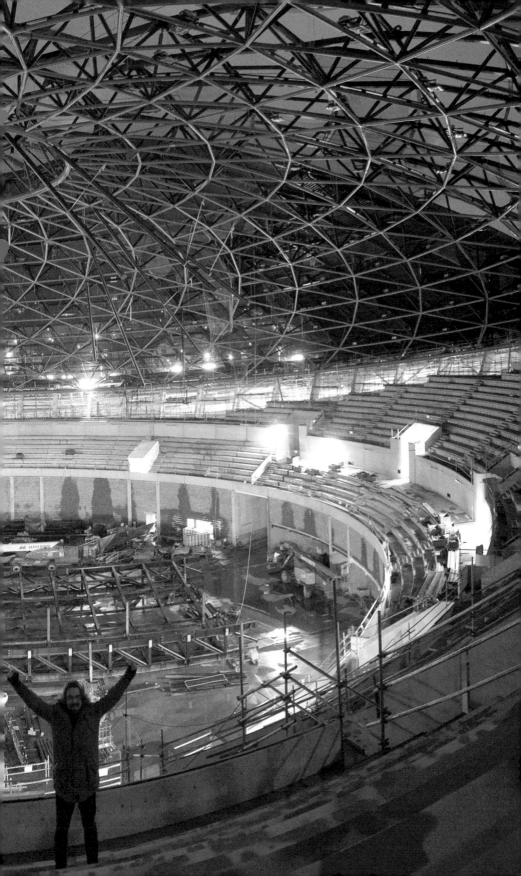

We left Rusholme and drove the few miles it took to get to Stockport, the location of the UK's biggest supplier of biscuits. Floodlights drowned the staff car parks and we approached the exterior fence with trepidation. The obstacle before us consisted of only a ten-foot chain-link fence with a further three rows of barbed wire, which, on balance, was very little security for a huge factory.

The factory was in use twenty-four hours a day, seven days a week, so we had the added risk of being seen by a member of staff, in addition to the security guards. We lay down in the trees, peeking out of our hoods to see forklift trucks carrying goods to and from the loading bay. We waited for them to go past and then sprinted across the gap between the woods and the factory, gluing ourselves to the wall so as not to be seen by the CCTV cameras on every corner of the building.

An open door had led us to a staircase. The generic sound of factory rumble, banging metal, clunking machines and voices filled our ears, but we progressed nevertheless up the stairs to find a doorway to the next level. The most glorious smell of oats, freshly baked biscuits coupled with boiler room industrial odours filled our nostrils. We stood there for a minute breathing in the fumes and listening to our hearts thumping away.

We climbed out onto a high metal gantry that went over the entire factory floor. Below us there were production lines and people in white coats pressing buttons and operating machinery. We looked excitedly at each other, hardly believing that forty feet below us, the world was carrying on as normal, and we were just its spectators.

We decided that we'd probably pushed our luck far enough, and realising the consequences of being found in a live sterile food factory, we made our escape. It was amazing thinking as we were driving home how easy it had been to enter into that environment. I can only imagine that if we had been discovered, the whole factory would have had to cease production due to contamination, and the legal consequences would have been catastrophic. We'd managed it though, and it kept us afloat at least for a couple of days – until the never-ending itch would need to be scratched yet again.

As Lyng rightly points out, risk-taking is necessary for some people's happiness.[37] Many people feel no need to have their life safely guided, to develop their own control over their environment. This inspires edgeworkers to articulate a feeling of 'oneness' with the world while undertaking risks, what I refer to as the meld.[38] Dan told me the places he felt he had the deepest relationship with were where risks had been taken, social codes broken, and new templates drawn up from desire and the recognition and transcendence of fear.

In those places, urban explorers bond not only with the environment, but also with friends who have shared those risks. Participants are trying things out, engaging the city experimentally, gradually gaining insider knowledge.[39] In contemporary society, it is a rare moment when the action of the human body can take control over the environment, rather than simply reacting to

relentless urban stimuli.[40] Taking agency over a situation allows explorers to submit to, or indeed create, moments outside of normative everyday experience, revisiting the 'known' on terms of one's own choosing, where fulfilling desire constitutes a form of political resistance and escape.[41]

The transition from urban exploration to infiltration to edgework and place hacking is, then, a move deeper into the libertarian notions of freedom that many explorers embrace. This was clear in the desire of the LCC to push the boundaries past known limits. If, as philosopher Jean-Paul Sartre writes, 'freedom is what you do with what's been done to you',[42] the desire of the LCC to explore construction sites and rooftop features could be seen as a reaction to a growing existential angst built on feelings of disappointment, anxiety and ultimately frustration.[43] These feelings are on public display in a manifesto for draining by the Australian Cave Clan member and avowed anarchist Predator. He says, 'We enjoy thumbing our noses at petty bureaucrats and puerile legislators, and their half-baked attempts to stop us going to the places where we go ... places they built with our tax money.'[44]

The question that then confronts those in positions of power is whether to leave open creative spaces in the city where people can feed their energies, whether to channel those energies into controlled environments like sporting events, or whether to try to repress these impulses altogether. If we live in a society that prides itself on democratic and populist principles, the latter should never be an option. Still, the LCC found ourselves playing more and more elaborate games in order not to find ourselves at odds with the state as our actions began to take on a more 'threatening' aura to those outside our group.

Construction sites are more similar to ruins than they first appear – once past the border of cameras, motion sensors and security guards, we were relatively free to do as we pleased. However, the methods of access are often different in these places. In gaining access to derelict areas, stealth is almost always the preferred tactic, whereas infiltration often requires more elaborate creative thinking, planning and group cooperation. When entering a construction area, we found that posing as workers (builders) proved effective. As the street artist D*face points out in an interview:

> **The best camouflage is actually not being camouflaged, and looking like you are meant to be there and pitching up in broad daylight, wearing a neon vest and acting like a worker. Start painting a wall. You look like you have permission, and who is going to question you?[45]**

Londoners seemed to ignore the hidden vertical dimensions of the city not just in a physical but also in a social sense. The middle class, true to

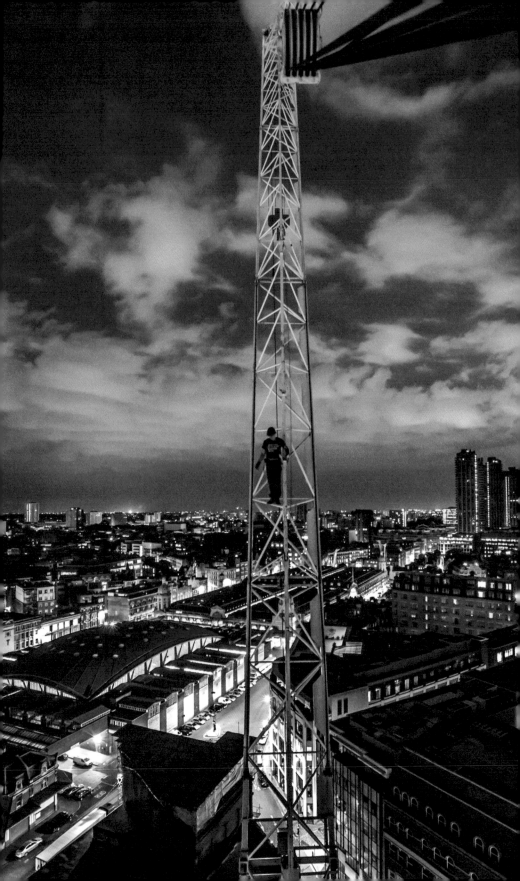

its name, moves horizontally and overlooks most of what doesn't concern it, including builders. When we dressed up in high-visibility vests and hard hats, we looked like we were at work, and in a sense we were – we just weren't working for anyone else. In these instances, attitude was everything; our stealth tactics gave way to social engineering. These were tactics Team A had already learned a great deal about in previous years. Dsankt and Winch had a discussion about it on a joint exploration.

Winch suggested, 'There are only two types of barriers we face, aren't there? There's the physical, which we have little problem with now, and the social. Social barriers can be overcome too; we just have to hone our skill.'

Dsankt replied, 'Yeah, we just hope the people who know what's going on don't show up in the meantime.'

Dan Whitchalls, a roofer from Essex, announced in 2012, after we had released photos from the top of the Shard, that he had BASE-jumped off it four times, once infiltrating the building dressed as a visitor with a name badge, hard hat and high-visibility vest. Walking blatantly to the top with a parachute tucked in his rucksack, he hurled himself off of the edge of the building, landing in an empty parking lot hundreds of metres away.[46] A few months later, Keïteï ran into Whitchalls on top of 20 Fenchurch Street, the 'Walkie-Talkie Building', at 2 a.m. He told her he was annoyed we had released our photos, since that had forced him to 'sell his footage to the *Sun*'. He then launched himself off of the crane into the mist as Keïteï stood there with her jaw hanging open.

Organised subversions against the authoritarian constriction of the city aren't always as directly transgressive as street riots.[47] Creative resistance may take the form of refusing to move where you are expected to, such as in a flash mob, where large groups of coordinated participants freeze in unison in public spaces designed for pedestrian flow.[48] Subversions can also take place in rural areas that are designated private property, where groups such as the Ramblers Association of Britain hold annual Forbidden Britain Day mass trespasses, a simple act of walking where you're not supposed to.[49]

Some incursions do not even occur physically. Trevor Paglen has undertaken shocking visual trespasses onto United States military property through the telephoto lens of a camera, sometimes from miles away, mapping some of the darkest corners of the Bush-era CIA's extraordinary rendition programme.[50] In a more recent work, *The Other Night Sky*, he photographed US spy satellites that allegedly do not exist.[51]

Like Paglen waiting in the desert for those shots, place hacking, while conceptually provocative, can be pretty dull in practice. A lot of time is spent, for instance, sitting around waiting for security guards to leave or

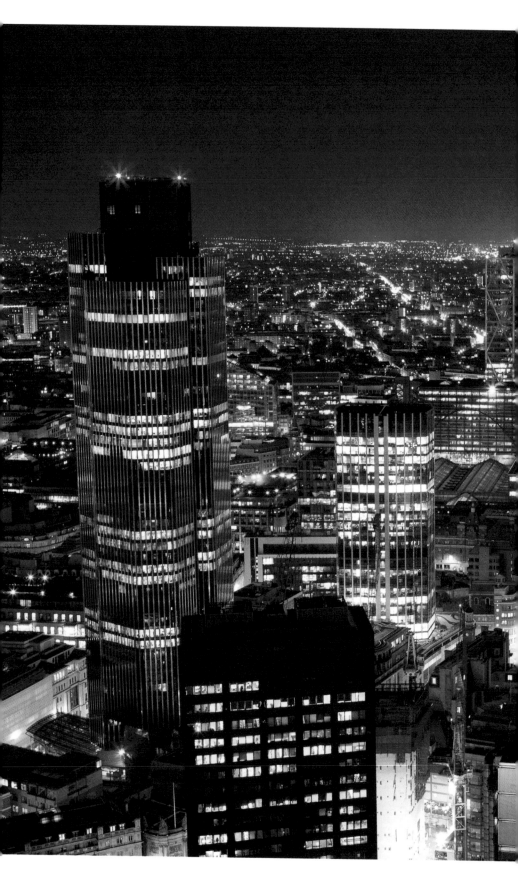

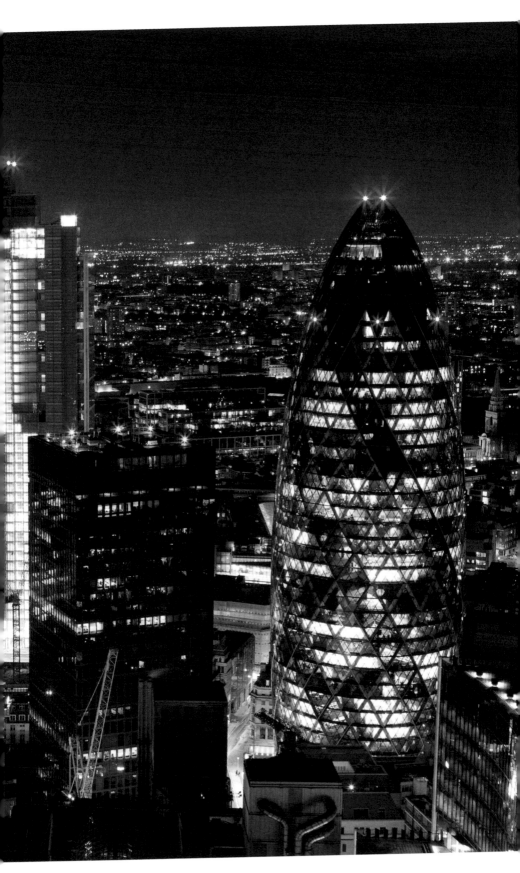

setting up to take photos, moving lights around to achieve the desired luminescence and shadows. The edge brought to the activity is in fact largely abstract – it's the notion that what's taking place, what the group is actively participating in together, is authentic life, whether or not anyone actually cares (or knows) that it's happening, much of it right under their feet.

I met up with Moses Gates again, straight off the plane from New York at about 11 p.m., outside Aldgate East Station, the site of one of my favourite cranes. It had been a while since I had seen him, and he showed up, as usual, looking relaxed in a leather jacket and with no bags. 'So what are we climbing tonight, man?' he asked as we cracked a Red Stripe on the street.

We walked around the corner to the backside of a construction yard, where we hopped a security gate in front of two disabled cameras. Moving quietly to the central crane, we got on the ladder and started climbing. Up top, it was chilly. After finding the crane cab locked, we decided to see if we could get onto the roof of the Ibis Hotel next door. However, halfway there, we were halted by an amazing moment. From a particular vantage point on the roof, we realised we could see the entire backside of the twelve-storey hotel. Many of the occupants, assuming the construction site was empty, had

their curtains open, and in each window a miniature scene was unfolding: a couple fighting with dramatic hand gestures, a woman undressing and admiring herself in the mirror, a guy watching TV eating snacks off his naked stomach, a pair of women stripping for each other. Sitting down behind some construction materials, I pulled two more beers out of my bag, and Moses said, 'So *this* is why you guys keep coming back to this place!'

After watching the real-life diorama for a while, we found some pallets on the construction site, stacked them up like ladders and got on the roof of the hotel. From there, entering the worker area, where the door was propped open with a shoe for smokers, was relatively easy. We passed through and into the hotel, took the lift to the ground floor and waved goodnight to the hotel staff as we headed home, having scaled one building, spied on people and exited a different building. And nobody had a clue but the two of us.

Chapter 5

GRAILS OF THE UNDERGROUND

'Although born in a prosperous realm, we did not believe that its boundaries should limit our knowledge.'

– Montesquieu

By 2010, we had had begun to map out more diligently the famous sewer system built in the 1850s by Joseph Bazalgette.[1] We were encouraged by the groundbreaking work of Team A explorers JohnDoe, Zero, Snappel, Dsankt and Bacchus,[2] the first explorers to access London drains.

Cracking a sewer lid releases a blast of hot gases and warm air that has its own noxious comfort, especially in the cold of winter. The satisfying *clang* of the lid over our heads, plunging us into darkness until somebody clicks on their headlight, is fulfilling; the drain is a place of rare

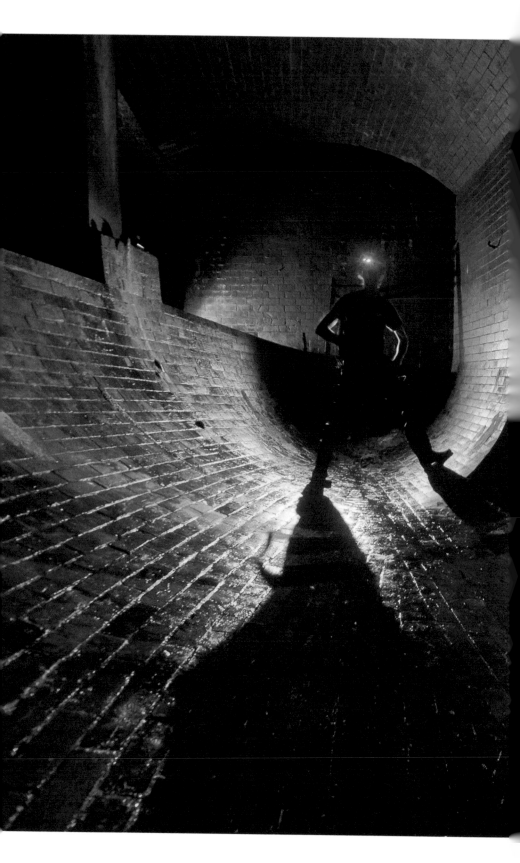

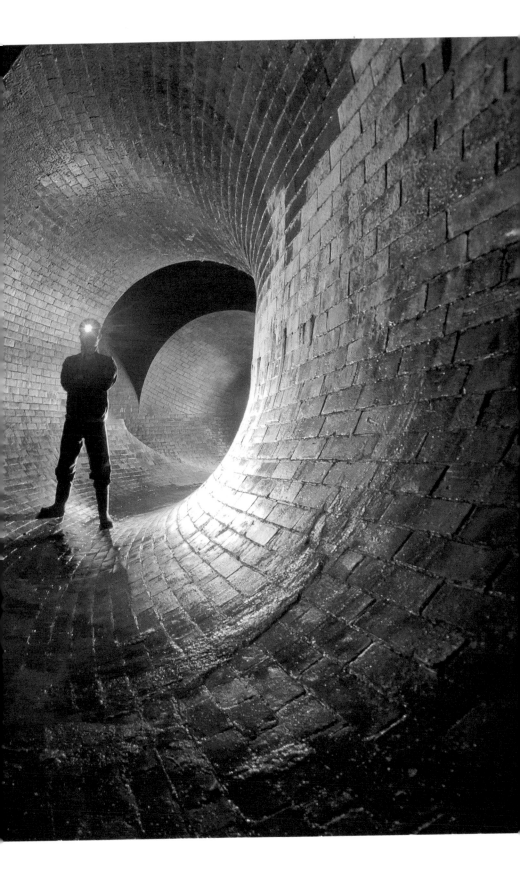

safety and security in the city, the traffic noise is attenuated to a low hum, drowned out by the sound of water flowing over glistening Victorian brick. The feeling of security is also satisfyingly ironic, of course, given that we had to breach urban security to gain entry, and if it were to rain suddenly, we would likely die.

On a night when urban sludge froze in the London gutters, four of us descended into a sewer in Knightsbridge. As we walked single-file down the drain, the sound of fishing waders resisting the rushing grey water took on a lovely rhythm, and our conversation, muted by the ceaseless swishing, morphed into singing and screaming, as we used our voices as drones to test the spatial reverberations of the subterranean architecture. These choral drones probably floated out of manhole covers into the street, causing passing dog walkers to crack a smile or panic slightly.

As we reached an enormous chamber, we all stopped to take photographs, the noise of the expedition suddenly dissipating into the vast space to create an otherworldly echo. For a while we sat around basking in the stillness, the sound of trickling sewer water upstream, a slow build-up of condensation on a piece of hung-up toilet paper dripping methodically nearby, the distant prospect of a rushing river of unknown depth behind a brick barrier ferrying

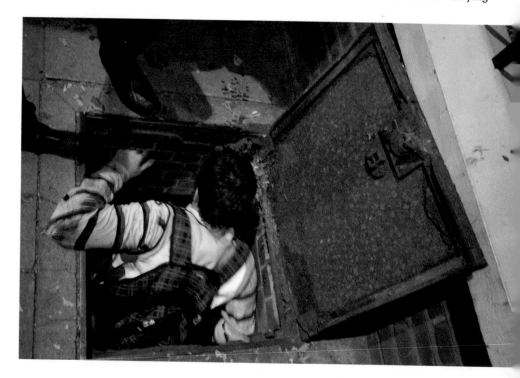

little pieces of decomposing mixed matter towards the Crossness pumping station, on their way into the Thames during ebb tide in a very different form. Our stomachs were still quivering from the nervous thirty seconds it had taken to get under the lid and close it, the fear of drowning in fast-rising water during an unanticipated rainstorm leaving us tuned in to everything around us, keeping the excited hum going. It was delicious to use all of our senses. The experience was pungently vivid and existentially accelerating.

The slow pace of sewers inspired thoughtful photography. Eventually, Peter developed a photography technique of using cheap block LEDs to backlight explorers with red-head torches on. These pictures were highly staged, but in the sewers, reality, like the sewage itself, flowed on in spite of our frozen fictions.[3] These photos, more than any others, were the result of collaboration and could not be taken with fewer than three people, but they deserved that much effort.

The sewers of London are an exceptional achievement of engineering. Mid-nineteenth-century London was a place of radical infrastructural transition. Until that time, city planners had never developed a systemic way to deal with sewage, viewing the disposal of human waste as a primarily domestic issue. However, these piecemeal infrastructural systems were

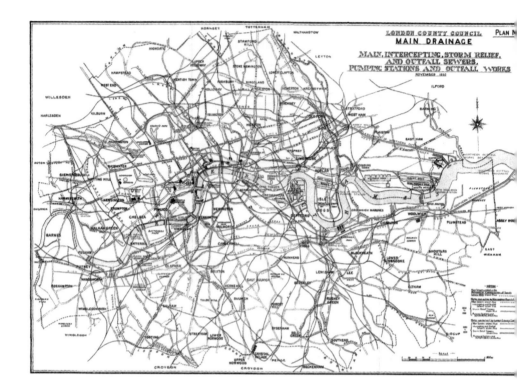

collapsing under the weight of two million inhabitants and a rapidly expanding city, leading to a catastrophic cholera epidemic, among other issues. Following a survey of London sewers undertaken in 1848, Sir Joseph Bazalgette, chief engineer to the Metropolitan Board of Works, was commissioned to deal with the problem.

Bazalgette's new sewer system, quickly funded and implemented, was described in the 1861 *Observer* as 'the most extensive and wonderful work of modern times', comprising eighty-two miles of main sewers, more than one thousand miles of smaller sewers and 318 million bricks.[4] The idea was a simple one – Bazalgette would utilise the watercourses already running through London, many of which were already informal deposit sites for raw sewage. He harnessed London's rivers and channelled them into the large intercepting sewers running perpendicular to them, flushing the waste to two pumping stations, one at Abbey Mills in East London and another at Crossness in South London.

Bazalgette arguably did more for the health and wellbeing of Londoners than any person before or since.[5] Yet he remains today a somewhat enigmatic figure, his moustachioed bust looming over the Embankment he

constructed on the North Bank of the Thames where Londoners walk, jog and cycle by, paying it little heed. The Victorian public, by contrast, were frustrated and enthralled in equal measure by the public works taking place around them. It likely seemed that the whole city was being dug up and turned over, though each spade of dirt was full of the promises of a new age. Urban planners seemed to suggest that an egalitarian human liberation awaited citizens behind every public-works project, bringing order, health, safety and freedom from excessive labour.[6]

The cost and scale of the work was unprecedented. As Fiona Rule relates in her book *London's Labyrinth*, the 1859 pre-construction estimates sat at around £3,000,000 (£234,000,000 in today's terms) and were, by all standards, an immense urban makeover.[7] The new system required the construction of two pumping stations, seven interceptor sewers and many interconnections into the old local rivers and ditches, all hand-dug by labourers.

THE SEWER-HUNTER.
[*From a Daguerreotype by* BEARD.]

Problems plagued the project. There were sewage spills, cost overruns, untrustworthy subcontractors and worker deaths due to explosions. When one wealthy resident, the Sixth Duke of Buccleuch, who had a back garden on the embankment, offered £90,000 per year to retain private access to the new embankment, an outraged public condemned the Duke, and Parliament insisted that public access and right of way would be maintained.[8] Rights to the city were important to the Victorians. Later, when the sewers became closed spaces, Londoners would, of course, simply sneak into them.

Henry Mayhew, writing in the mid-nineteenth century, was an important social documentarian, depicting the hidden daily lives of the lower classes in London. In his book *London Labour and the London Poor*, he describes the toshers, or 'sewer-hunters', as people willing to enter the London sewers and explore them to a considerable distance in the search for 'tosh' – anything made of copper. Mayhew goes on to describe the illicit work of the toshers as they creep through the underground stream:

> **Whenever [they] come near a street grating, they close their lanterns and watch for their opportunity of gliding silently past unobserved, for otherwise a crowd might collect over head and intimate to the policeman on duty, that there were persons wandering in the sewers below.[9]**

John Hollingshead, while traversing London's sewer system in 1861, noted that 'a piece of ordinary rust or of moist red brick is soon pictured as a trace of blood'.[10] Entry into the subterrene quickly became acceptable only for rats and criminals, those who were already seen as polluted bodies, depicted in books and films such as *Les Misérables* and *The Third Man*.

It was no coincidence then that these systems were buried and forgotten. Due to long-perceived associations of subterranean space as unhealthy, unclean and evil, citizens nursed a multitude of obsessions with fissures, cracks and imperfect junctures, sites of contact from which 'mephitic exhalations' would waft.[11] The construction of these systems, as well as the waning interest in seeing them, led to the mysterious mythologisation of urban infrastructures, viewed only occasionally where seams fractured.

Historically, these imperfect joinings between the city and the subterranean, when cracked open, were seen as analogous to a flesh wound, the broken skin now ripe for bidirectional infection, the urban body as host, the city's innards a filthy contamination zone. We dove right into that zone just like the toshers once had, dispelling the myths of the Victorians while also paying them reverence.

Less diligent than the toshers had once been, we still rooted around in the stream in search of treasure. We did not find copper, but credit cards,

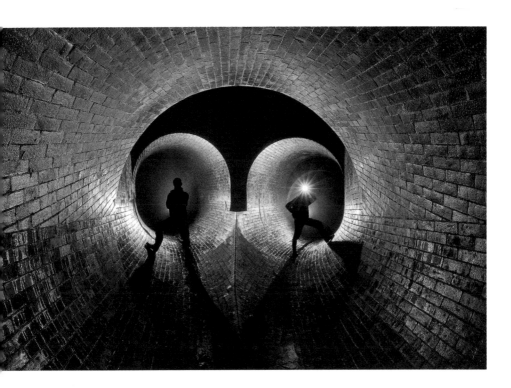

knives, tampons, plastic toy pieces and a lot of toilet paper. Once we discovered a handwritten letter that had been torn up and stuffed through a grill. Reassembling it occupied us for hours.

The spaces on the margins, or indeed under or above the city within the margins, facilitate the urban body in achieving altered states of experience, an awareness that Dan tells us 'is right there in front of you; you just have to grab it'. Sites of exploration become portals to the surreal cut into the everyday landscape, as well as an affirmation of the place and potential of the creation of unsanctioned beauty as part of our explorations of worlds, subjects and knowledge in-the-making.[12]

In short, we saw these cracks into the underworld as portals to opportunities as well as potential zones of infection. Urban explorer Michael Cook writes:

> The built environment of the city has always been incomplete, by omission and necessity, and will remain so. Despite the visions of futurists, the work of our planners and cement-layers thankfully remains a fractured and discontinuous whole, an urban field riven with internal margins, pockmarked by decay, underlaid with secret waterways. Stepping outside our prearranged traffic patterns and established destinations, we find a city laced with liminality . . . We find a thousand vanishing points, each unique, each alive.[13]

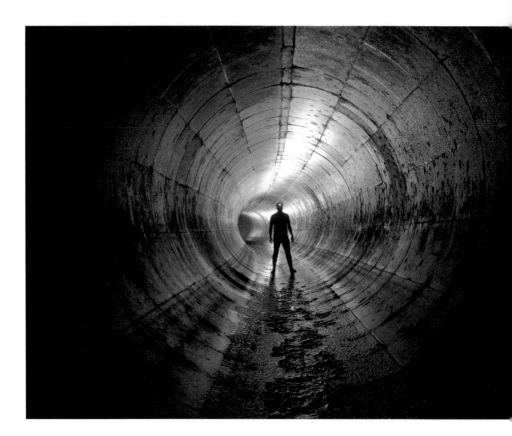

Cook's writing hints at the possibility that the structure of the city doesn't just *seem* alive; it *is* alive. The topology of the city, its architecture, actually endeavours to express itself.[14] If architecture and the built environment is a reflection of what we know, then it comes as no surprise that we have constructed our buildings, our cities, as corporal simulacra. Descending into Cook's 'vanishing points', we enter the city's bloodstream and begin to witness our effects on the urban metabolism, melding body with city.

Mr. Hollingshead, our Victorian London drainer, had such an encounter while venturing into a drain under a house he once owned in London's West End. He wrote that he 'felt as if the power had been granted me of opening a trap-door in my chest, to look upon the long-hidden machinery of my mysterious body'.[15] The connection between his body and the drain that once contained the contents of his body was no accidental correlation.

In the Tyburn River we stood underneath Buckingham Palace. Bacchus, turning to look at the other drainers on the expedition, said, 'Boys, you

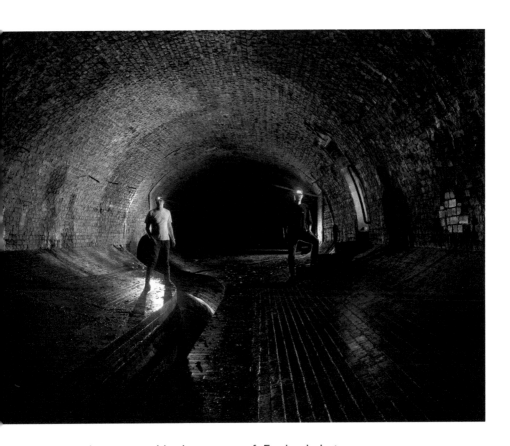

may never have tea with the queen of England, but you can now say you've stood in her shit.' Sewers are the great class leveller.

The present-day map of London looked quite different when taking into account the Fleet, Westbourne, Effra and Tyburn sewers, crisscrossed by subterranean storm-relief systems, cable and utility tunnels, the Tube and various deep shelters. Essentially, London, in any one place, might be composed of five or more vertical layers of space, with daily life for most inhabitants only taking place in one or two (for instance, the street and the Tube). The LCC moved steadily deeper into each successive layer, and often it felt as if those layers were collapsing as we redrew our mental maps of the city. We were reminded through our infiltration of skyscrapers and subterranean space that that the city is constituted vertically as well as horizontally.

In Pimlico, we were on top of a roof of a council estate looking across to Battersea Power Station. Patch pointed to an infrastructure tower in the middle of the estate and said, 'That must lead somewhere.'

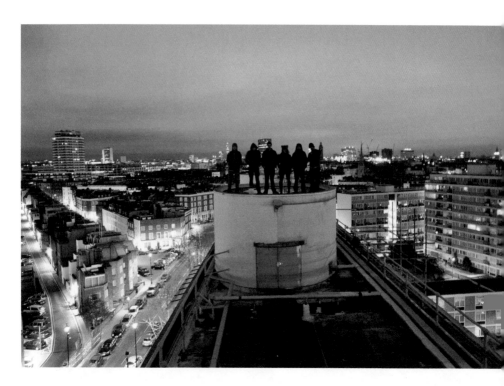

Silent Motion easily hopped the fence and opened it from the inside. We ended up in boiler rooms and then found ourselves in offices. The computers were still on, and someone's stagnant coffee sat on a desk. We moved through and found a door with stairs leading down. Taking them, we found ourselves in a massive subterranean tunnel filled with huge pipes headed towards Battersea Power Station.

We carried on walking, and at some point I came to the shocking realisation that we were under the River Thames. Following the pipes to a vertical shaft, we found that they led to Battersea Power Station itself. After a discussion, we came to the conclusion that excess steam from the power station must have once been used to heat the council estate. I couldn't help but wonder how many spaces like this were under the Thames. I did some research later and found that there are over twenty miles of tunnels under the great river.[16]

We are constantly surrounded by new tunnelling and excavation work that most people never see the interior of, and are only reminded of their existence when, for instance, workers hit a water pipe or run into a burial ground, as happened in 2013 during Crossrail excavations in Farringdon.[17] As geographer Stephen Graham has written,

The expanding subterranean metropolitan world consumes a growing portion of urban capital to be engineered and sunk deep into the earth. It links city dwellers into giant lattices and webs of flows which curiously are rarely studied and usually taken for granted.[18]

Recall, of course, that the Victorians were afraid of noxious gasses and spiritual forces that resided underground, so the state found need to convince and educate people about the benefits of subterranean infrastructure. It wasn't long, however, before people were actively excluded from that spatial information. Today, citizens are treated with greater suspicion than ever before, rarely given any detailed information about the 'secret city' their taxes build and maintain underground.

In *The City & The City*, China Miéville, a London-based science fiction writer, presents us with two cities that exist in the same space: Freud's classic palimpsest physically materialised. Citizens of each city are prohibited from acknowledging the existence of the other one. When the line is

crossed, a mysterious police force called Breach emerges to address the transgression. Although the book is fictional, it is a fascinating commentary on the politics of surveillance, divided cities and hidden verticality. Today we all live in cites that are divided in various ways, and the majority of the city is an 'exclusion zone' for most of the population. In Rio de Janeiro, the wealthy elite even take helicopters from skyscraper to skyscraper so as never to associate with the unwashed masses at street level. Perhaps this portends London's future.

The explorer, after a long, deep and intimate association with the hidden features of the city, can begin making connections between places, even between whole networks, reconfiguring conceptions of connections.

The urban explorers Deyo and Leibowitz write:

> Our cities have become so complex, so overwrought with layer after layer of complexity, that there is really no one person who understands how all the layers work together, [but while exploring,] in the diamond clarity of fear we find the difference between speculations and experience, between philosophy and science. It's the difference between reading about the George Washington Bridge and climbing it.[19]

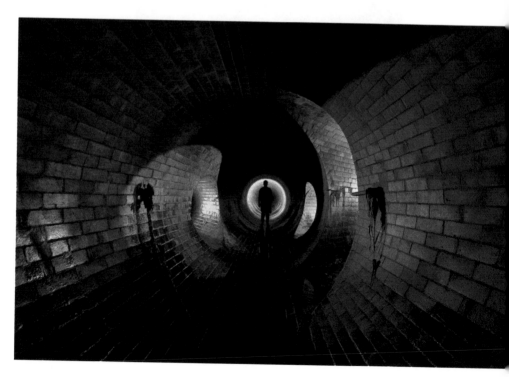

Through draining, the LCC became gatekeepers to an intimate spatial knowledge about our functioning 150-year old Victorian sewage system that most of the city's inhabitants have ignored. It was an empowering and exciting role. Predator, the explorer from the Cave Clan in Australia, posted a manifesto online in 1994 demanding public access to public works with similar goals in mind.[20] Ninjalicious, in 2005, suggested that what urban explorers are doing is participating in the secret inner workings of the city, creating meaningful experiences that meld us with space rather than passively consuming entertainment that distracts us from it.[21]

These secret city mechanisms were evident not just from the dazzling heights where we did our aerial edgework but also from below street level, where pumping bass from nightclubs, the sounds of rolling tyres over manhole lids and high-heel click-clacks drifted down to us as we walked single-file through drain systems in stunned rapture, the waste of our fellow inhabitants flowing over our fishing waders.

We excitedly discovered the extent to which the city was interconnected, where buildings reached into the ground to connect to the arterial systems of hidden watercourses, keeping in mind that these networks connect people as well as places.[22] Rather than take the functioning of those systems for granted, we chose to enter them and try to decode the mysteries behind the urban metabolism.[23] If cybernetics is the revision of information through the exchange of information,[24] then urban geographer Matthew Gandy is right to assert that 'the material interface between the body and the city is perhaps most strikingly manifested in the physical infrastructure that links the human body to vast technological networks.'[25]

In the book *Divided Cities*, a study of urban partitions people have to live with in cities like Belfast and Mostar, a sewage worker in Cyprus tells the authors, 'all the sewage from both sides of the city is treated ... The city is divided above ground but unified below.'[26] While London is not divided quite in the way Cyprus is, unveiling the interconnectivity that we didn't know existed excited many of the explorers.

Hacking the sewer changes the explorer as well as the invaded space. The explorer must open herself to disease, danger, peril and possible confrontation with authority. Exploring the living city is politically crucial for these reasons.[27] At the heart of this search for exceptional places is a call for urban-dwellers to become actors rather than spectators, to effect change rather than simply witnessing it. This is the point at which urban exploration is undeniably political, and the hackers themselves are deeply vulnerable when honing the edges of possibility.

Sometimes searching for drains revealed other things. On one occasion, I met with Popov to check out a system of air raid shelters under Luton,

north of London. Popping sewer lids, he had inadvertently come across the bunkers where residents had been tucked safely away when German air raids were trying to knock out the Vauxhall Motors factory that was producing Churchill tanks.

Popov mystified me with his calm, organised and rational approach to what he called 'overt camouflage'. He pulled his car up on the pavement, adorned himself with a high-visibility vest, coned off the area, and proceeded to wrap tape around the cones, creating a cordon, redirecting pedestrians and giving the site the look of a public works project. He then produced two drain keys that we fitted into a split-square manhole, lifted it up, and voila! Sixty years of buried history was ours to experience: bunkers full of old cans, decaying mattresses and benches along walls that would have once been lined with terrified families as chains of Luftwaffe bombs levelled their city.

At a party a few weeks later, I asked Winch whether he felt we had gained new skills when we moved into infiltration. He said, 'Yeah, it's shocking how two years ago we didn't really understand this concept. Now it's just part of how we work.' In fact, forays into the city dressed as workers had become so common that we now carried uniforms in the boot of the car at all times.

On some level, we so thoroughly convinced ourselves of the normality of overt camouflage that we were taken aback on the rare occasion when someone actually confronted us. In one instance, a drunken woman on the street in London asked Winch why he had a hardhat and a high-visibility vest on at 3 a.m. He responded, in all seriousness and slightly annoyed, 'Obviously we're going into the sewer to take photos.' She then gave him a hug and turned to punch Neb in the groin for no apparent reason.

In a sense, the group's explorations became less about the places themselves and more about the freedom to choose to spend time as we saw fit, deciding how to interact with our environment and experiencing the pleasure and excitement of being drawn out of our safe daily routines to encounter a strange and new city, night after night.[28] We stored that information in our brains and hard drives, making us more active and participatory citizens in the way we constantly acted, reacted to and caused reaction in the city. Explorations became more about boundaries than sites, more about the hack than the place; the adventure, rather than being 'out there' to be found, was inside all of us. When I asked Guts about our transformation into an infiltration crew, he responded, 'When you become obsessed with pushing these boundaries, you move from urban exploration to infiltration.' And once you cross that line, it's very hard to go back – each success marking a new boundary we could continue to cross with relative impunity.[29]

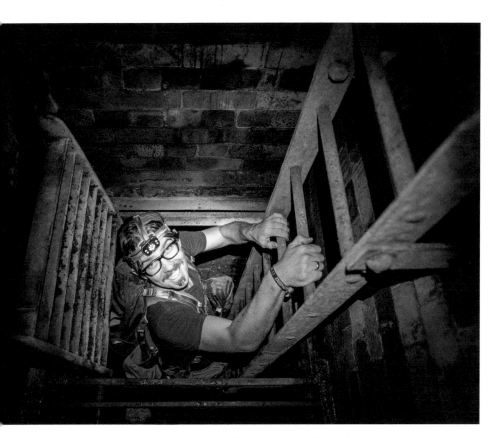

Urban explorers know and love cities inside *and* out, because in many cases they learn cities inside *then* out. Explorers express deep admiration for their environment and its history, even as those moments are indebted to the modern legacy of transgressive behaviour (graffiti, punk, hacker, beat, and so on) and disregard for what is socially expected or acceptable. The libertarian philosophy behind much of the motivation is not to be mistaken for progressive politics. Marc makes that point: 'I would not like to associate, for instance, with a group who protests against the waste of empty space in prime locations. I don't think we are against the system, we're just pointing out its limits. And as soon as the authorities realise we do, the boundaries evolve. That's the game.'

We knew that when Bazalgette had built the interceptor sewers in the Embankment, he also made room for utility tunnels. Today these subways are packed full of contorted twists of fibre-optic and telecommunication cabling in addition to gas pipes. It wasn't difficult to figure out how to get into these once we had accessed the sewers.

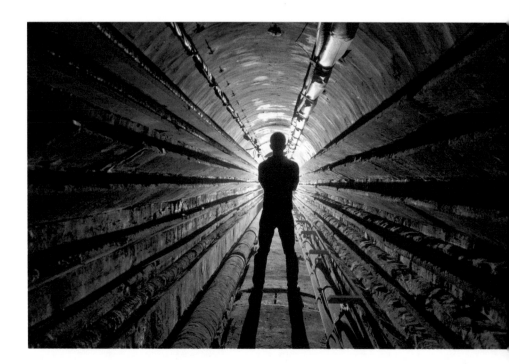

After walking from Blackfriars to the Embankment Tube station inside the Embankment itself, we arrived at a grill that opened onto the street. Just above us, partygoers were standing out front of a nightclub smoking. We sat down and cracked a beer, watching them through the grate, feeling strangely voyeuristic, though if they had simply looked down through the grate, they would have seen us as well.

It was as if we existed in different worlds at the same time, like we were inside Miéville's novel. Later that night we found a hatch from the cable runs into the speaker wall of the club, straight onto the dance floor. 'Gary' said, 'Win! We just found a portal to the other dimension!' We planned to return to the pipe subways in suits, go through the hatch and start dancing, blending in with the crowd.

A few weeks after accessing the Embankment cable runs, Guts, 'Gary' and I then infiltrated a different set of pipe subways under Bloomsbury. We dressed in high-visibility vests and hard hats so as to avoid arousing suspicion. We had entered a lid in the street median at around 9 p.m., and when we returned to the entrance a few hours later we could hear a crowd of people outside. We decided just to get out quickly, not knowing what was happening above and aware that we were in a relatively visible

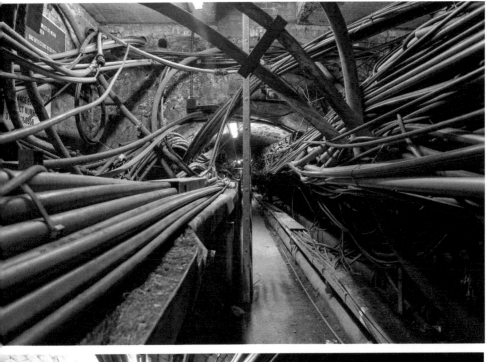
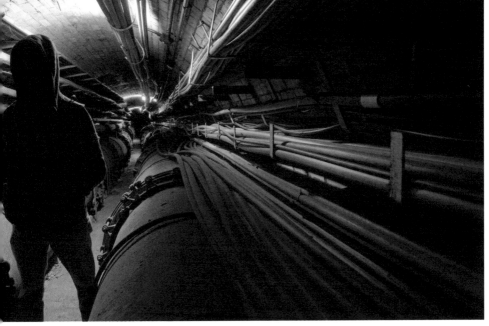

location. As we emerged, people started screaming and laughing, and we realised they had just left the nearby theatre. Everyone around us was dressed smartly, holding drinks.

A woman pointed at us and screamed, 'Oh my god, it's the Ghostbusters!' We all laughed nervously, closed and locked the lid quickly and returned to the car. Driving away, as we pulled off our costumes, we laughed about the absurdity of the situation until our eyes were watering. 'Gary', barely able to speak through his laughter, said, 'Those people are going to be trying to figure out what the fuck just happened for weeks!' And he was right. If any of those people spent more than a moment thinking about what had just happened, it would be pretty clear we weren't legit at all.

As Hollingshead noted 150 years ago, 'There is a fatal fascination about sewers, and whenever an entrance is opened, a crowd is sure to gather.'[30] In contrast to the relatively covert exploration of ruins, emergence from infrastructure into public space prompts bystanders to question the urban environment around them – much to the explorer's delight.

In these situations, explorers go beyond asserting 'I did this' by intentionally implying 'You could also choose to do this.' Political implications emerge in the resistance of the apathy most people exhibit daily.[31] The transition into infiltration from ruin exploration is an organic progression. Our early explorations revealed cracks in the façade of the urban spectacle. Further exploration, leading to infiltration of infrastructure, was nothing less than a rejection of our pact with social norms.

In her book *New York Underground*, Julia Solis writes, 'the real adventure is far below, down the elevator shaft, where you can feel and smell what New York is really made of and where the very fabric of the city vibrates with life.'[32] Again, that tone of 'authentic' experience is made in contrast to 'everyday life'. What we discovered as we become addicted to infiltration that it is not the authenticity of *place* the explorer wants so badly to share, it's the authenticity of *experience*.

Slightly earlier than Bazalgette's work in London, unprecedented subterranean construction was also taking place in Paris under the helm of the Baron Haussmann and Eugène Belgrand for Napoleon III, who ordered the construction of hundreds of kilometres of new sewerage tunnels. The fervour of the urban overhaul, along with the destruction of the sordid Place du Carrousel, caused the poet Charles Baudelaire to lament, 'The form of a city changes more quickly, alas, than the human heart.'[33] Many Parisians, like Victorian Londoners, were enthralled by the infrastructural improvements and took boat tours led by sewer workers down the stream of the combined system.[34]

When Winch, Peter and I went to visit Marc, Dsankt, Isis, Olivier and Cat in Paris in 2010, we entered a round manhole in an alley. We walked for some

time underneath the city before finding a side channel in which there was a ladder. Climbing the ladder, we found ourselves on top of a metal mesh walkway going over a highway. Following it farther, I gasped when I realised we were walking over the Seine in some sort of maintenance area *inside* the bridge, totally obscured and inaccessible from the road on top. Halfway across, we dropped down onto one of the bridge supports. Dsankt and I climbed out onto the crossbeams over the swirling Seine and sat on a beam for a photo.

Continuing along the bridge, we found, strangely, that it placed us inside a semi-derelict power station, which we also explored. At the end of the night, we had cubed the location and ended up miles across Paris from where we'd begun, having traversed sewers, utility tunnels, bridges and a building, the connections to which would never have been obvious from the view of 'everyday space'.

Once we had taken the route a few more times and learned the connections, it became a viable way to move across the city, changing our perception of traversable space indelibly. It was also, ironically, probably a safer route than crossing the bridge over the Seine by foot at times.

Exploration of derelict places in the city that led to sewers and cable runs in London and Paris, and the political implication of not only what space is 'open' to access but also the significance and affordances of 'off-limits' and 'off the grid' space on the whole, drove us to begin unravelling everything around us. Our gaze had been so indelibly altered that we could

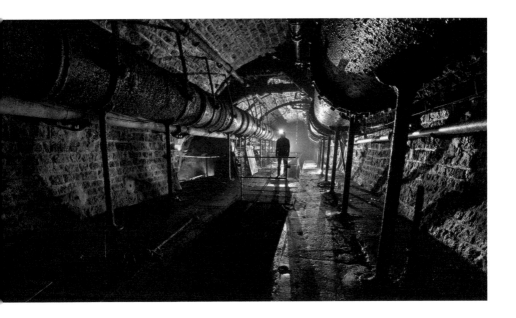

no longer see the city in the form presented; the spectacle was being recoded. The crew followed architect Alan Rapp in his assertion that 'today's infrastructure sustains the paranoid and waning civilization that will be tomorrow's ruin.'[35] Guy Debord wrote that the new existence he sought, full of adventure, mystery and mysticism, would be built on the ruins of the modern spectacle.[36] Many of the subterranean places we accessed had clearly been empty for decades. Were these Debord's ruins?

Winch, Peter, Marc and I wanted to delve deeper into the Paris sewer system, chasing the ghost of the Parisian eccentric Félix Nadar.[37] Nadar was a photographer who, at the time he was working, sought to make a photographic record of what many saw as modernity's finest achievement: the mechanisation of the urban metabolism in the form of the Paris sewers. He was fascinated by these changes, as well as all things subterranean, and spent a great deal of time photographing the Paris catacombs and sewers, leading many urban explorers to think of Nadar, along with his contemporary John Hollingshead in London, as the first 'drainers'. (Presaging the spirit of modern drainers, the name Félix Nadar was even a pseudonym!)[38] Nadar, of course, worked with early cameras, taking some of the first low-light

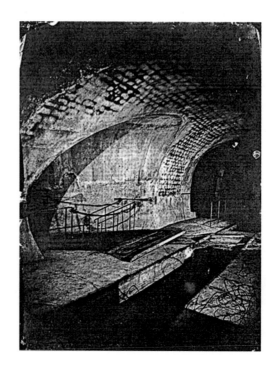

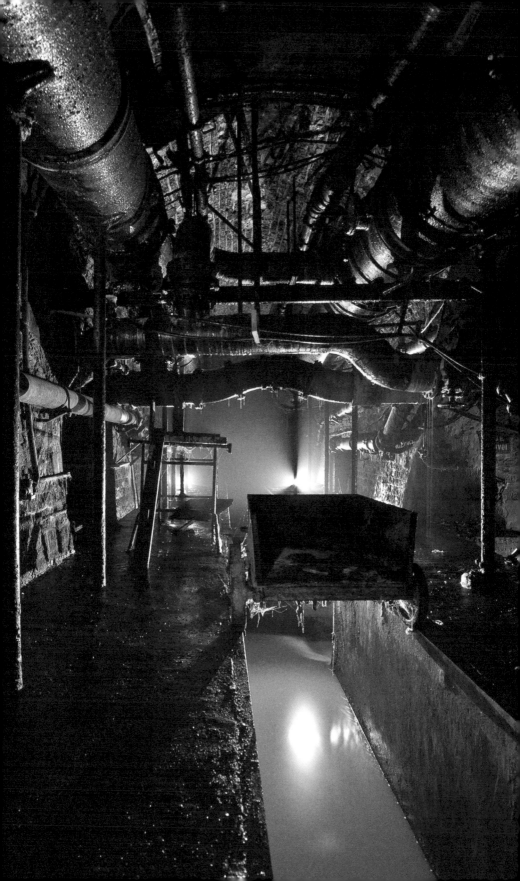

photographs with eighteen- and twenty-minute exposures. Technological advancements in photography allowed us to take sharper, more detailed photos of the same sewer junctions in twenty to thirty seconds.

The radical infrastructural transformations between 1850 and 1870 that Nadar was photographing were provoked by a massive population spike that led to a cholera epidemic, flanked by typhus outbreaks. These conditions required a similar solution in Paris to what had already been done in London. In Paris, the construction of the sewers that still exist today were that solution: a utopic promise to urban-dwellers plagued by disease in the nineteenth century.

For contemporary urban explorers in both cities, the period when Nadar was doing photographic work in subterranean Paris was a crucial one. During that time, both of the drain networks were built to the rough configuration in which they remain, the work of urban planners and engineers Joseph Bazalgette and Baron Haussmann.

These early construction projects impressed a public that eagerly awaited technological emancipation. Hollingshead and Nadar were there to render those constructions transparent, to give vision to promise. However, as people found themselves working even longer hours under increasingly monotonous conditions, a realisation dawned that these technologies had not delivered on their promises of liberation from oppression, but rather relegated more of people's time to work.

As a result, urban geographers Kaika and Swyngedouw suggest that 'the mess, the dirt, the underbelly of the city, both socially and environmentally, became invisible and banned from everyday consciousness'. Sewers were forgotten in an effort to promote yet another new promise – the networks were no longer to be revered, but ignored. In the language of the 'new' promise of freedom from suffering, in the efficient language of architects like Le Corbusier, 'the perfect house became individual, clear, pure, functional and safe for the inhabitant, protected from the anomie and the antinomies of the outside and the underneath, the urban'.[39]

Rouge, Marc and I walked through Paris in helmets and fishing waders, past highway overpasses and old railroad tracks, into a dark alley frequented by graffiti artists and underage kids drinking cheap wine, into a hole in the wall with a four-foot drop behind it, and voilà; we had crossed the liminal zone of the 'known' city into a realm of illicit encounter, raw experience, playful exuberance and corporeal terror. We crawled on all fours through the mud into the darkness.

In the Paris catacombs, we found ourselves in a spatial gap, perhaps even a negative space, where stone had been quarried to build the city

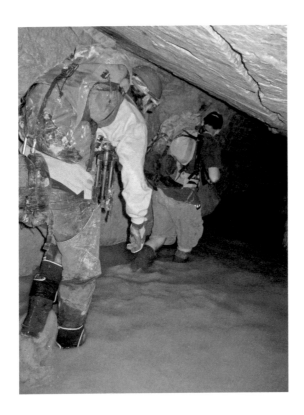

and then the city had been built over it. In architecture and urban planning, this is sometimes referred to as space left over after planning – SLOAP.[40] In work like Iain Borden's research on skateboarding,[41] we find that these negative spaces are used for various urban subversions, but we rarely imagine SLOAP being as vast as the underground in Paris.

Entrance to the catacombs has been forbidden since 1955. Before that, they were used for growing mushrooms, storing alcohol and fighting wars. During World War II, French Resistance fighters built a bunker in the quarries.[42] Little did they know, the Germans had also built bunkers in them. These underground chambers were at one time all separated from each other by filled-in dirt, until cataphiles went down with picks and shovels and connected the rooms. Other parts of the catacombs are filled with human bones, pushed down there when space to bury the dead ran out and old paupers' graves could be easily swept from the course of modernity without much notice. There is certainly a lot of space to hide bodies here. As Marc Explo told me while we were wandering the 180 kilometres of subterranean galleries and chambers, 'If you want to know how big the

quarries are, just look at all the buildings made of limestone in Paris. Then you understand the immensity of what we're in.' Much of it didn't feel immense, however; it felt crushing.

Crawling through the catacombs, I experienced what I can only describe as existential pressure. Anthropologist Kathleen Stewart describes these moments, in a more everyday context, as atmospheric attunements, flashes when we negotiate the kinds of events that might or might not add up to something.[43] These qualities are abundant in the catacombs, where the ghosts of time await the conjuring that takes place when the threshold is breached.

While these experiences are certainly emotionally charged, they are not reducible to simple emotions. They are both something more and something less than the sum of their parts.[44] As much as urban exploration is a deeply physical practice, much of what urban explorers are searching for is that which verges on the indescribable, the sensory surreal. In short, 'embodiment' here is as much about emotions, feeling and affect as anything else. Winch sees the experience of discovery in the catacombs as deeply personal:

> **The whole point of this activity of ours is to discover, and those noobish ideas of discovering histories are washed away with the sweat we excrete when we're discovering experiences and emotions. Nostalgia is usually a rich ingredient of those experiences we seek, be it the nostalgia for youthful play or the nostalgia of a bygone age we inexplicably aspire to. It's bollocks really; the discovery we really make is within ourselves.[45]**

After entering the catacombs,[46] our expectations of what to expect, think and feel began to melt, dripping off us with the sweat and blood and caked quarry mud. It seemed all we could do was act, except in those moments when we were so shocked by some sight, smell or crushing feeling that we were rendered temporarily inert. We would sometimes run into other sub-urban dwellers down there, cataphiles who spend the majority of their lives beneath the City of Light. We also encountered groups of people hunched over single-file with bobbing headlights and bottles of port, and we would nod hello as we passed, acknowledging our shared experience in this space of unregulated sensory immersion. It seemed to go on endlessly, and we achieved a meld state of supreme disillusionment and exceptional clarity. When we left and had to reconform to social expectations, the comedown hit hard.

At the end of three days in the catacombs, perhaps due to the delirious excitement that had been amassed over the course of the expedition, we thought it would be a grand idea to exit via a manhole cover in central

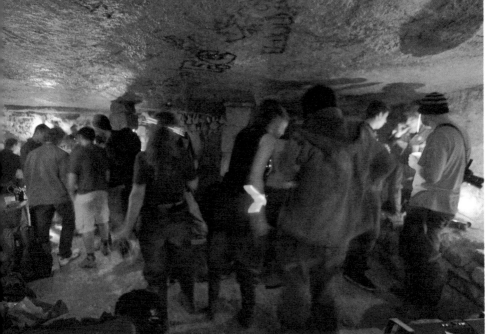

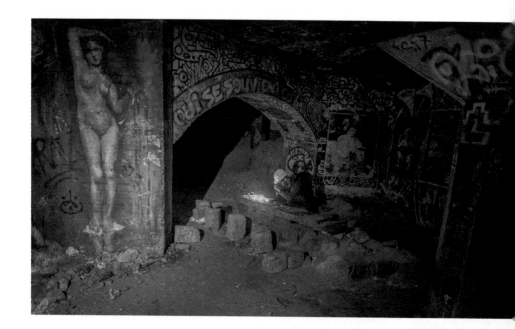

Paris at 4 a.m. After some cartographic negotiation involving deciphering handwritten notes about newly welded manhole exits, we found the cover we were looking for, realising with some trepidation that it was up a thirty-metre ladder. While Rouge guarded our packs, Marc and I climbed slowly and carefully to the top of the wet ladder and began taking turns pushing up the round iron plate, which seemed to have a newly welded bar underneath, necessitating superhuman strength to lift it from the inside.

After a few minutes of concerted effort, I panicked and began pushing with all my strength, my back against the cover, balancing on the slippery steel ladder in the darkness, the trembling beam from my head-torch shaking against the wall. I jammed my shoulder blades firmly against the cover, and it tilted slightly but remained wedged like a biscuit too large to fit into a cup of tea. Traces of light fluttered in from the quiet street above and I could see pavement. I felt hopeful.

Then a car drove by. No – it was a van. A police van. And it stopped. And then reversed.

Seconds later, torches were beaming through the open crack in the manhole, voices yelling unintelligible inquiries in French. An exhausted Marc explained to them that we were stuck and that we needed help getting out. It took four police to open the manhole cover. I emerged first, being at the top of the ladder, and was sat in the police van I had seen

from our subterranean prison, too tired and overjoyed about breathing fresh, open air to care that I was in police custody.

A female officer, assigned to guard me, looked me up and down, and only then did I remember that I was wearing hip waders, my head-torch still shining, wrapped around a greasy mop of hair that had not been washed in three days, smelling of whiskey and sweat and coated in quarry mud from head to toe. I could tell that her first instinct was to assume I was homeless or a vagrant living beneath the city, but the obviously expensive video camera setup strapped around my neck was confusing the issue. Eventually, the police told us we should go home and get some sleep, gave us some cigarettes for our walk, and cheerily waved as we walked away dragging muddy bin liners.

After exploring dozens of drain systems, electricity tunnels and catacombs in London and Paris the LCC was more than ready to go anywhere that would lend itself to unique experience, and the harder it was to get into, the better. We wanted to go deeper underground, to see the most rarely seen places in the city. We wanted holy grails.

Marc and I were on one of those little benches inside a Paris Metro station, one you would never sit on under normal circumstances. We were wearing black and covered in grime. I had a head-torch on over my hoodie. We had been up for two days and were a bit loopy.

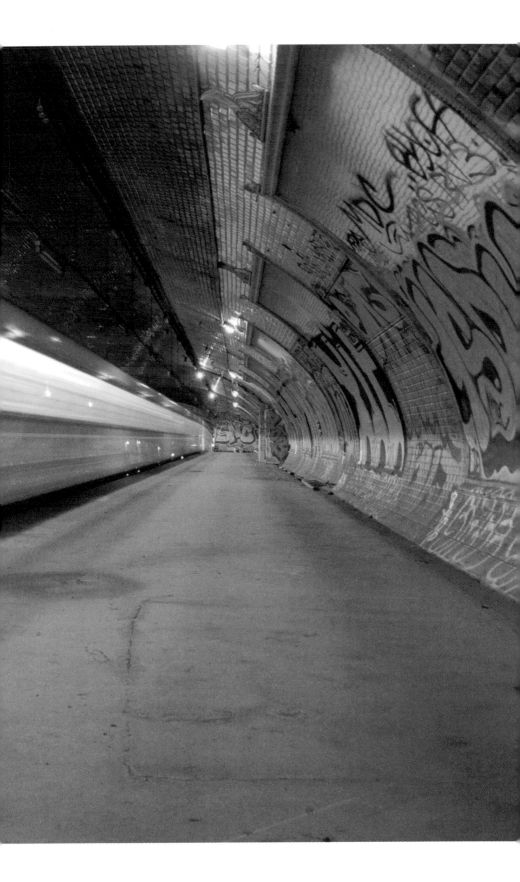

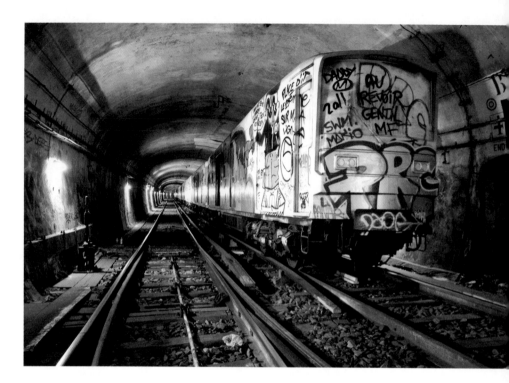

On the other side of the station, there were three drunken guys lying on another bench harassing the people walking by. I looked at the board and there were two trains arriving, one in two minutes and one in six. There were various people lingering on the platform. People looking at their watches and mobile phones are good; they're not paying attention, and are likely in a rush. However, a little girl with a balloon was staring at us very intently, her parents oblivious. She knew we were up to something, and she wanted in on the secret.

Marc looked me over and whispered, 'Tuck that strap in on your backpack. If it gets caught and you go down, we won't make it. Remember, we only have four minutes in between trains.' I realised with a start that by 'not make it', he meant we would get hit by the train arriving in six minutes. Now five.

The next minute was the longest of my life. I felt like I could hear the heartbeat of everyone near us. My body was tingling and shaking. I stopped myself from instinctively looking at the security camera and pulled down my hoodie, covering my face a bit more. By the time the wind began to push in through the tunnel and the electronic bells announced the arrival of the train, I was sweating. I felt like everyone was staring at

us, but I pushed that to the back of my mind as we got up slowly and walked towards the last doors of the train. The doors closed just as we got to them, and we both feigned disappointment and turned to leave the platform. Except we didn't.

The last thing I saw as Marc threw open the barrier on the end of the platform and we ran into the dark passage onto the trembling tracks was the little girl staring at us out the window as the train pulled away, her face glowing red in its taillights.

Not long before Marc's birthday party in King's Reach Tower, we'd run the tracks to some ghost stations in the Paris Metro, including Croix Rouge, above. We then cut our teeth on Mark Lane, an abandoned London Underground station on the District Line between Monument and Tower Hill we accessed by squeezing through a small window under a restaurant. Inside, we found the station covered in withering posters from another

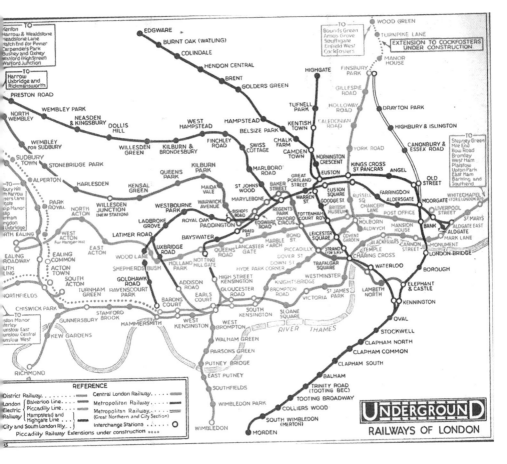

time, and we hid behind walls as trains passed through, surging beams of light that lit up the soot-covered tunnels like something out of *Blade Runner*, an amalgamation of forgotten urban archaeology and mechanised transport technology. That was the first disused London Underground station that Team B had done, despite the fact that Bacchus and others on Team A had already explored a number of areas in the network and had generally been doing abandoned rapid transport stations (ARTS) in other parts of the world for some time.

Dsankt, QX, Marshall and others had famously 'demolished' the Paris Metro before we even began in London, a story that went viral all over the Internet.[47] They had made their way into each Parisian 'ghost station': Champs de Mars, Croix Rouge, Porte Molitor, Saint-Martin, Arsenal and more. They did it slowly and methodically over the span of several years. It was the first completion of a major 'system' by explorers, and some of us, prompted by Marc and Patch, had also tried our hand at a few of the Paris stations.

Before that, Team A had tackled Niagara Falls, where Stoop, JohnDoe and Dsankt had bolted a pitch to abseil into the tailrace under the cascades, one of the largest manmade tunnels in the world. It was work like this that defined the limits of urban exploration at the beginning of the twenty-first century.[48] This was the legacy we wanted to live up to, making our own discoveries that would be recounted a decade on.

The London Tube, like the sewers, hovered on the edge of dereliction, in a state of necessary neglect. The disused stations were unique, since they had never strictly been abandoned – the whole system was 'live' with workers twenty-four hours a day, with trains passing through most of the derelict areas, and all of it well secured. The constant tension between presence and absence in the Tube gave us an adrenaline rush unlike any other location we had explored – a combination of the historical importance of fascinating ruins with the thrill of breaching top-level security.[49]

Some of us feared our initial Tube experiences in Mark Lane, while others revelled in it. Those of us who lapped up the adrenaline rush of trains flying by on the District Line while we hid in shadows and photographed the light beams streaming past the derelict platforms that thousands of people passed every day without seeing quickly became 'Tube junkies' and were quite openly obsessed with finding more stations to explore. Guts told me, back inside Battersea Power Station a month later, staring at a bank of industrial switches with a glazed look in his eye, 'When you become obsessed with the rush of the Tube, it's hard to go back.' Dsankt told me a few months after Mark Lane, when we had done some Paris Metro and it was clear we were going to carry on exploring

the Tube in London, that 'real exploration begins once you get over that initial dereliction fetish'. He was happy we had arrived.

Similar to the way I had questioned our move into construction sites, I also probed our desire to explore the Metro and found everyone, even more pervasively, having difficulties articulating the sensations they were experiencing. There was simply something eerily thrilling about being in the Tube after hours.

London has the most ghost stations of any subterranean transit system in the world, due to intense space pressures and a contorted series of changes in private ownership of the different lines over the course of 150 years.* After Mark Lane, we gathered all the information we could on the Tube: pre-war Tube maps, post-war rebuilding plans, new worker track maps and two books, the *London Railway Atlas* and *London's Disused Underground Stations*.[50]

The information we got was fragmented, as many of the stations had been knocked down, retrofitted or simply left to rot. Sometimes the stations were simply built too close to each other and stopped being used or were never used at all. Other times, they had more dramatic endings. St Mary's station, for instance, was levelled by a German aid raid in 1941, though, as we eventually found, the platforms remained intact underground. Some, like Marlborough Road, City Road and Stockwell, no longer had platforms or had derelict areas within them. In other cases, like Holborn and Charing Cross, one platform was live and another derelict. We all debated about what qualified as an 'abandoned' station. Bacchus put them all onto a map. Eventually we had a list of fourteen clear goals and another four worth checking out.

Down Street station was at the top of the list. The station was between Green Park and Hyde Park Corner on the Piccadilly line, opened in 1907. It was 550 yards from Hyde Park Corner, and few passengers used it. Aside from Aldwych, it was the least profitable station in the system and closed in 1932. It had a second life as home to the Railway Executive Committee and then to accommodate the War Cabinet of Winston Churchill.[51]

Brompton Road was also of particular interest. Like Down Street, it was a station that fell derelict due to disuse, but was rumoured to be still completely intact, with original tiling on the walls and wooden handrails in the stairwells covered in decades of dust.[52] It was now being used by the Ministry of Defence for 'training', and access was going to be particularly difficult.

* One of the most bizarre private train lines was the London Necropolis Railway, which was used to carry cadavers between London and the Brookwood Cemetery southwest of London, in Surrey.

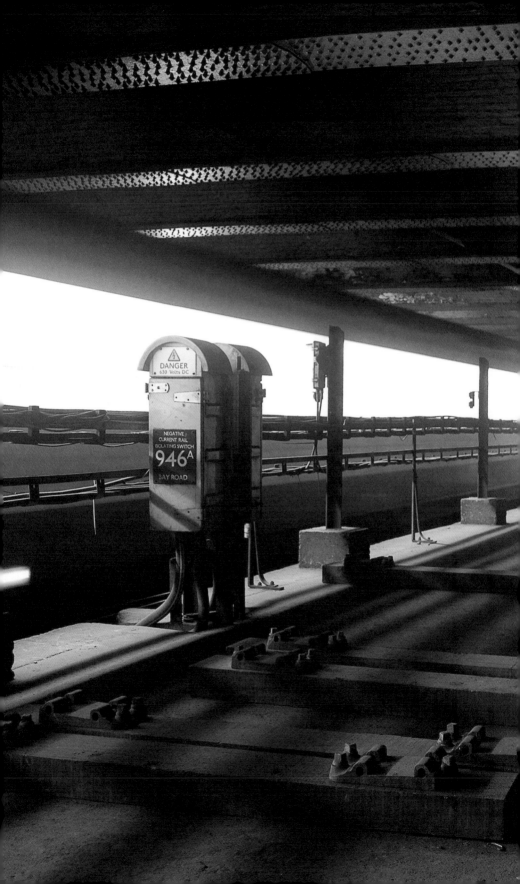

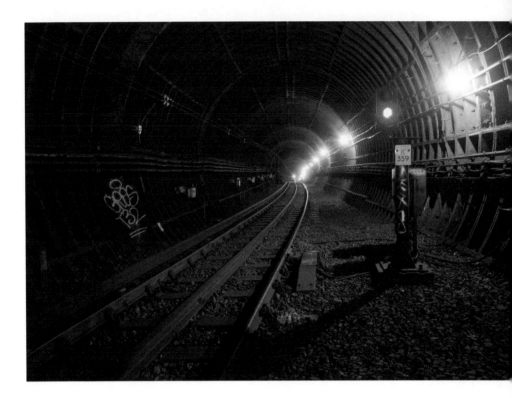

The crown jewel of the system was Aldwych, which used to be known in the early 1900s as Strand Station. The station was last closed in 1994 but had been used, like many stations, as an air raid shelter during World War II. It also housed items from the British Museum, including the Elgin Marbles, during bombing runs. The most interesting thing about the station, however, was that there was a wood-floored 1972 Northern Line train, awkwardly on the Piccadilly line, permanently stabled there for filming and training purposes. We wanted to sit in that train.

The most difficult was going to be British Museum, which had closed down in 1933. London mythology suggests that the spirit of a dead Egyptian pharaoh, who had escaped from the British Museum, haunted the station. There was no way to access it from the surface, as the station had been demolished and a Nationwide building society erected on top of it. We figured running the tracks from Holborn might be slightly easier than trying to find an entrance through the building society's floor.

We started prowling the city at night in separate teams, checking possible doors, hatches, locks and ventilation shafts to gain access to the Tube. At City Road, a ghost station with no platforms that had been

used as an air raid shelter in World War II between Angel and Old Street, the crew returned week after week, checking the same maintenance door until, finally, a worker left it unlocked. We immediately made calls, gathered ropes, tied off and abseiled into the station, springing the London exploration scene into action as soon as the security loophole had been identified. That night, London pulsed with subversion as the crew abseiled into the London Underground one after another. It had never been done before, but once we had done it, other explorers followed.

City Road did a lot to establish our credibility as a group. That success encouraged us to explore Lords station, running the tracks when the current to the third rail was switched off for the night, and then on to the connecting stations at Swiss Cottage and Marlborough Road. Five of the fourteen stations we'd identified were done in a few short months.

After Marc's birthday, there were more than a dozen of us in the LCC down in the Tube every night. South Kentish Town, Brompton Road, Old King's Cross, St Mary's and York Road followed rapidly. We would find access, explore quickly, record the spaces, and vanish without a trace. TfL workers would often close access only days later, and we wondered if they were aware of our nightly escapades. We mused that perhaps they thought it was graffiti crews looking for layups.

Inside the Tube network, the feeling of trains passing by at high speed, the warm wind smashing against your face as they screamed through every two minutes, watching the light panel as the current switched off after the last train and then playing on the tracks, running down the tunnels of the Northern, Piccadilly, Central and District lines, the sheer audacity of the pursuit, spilled into our everyday lives in unpredictable ways. When riding the Tube past a station we'd explored together, conversations would cease and we would all stare out the window and then laugh, harbouring a secret that no one in that carriage could ever guess – until we cracked open the backcab in front of them with a homemade key and sat in the driver's seat going backwards.[53]

The more stations we revealed, the more we began to understand and appreciate the intricacies of the connections and function of the transportation system we used every day. The interconnections between lines – such as at Holborn, where the Piccadilly line connects with the Central line sitting on top of it, both underground, with trains passing through each day transporting millions of people to and fro – are almost incomprehensible. Add to that that there were known bunkers underneath this tangle of tunnels and a new Crossrail system being planned and drilled underneath it all, and the vertical reality of London began to feel like one of

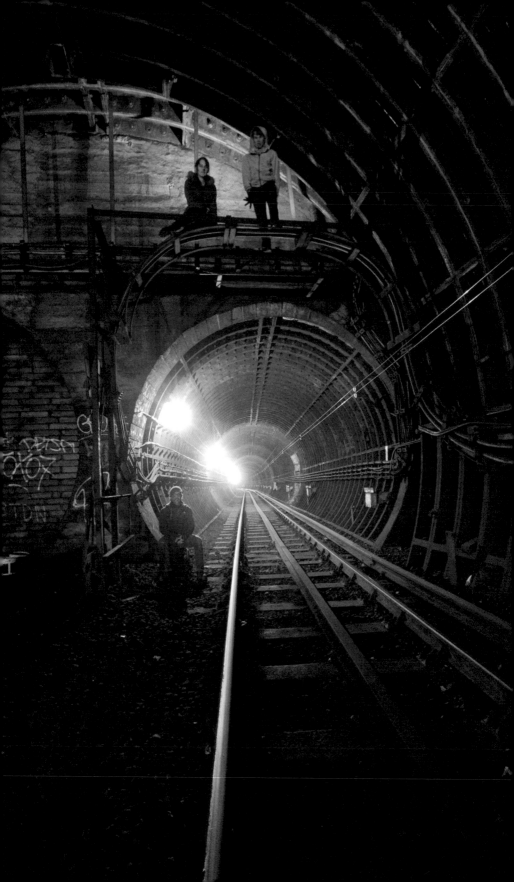

those incredibly impossible nineteenth-century Piranesi engravings. And we were inside it.

As we began to undertake more infiltration, we responded to starker infrastructural backdrops, like transit tunnels, by putting a body in frame when photographing them. This serves to break up the symmetry of the imagery and provides scale, but it also marks the presence of the place hacker, where, as geographer Katherine Yusoff writes, 'the tension between mark-making and being-marked locates the explorer at the threshold of representation and place'.[54]

When Bacchus and Team A initially led the way to cracking the Tube in London, Dan commented that he 'was in every frame of every shot' in the photos he posted online. Patch said, 'Look what he's done, for fuck's sake! Wouldn't you want to be in every frame too?' We did. The Tube is a complicated system of mostly hidden flow, and we wanted to photograph that flow, as well as our ability to stop it up and reconfigure it in the image of the meld. Transport for London, by charging £500 per hour to photograph the Tube, unwittingly made it the most enticing target possible in which to put a person in the frame who obviously hadn't paid their egregious fees. And so the place itself began to shape our photographic practices beyond a simple aesthetic response. The social fabric of the place was evident in each photo. In the Tube, the photograph asserted its power by being a record of hidden place and a marker of that physical moment of witness.[55]

Those of us who began taking greater risks in the Tube every night soon realised that not only were there greater rewards to be had in terms of unique sensations and understandings, but that there was a possibility of a holy grail at the end – a complete, clandestine photographic survey of the disused parts of the London Underground. We shifted entirely from exploring sites to striving for completion of an entire urban transportation network. The rush of chasing a grail was like nothing else we had ever experienced.

One of the most memorable was Down Street station on the Piccadilly line. It was about 11 p.m. in February 2011 when I found myself walking from Green Park station into a swanky bit of London towards Hyde Park Corner. It seemed the least likely place to undertake an infiltration of the Tube, but given the previous few months, after seeing so many stations, I was sure we were going to find access. Neb, Winch and Bacchus kept watch as Guts and I slipped down a side alley on Down Street. There we found a small hole in a ventilation grill and tried wiggling through it. We fitted – just barely. We walked back to the street, and Neb assured us no one had seen. Then, one by one, we slipped in, clothes snagging on the edges of the entry.

GREEN PARK TO HYDE PARK CORNER

PO66PWBLO

540m

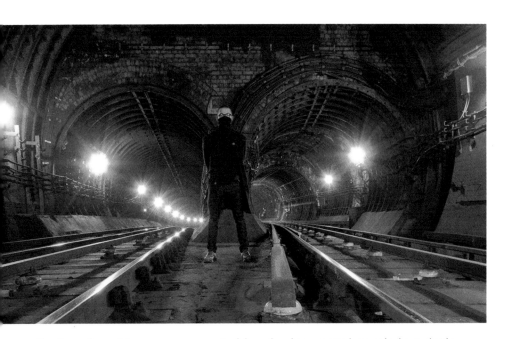

On the other side, we were greeted by glowing control panels in a dank room. The floor was a mesh metal grate that gave as we walked. As Bacchus was pulling his bag through behind us, I heard Guts say, 'Shit, they've locked up the hatch.' I looked down to where he was standing and saw it was indeed locked. Winch then looked up and said, 'Looks like we're going over, then.' We climbed over a five-metre cage and dropped down on the other side where we could get hold of a ladder. At the bottom of the ladder, we sat on a concrete ledge with a straight twenty-metre drop into darkness. Every few minutes, a train on the Piccadilly line would fly through the tunnel underneath us, pushing a warm wind laced with black dust into our faces. Having no ropes, we carefully grabbed on to the bolts holding the structure of the shaft together, along with some rusty pipes, and began the descent to track level.

Layer after layer, we had to continually overcome small problems in access – closed hatches, locked gates. Finally, though, we emerged at the bottom of a set of stairs into the halls below the ticket offices and real-ised we had done it – another Tube station had been cracked. Around us, the creamy, dust-covered walls of the station were lit by searing fluo-rescent lights. It smelled musty, like a damp cave. Walking through, we found Churchill's war rooms, complete with urinals. I used one, hoping that I was the first to do so since the British Bulldog. We hid in small nooks as the train drivers sped past, all of us now knowing the rhythm

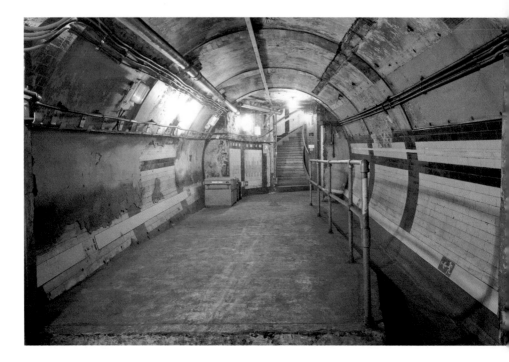

of the trains and the various methods of hiding as intimately as we knew our camera gear.

We had planned the timing of this infiltration perfectly, and as the last train on the line went by, followed by a work train, we watched the glowing panel next to the tracks as the TfL workers turned off the power to the third rail, which is also the trigger for the lights to turn on in the channels. We then spilled onto the tracks, quietly jumping the rails and running off into the tunnels. Previous experience told us we had about fifteen or twenty minutes until the 'trackies' arrived to do inspections, and we made use of all of them, running into side tunnels, running into each other, laughing and adeptly setting up tripods in waves like a volley of rifle fire, moving together so as not to get in other's shots for ten-, fifteen- and twenty-second exposures. Without speaking, everyone knew when it was time to leave. Gear went back into bags and we made the slow climb out.

After emerging from the hole onto the quiet London street, the only material reminder that we had ever been in Down Street was a small 'explore everything' sticker, tucked in the station where the next explorer would find it. By 2 a.m. we were sitting in Green Park. We talked for hours, celebrating yet another disused station brought to light. We all knew it was only a matter of time before we had seen them all.

Along with the thrill of working towards a grail, seeing the inner workings of the Tube, with its beautifully lit tunnels snaking off into infinity, replaced what we had found in ruins, skyscrapers, sewers and cable runs in higher doses.[56] Other crews scrambled to keep up, hitting stations we had cracked right after us.

After the consolidation of Team A and Team B into the LLC, through individual ambition and group collaboration, as Peter put it, 'The unconquerable was always conquered.' And as Brickman gracefully added, clutching a beer at an LCC party, 'TfL would fill their pants if they came across what we get up to on any given night.' I also hoped, at the time, that they would respect it on some level. Only TfL workers could truly understand the depths of the Tube and train fetish we had developed. Clearly only a group with a great love for the network and the engineers, drivers and inspectors who kept it running would spend all their free time studying old Tube maps, finding access to and recording locations, and working to bring them all to light. After a year of probing the system, night after night, Patch joked, 'If I'd filled my head with knowledge that's actually useful rather than endless information about the Tube, then maybe I'd have come up with an amazing idea or business model and become a millionaire by now.'

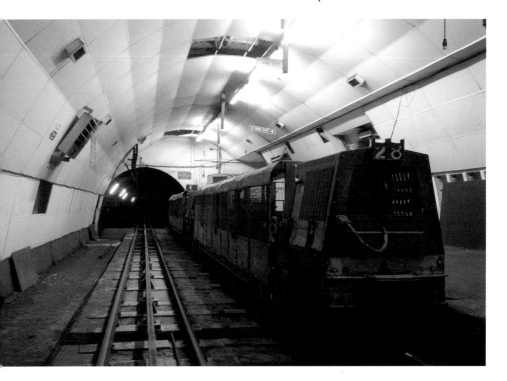

Although much of it remained unpublicised so as not to attract undue attention before we had finished, information about the LCC incursions into the London Underground travelled quickly within the UK explorer community, online and off, on secret forums and public ones. Sweed, a London explorer, wrote on 28 Days Later,

> I think most people could see it coming . . . the whole scene in London is really on its toes right now. You have a large group of very capable people who are not afraid to take big risks and push into stuff people have previously only skimmed the surface of. It was only a year or so ago one of the main protagonists was telling me how he was moving to London and was going to 'batter the Tube' and things to that effect. A year on and he's done exactly what he said he would.*

That individual did in fact move to London, into my home in Clapham, where I had ended a dispute with my landlord by squatting a flat on Narbonne Avenue. This became our new hideout in South London, and often there would be six to eight people sleeping on the floor each day, emerging each night to carry on the quest. Group dynamics were further solidified by undertaking this work while living together, as well as through our collaboration on the concerted goal of achieving complete exploration of the entire set of disused stations. We also set ourselves on a path towards another grail: the mythical London Mail Rail, a miniature Post Office transportation system even deeper underground than most of the Tube.

The Mail Rail was a separate system of eight stations built far below the city in 1927 used by the Post Office to transport letters across London. Supposedly it had been mothballed since 2003 and could somehow be accessed, though we had no idea how.

Then, on Halloween 2010, ravers temporarily occupied a massive derelict Post Office building and hosted an illegal party of epic proportions. When pictures from the gathering emerged, we were astonished to find that a few of them looked to be of a miniature rail system somehow accessed from that building.[57]

Dan, Winch, Guts and I drove over a day later. Guts and Winch kept watch while Dan and I wedged our bodies between two walls and wiggled up to an open window on the first floor. It was absolutely ravaged inside. After hours of snooping, we finally found what we thought might be a freshly bricked-up wall into the mythical Mail Rail that the partygoers had inadvertently found. We went back to the car and discussed the possibility of finding

* This thread was viewed in July 2011 but was removed as of January 2012.

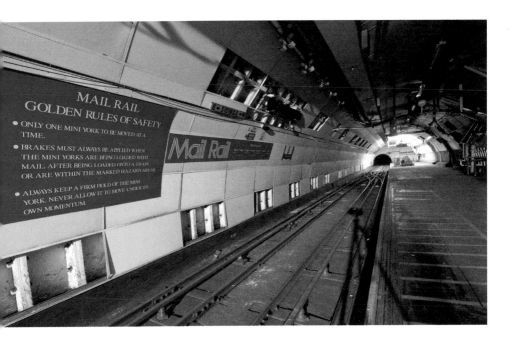

other entrances that were not bricked up. We decided, given how soon it was after the party, that postal depots would be too hot to scope just now and walked away, vowing to take another look in a couple of months.

Indeed, a few months later, while I was in the Mojave Desert on holiday, wandering around an abandoned low-security prison called Boron, I got a message from Guts that simply said, 'We found it mate.' A day later, pictures were up on our internal forum. They were beautiful. The crew had found the complete 6.5-mile system underneath London, full of small trains or 'mini yorks' used to move mail around the city. Guts wrote on the forum, 'It's unreal how this hadn't been done before, all the access info was online via Subterranea Britannica's website and it just involved a bit of climbing!'

It was a clear indication that, as much as the discovery of grails or epics was about skill, it was also about luck and persistence. The stories emerging from the trip were like something out of the Royal Geographical Society archives: miles of tunnels running right underneath central London that almost no one knew about. The crew made multiple trips into the Mail Rail that June, walking from Paddington to Whitechapel. As 'Gary' explained:

The tunnels become tighter approaching the stations, meaning stooping was required at regular intervals throughout the trip. Towards the eastern end of the line, calcium stalactites were more abundant, hanging from the tunnel ceilings, and gleaming

under the fluorescent light. This produced a very real feeling of adventure, like we were in an Indiana Jones movie, in some kind of mine or cave system with wooden carts and the smell of damp throughout.

Ercle said that it was almost comical: 'It felt like we were inside a model railway, with it bearing a striking resemblance to the full-sized Tube.'

Although accessing the system required good timing and a bit of climbing skill, Ercle explained that once inside, 'The threat of security felt a very long way off for all but one of the stations', even while dodging the CCTV cameras. As in most places, once past the liminal zone of motion sensors, security guards and cameras, we were relatively free to do as we pleased in derelict urban spaces.

Comparing ventures into the Mail Rail to our recent Tube explorations, Scott Cadman described it as a casual exploration, during which they were 'totally relaxed, free to chat and enjoy ourselves as it got later and later into the night. It was a luxurious experience and was reminiscent of the feeling of exploration when I first began; pure admiration of my surroundings.'

For four days, the crew went back again and again, running longer down the lines to additional stations, gunning it past security cameras and occasionally setting off alarms and then scurrying out of the system before anyone arrived. Finally, on the fourth night, their luck broke and Guts, Patch and Winch were busted. Winch sent me a message with the whole story:

After standing on the street waiting for a period of inactivity, the three of us swiftly made our way over the wall and down the shaft, pleased with ourselves for such a well-executed entry. Having continually checked for unwanted attention and seeing nobody, we assumed we were safely in.

'Right lads, stay where you are. The police are on their way. You're fucked.' We froze – a postal worker was staring down at us. We ran to the tunnels. We trod quickly and carefully, finding a pitch black station to exit from twenty minutes later.

We met with Peter and Bacchus on a nondescript street to rearrange ourselves. A van buzzed down the street. The siren stopped. The van stopped. The questions started.

The instinct is usually to depart pretty sharp after an 'on top' situation like the one we'd just found ourselves in. The other desire is to stick around to see what happens. We just made a bad decision. Getting seen there wasn't the problem, it was sticking around in the same part of the city that we'd just caused problems in.

Collectively we've achieved a lot in 2010, and even more so far in 2011. It's time to take stock, look at some of the decisions we make and see where we can make better

ones. Getting out of the city would have been the best decision to make last night, but it was the desire of the group to see more, do more and ultimately push the boundaries that resulted in the bust. We're not all invincible, we do get caught from time to time.

The crew was let off with a warning from police officers, who told them that they knew what the group had been up to, and with the royal wedding of Kate Middleton and Prince William taking place in just over a month, they advised us to stay out of the underground – police would be placed in the sewers and lids welded because of the LCC's nightly activities.[58]

Silent UK was the first to post the story of the Mail Rail on their blog. It hit a number of major news providers within hours and went viral, pulling in millions of hits across the globe and crashing the website. The LCC was splashed all over the Internet for weeks, leading to another backlash from the wider community as well as dejection among the crew as people realised that the list of places left to explore was dwindling, and the pressure on authorities to stop us was increasing based on the information the police had relayed at the Mail Rail bust. A few explorers made comments to the effect that London was 'rinsed' now, that there was nothing left. But Patch argued that 'there will always be more to explore; this isn't about places, it's about experiences, and those aren't finite resources'.

Soon after, the crew found our way into the Kingsway Telephone Exchange and British Telecom (BT) deep-level tunnels. These tunnels were originally built as air raid shelters under Chancery Lane, then sold to the General Post Office (GPO) in 1949, when they became the termination for the first transatlantic phone cable. The tunnels stretched for miles, only had three surface entrances and supposedly once contained a bar for workers on their off hours – rumoured, at sixty metres down, to be the deepest bar in the United Kingdom.

The crew found access through one of the shafts and spent eight hours wandering around in it, knowing they were being recorded by CCTV in the deep-level sections, the risk well worth the reward. A few in the group argued that the Kingsway Telephone Exchange was the third and greatest grail the LCC had grabbed, being one of the most secure and sensitive of a trio of telephone exchanges sites in Britain, the others being Anchor Exchange in Birmingham and Guardian Exchange in Manchester.

However, shockingly, we were not exactly the first explorers to see the Kingsway tunnels, which sort of disqualified it as a grail. Who *did* see it first is a bizarre piece of urban exploration history.

The tunnels into Kingsway were being adapted secretly by the UK government in 1951. However, as journalist Duncan Campbell writes in his book

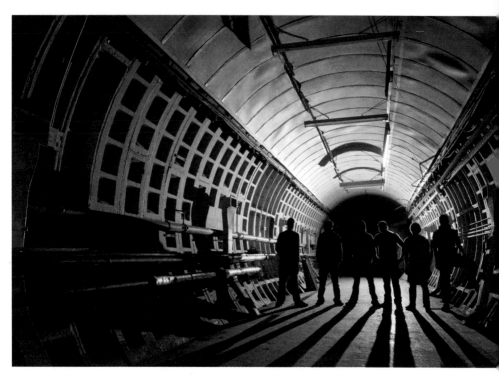

War Plan UK, 'the secrecy of the new government project did not last long – a report of the "Secret network of tunnels" appeared on the front page of the *Daily Express* in September 1951.'[59] The *Daily Express* then issued a second article suggesting that new tunnels were being dug under Whitehall. The Cabinet Office called a meeting with MI5 officials, GPO employees and Ministry of Works officials to discuss their options for suppressing the *Daily Express* or leaking counter-information about the tunnels.

> The minutes of the secret committee, known only as MISC 379, observed: 'It would be embarrassing to the Government if the public got the impression that deep shelters were being constructed. Either the public would think that the Government were out to protect their own skins and those of their immediate servants; or the public would assume that the shelters were intended for public use in time of war and would be disappointed when they found they were not.'[60]

Consequently, news of these tunnels systematically disappeared from the media. Then, incredibly, in 1980, Duncan Campbell gained access to them, armed with a bicycle and a camera, and explored the system, posing for photos in what we recognised immediately as 'hero shots'. He published

his explorations, including those photos, in the *New Statesman*.[61] The GPO, then interviewed, suggested the explorations were fake and that the photos of the tunnels had been made in a studio. This obviously wasn't the case, because Campbell relayed access details for the tunnels, which, thirty years later, got the Consolidation Crew past the doors and into the Kingsway Telephone Exchange.[62]

However, as with much of the Tube, and because of having to walk in front of CCTV cameras inside, Kingsway and the BT deep-level tunnels were too sensitive to share. After the media exposure from Mail Rail, the crew kept the photos internal. It was yet another indication of how the group dynamic had changed over the past few years, becoming increasingly insular. It was clear that the photographic aspects of the practice were now much less of a group motivator for exploring than the actual experience of cracking new sites and completing our understanding of the underground interconnections of the city. We had moved a long way from what we had considered urban exploration just a few years earlier.

Though for years our photographic repertoire consisted mostly of posed hero shots in sewers, on rooftops and in the Tube, we also now began to change the way we shot imagery. Dan started breaking the mould,

creating long-exposure photos of bodies in motion, ghosts in the frame for a tiny part of a thirty-second shot. Most of our pictures were manufactured to look as though they were captured in a shockingly sharp slice of time – but Dan worked to render visible where a body could go in five, ten or thirty seconds, often using a handheld camera and no tripod. When I asked him about his motivation for these shots, Dan told me, 'I want the images to show bodies interacting with spaces, not just posing in them. Exploration is an act of the body.' Dan's images were resonant blocks of space-time; they had duration.[63] With the help of long exposures, this could be instilled visually.

In one set of images, Dan wore a white shirt while climbing the walls of a room with an extractor fan inside the filthy Rotherhithe road tunnel. The gradual imprint of the space on the shirt, frame by frame, was a striking example of the explorer's body being marked by the interaction with place.

Over time, the images, as a set assembled by the collective, provoked a continual resonation that shifted the artistry of the whole community. Blurry, often confusing images began to be posted everywhere, with people highlighting not the hero shot but the action shot, often sacrificing the clean aesthetics of the photo to reveal access details and interactions with people and places. The process described above became de rigueur for 'dirty', blunted, high-ISO hip shots.

We also collected more video footage, slowly assembling a hard drive full of clips of our greatest explorations for a film we wanted to make called *Crack the Surface*. The shift from images to video also made our work increasingly visceral, since video is in some ways better suited to bringing viewers into the fold.[64] The responses to the footage we posted online, where many people commented that it made them sweat, seemed to reinforce this.

At the same time, we got inside information soon after cracking the Kingsway Telephone Exchange that the incident was being investigated by the London Metropolitan Police Criminal Investigation Department (CID). At a meeting at the pub to plan the final explorations on our list, 'Gary' said, 'Fuck, if it was CID . . . Guys, we're getting into serious UE now.' Despite the Mail Rail bust, everyone was re-energised, sure we were racing the police to tick off the last locations on our list: the abandoned British Museum Tube station and possibly even the secret military citadels under central London: Q-Whitehall and Pindar.

There is no doubt, looking back from the safety of hindsight, that the group had lost all sense of what we could reasonably get away with without

provoking a major investigation. At the same time, it was liberating to experience that level of freedom, to feel that we were confounding multiple police forces, outstripping them at every turn and imagining we had some sort of mob-style cork-board in a British Transport Police basement where they were trying to figure out how they could catch us. The group had so intimately fused our lives with deeper desires to do the impossible that we had completely reformulated our relationship with the city – and with ourselves. Our high tolerance for adventure also caused us to take clearly avoidable risks in ruins, construction sites and sewers that no longer seemed challenging as we waited for the right time to go for the final locations.

In February 2011, I got a call on my mobile. It was a garbled recording of Dan that sounded like he was underwater. All I could catch from it was 'help' and 'trapped'. I thought it was a joke, but I called him back, and after many rings, he picked up. The conversation was difficult; I could barely make out what he was telling me. What I eventually pieced together was that Dan, the most agile and sneaky of our crew, had got himself stuck in a lift in the Nido Spitalfields building at 100 Middlesex Street, a thirty-four-storey skyscraper destined to become student accommodation.

I called Popov, who I knew had a bag full of gear in the boot of his car for just such an occasion. We raced to 100 Middlesex, arriving at about 10 p.m. We jumped the hoarding and quietly made our way to the lifts. One of them was stuck on the thirteenth floor, the button unresponsive. We pulled out a set of lift keys, but none of them fitted this particular model. We then went to the stairwells and realised why Dan had taken the lift in the first place (something we learned early in our infiltrations never to do, both for safety and for the possibility of alerting security): the stairwells were boarded up tight.

We worked for hours trying to push the boards back without breaking them, not wanting to exacerbate the situation by damaging something should the authorities get involved, but to no avail. As Popov pointed out, even if we had got through the boards, there was no guarantee we would have been able to pry the lift doors open on the thirteenth floor. We had to give up.

With no way to contact Dan inside, we did the only thing we knew to do at 3 a.m. on a Monday morning in such a crisis – we called the fire brigade. The first time I called, the woman answering phones told me my 'story was not amusing' and hung up on me. The second time, I was told they would 'send a unit'. About twenty minutes later, twelve cars showed up, and the police walked into the building next door to talk to the

twenty-four-hour security guard. Clearly the guard had seen us hop the hoarding on our way out. The police had ignored a call from a concerned citizen, yet responded to a call from a security guard sitting in a corporate den – typical. I then rang back 999 and told them, 'Look, I am standing here now with officers everywhere, can you please send one of them into 100 Middlesex? This is not a joke, there is someone trapped in there.' The receptionist assured me that she would make the call. We left before the police started looking for us.

Nobody slept that night as we waited for word from Dan. Finally, at 10 a.m., he called. He told us that neither the fire brigade nor the police had come to his rescue, but a throng of workers greeted him when they turned the power to the lifts back on at 8 a.m. that morning. The site manager, not wanting to cause any 'unnecessary paperwork', sent him on his way. He'd spent forty-eight hours trapped in a lift. Although Dan was appreciative of our efforts and forgiving of our failure to rescue him, I had never felt so useless in all my life.

With the increased risk in seeing more deeply hidden sites came an increased possibility of things going wrong, or even of one of us dying – falling from a crane, being hit by a train, drowning in a drain during a rainstorm. But the romance, danger and fear that were now part and parcel of the lives we had built together made these possibilities seem remote and unworthy of consideration.[65] The risks being undertaken gave us the capacity to deal with chaotic, often seemingly impossible situations on a daily basis, and it was endlessly liberating.[66]

Despite the terror felt in the moment of 'emergency' situations, those moments often become the stories most worth telling. As Neb said to me, 'There are a lot of people who have near-death experiences, but not many who have interesting ones.' In fact, Neb, Winch, Guts and Patch had almost died in a Hastings storm-relief system called the 'Stinger', which Winch wrote about:

> We'd been there for perhaps forty minutes, and with a roar coming from the infeed on the right, the waters suddenly sped up. First they sloped up and over the edge of the walkway, then within thirty seconds they were flowing over the top and running down the walkways. With haste we packed up, and the others joined me from the platform on the right as the flow reached our calves and eventually our knees. We had two choices: either sit it out up high or aim to head down the 300 m or so we'd come up the tunnel and away.
>
> Neb's bag was carried away, and we crossed the flow using slings wrapped round our wrists, the combined body weight of the group giving stability to the person deepest in the water. We shuffled down towards the exit with haste, the distance seeming

far greater than on the journey up. Shadows and colours on the walls tricked us several times as we thought we had reached the exit but had only reached stained marks on the concrete wall. Eventually we reached the infeed tunnel and had to wade up through a waist-high flow, using an extended tripod to pull ourselves through to the ladders. We clambered up and out, grateful to be out of the sewer, as the thunder and lighting crashed around us. This hadn't been in the weather forecast, and certainly not in our script.[67]

Not all explorers are so lucky. In 2009, an explorer in Minneapolis was swept away by floodwaters into the Mississippi River and drowned. Solomon, from Middlesbrough, fell five stories from a hotel in Bangkok in 2010, killing himself instantly. Closest to our crew, and a friend to many on Team A, Downfallen – an explorer and BASE jumper who had illegally leapt off the Burj Dubai with a parachute on his back, setting a world record – fell to his death in the mountains of Switzerland.[68]

It is arguable that in childhood we experience fear more often, which, like play, can be liberating in inspiring the surreal and challenging notions of what is possible. In Greek, there is but one word that means both 'fear' and 'wonder'.[69] This bridges the physicality of an exploration with other

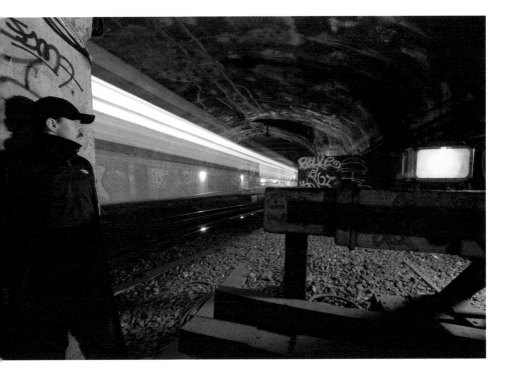

connecting emotions, of which fear is perhaps the most powerful. In a piece in memory of Downfallen, a friend quoted him as writing:

> **I choose to live my life to a different tune of music, one which is not censored or wrapped up so much with a blanket of over-regulation, Health and safety gone mad (because these days it has), fear and blind compliance to anything you are told to do . . . a blanket so thick that you no longer can hear the music. If I'm injured, you'll hear me blaming only one person . . . myself. It's acceptance of personal responsibility for my actions, a quality that's very much lacking in society these days.[70]**

Many urban explorers, like Downfallen, insist on their right to do their bodies harm, to put their bodies in harm's way. Downfallen died for this belief, becoming a hero among the community and adding himself to the list – along with Predator, Solomon and Ninjalicious – of those the community has lost (not all under such tragic circumstances). While it may be argued that the desire to push limits is innate in some people, it is also a reaction to an urban environment in the neoliberal city that increases our passivity and diminishes our capacities for empathy and meaningful engagement.[71]

Subjecting our bodies to circumstances in which we experience extreme and powerful emotions and overwhelming sensory inducements is something people are rarely, if ever, offered by the modern urban environment. There is a feeling among many people that the city is built for others, that we may look at it but may not touch it, the spatial equivalent of an artefact in a glass case in a museum.

At times that frustration manifests itself in violence, as in the summer 2011 London riots. Whatever the politics behind the event, there was a clear joy people experienced on being able to kick in windows and burn cars, taking what they liked from the city, huddled together with friends, sweating and fighting the police for control of neighbourhood streets. Jubilation was abundant as people connected viscerally to their environment, much of which was perpetually inaccessible in all other circumstances.

In geographer Stephen Saville's work with parkour practitioners, he writes, 'The traceur is ever questing towards new and often fearful movements, many of which are predicated on the attainment of bodily skill [where] fear can be a highly complex engagement with place, which can in some circumstances be considered more a playmate than paralysing overlord.'[72] Whereas in everyday urban life fear can be an ominous and perhaps uncontrollable force, like the vague possibility of a mugging or a terrorist attack, during an exploration of an inherently dangerous space the rapid apprehension of unfamiliar territory is necessary for one's own safety.[73] Fear, when met with existential resistance, can produce an internal state of calm in which a

person becomes more aware of their immediate embodied experience and less concerned with events occurring out in the world.[74]

The particular moment of action during an exploration when your feelings and emotions are overwhelmed by the potential for death – this is part of the addiction. The adrenaline rush of choosing the precise instant to tackle something unsafe, like climbing over razor wire, requires your entire body and mind, a complete engagement of the muscles, the viscera, the respiratory system, the skeleton. Blood pumps and pores sweat as you do everything possible not to be harmed.[75] Often you realise you're capable of far more than you thought you were, and the bar is raised.

The necessity of action reinforces the power of the individual over the situation, in contrast to everyday space where we are constantly under the influence of situations created by others (this is certainly the case for many people's lives at work). This is why Guy Debord insisted on the creation of situations that we find to be 'authentically real and creatively satisfying' to reinforce our place in the world.[76] Embedded in those moments of manufactured fear is a radical expression of freedom.[77] In spending our lives chasing money to purchase things and experiences, it turns out that what was sold was inside of us.

Along with created places for ourselves, egos evaporate when the self is subsumed by action and reaction. Attempts to control the chaos of unstable and unsafe situations reconfigure the wiring of our brains.[78] The LCC, by confronting fear and failure on a quest for discovery, were rewriting urban histories of capital, investment, banking, construction, national heroes and governments as a populist history in which we were the heroes, the adventurers and the criminals all at the same time.[79] That process of becoming was captured in images with a particular style, a signature that had become ours, now codified as the visual language of the LCC, a new aesthetic sensibility for Londoners to try to absorb.

At times the crew had to trust each other in heated moments, which served to solidify our tribe. As our list of successes as a group grew and our edgework reconfigured the boundaries of what we were doing, we located power in a society that affords little to the average citizen.[80] We were sure the acquisition of that power came from better research, better planning, the willingness to be caught if necessary, and a bit of blind luck.

When caught by the authorities, group members tended to react with deference, apologising to the police for wasting their time, especially because at times the police reaction was grossly disproportionate, sending dozens of cars, vans and dog teams to eventually give us a lecture and a 'stop and search' form. Encounters with workers, though, generally had no negative consequences, as during a run-in with two track workers at 3 a.m.

in an abandoned Tube station in Central London. Immediately after that incident, Dan told me, 'I think they were more confused than anything else – just walking the track and then suddenly there's some guy in a side tunnel with his face covered holding lots of camera gear.' Dan politely said hello to the workers and absconded up a staircase and out an emergency exit, leaving the pair standing in stunned silence. Poking around somewhere purely for the joy of it confuses people, but poking around somewhere looking for a unique photo that will be sold in an art gallery often makes sense, even if they then ask you to leave, so the 'art' of urban exploration often lends legitimacy.

Each exploration, even those that led to encounters with security guards or police, always resulted in an increase in skill level and awareness. Finding the edge in these situations was always a difficult balancing act between pushing the limits and not making bad decisions that led to unnecessarily complicated scenarios, such as setting off an alarm that we could have easily avoided.

It was inevitable, however, that at some point we would get ourselves into a problem we couldn't get out of.

Underneath South London, in Clapham, there rests a series of three disused shelters as deep as the Tube: Clapham South, Clapham Common and Clapham North. They were constructed during World War II as a safe place to bring evacuated passengers in the event of an attack. Inside the bunkers, we could find the boundary points between the bomb shelter and the London Underground, putting our ears to the breezeblock wall separating the two and listening as the Northern Line trains flew by. What was once a connected system had been divided by the simple erection of a wall. But as we know from Berlin, the Mexico/US border and the Israel/West Bank barrier, walls are powerful political statements – as is breaching them.

The Clapham North shelter was a site of serial illicit trespass. In March 2011, the crew threw a party there. We hooked up Neb's sound system, played 'bunker Frisbee' and danced to drum-and-bass under disco lights that Popov had dragged down the thirty-metre staircase. We had also made trips to Clapham South, where we found a rare mercury arc-rectifier, a beautifully alien-looking piece of machinery that had been used to convert electrical current before solid-state rectifiers were invented. But for a long time, the Clapham Common bunker remained uncracked. The complication was, it was now being rented by a file-storage company called Steel Mound. Then, in a rare moment, the opportunity presented itself, as it always does when you're paying attention.

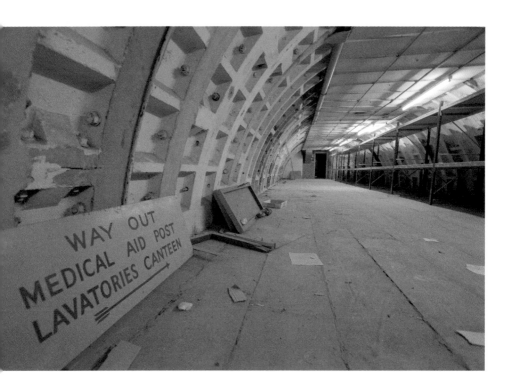

One sunny day, I was walking by the Clapham Common shelter with my lunch and found, to my surprise and delight, the door to the airshaft swinging open. I ran back to the squat and looked up the schematics for the shelter. It appeared, based on this and our previous knowledge of the other Clapham shelters, that we might be able to abseil down the thirty-metre airshaft and slip through the ventilation extractor fan into the bunker. There was only one way to find out.

I called up the usual suspects, and they arrived an hour later with ropes, harnesses, torches and too much adrenaline.

As Dan, Patch and I slipped into the broken door, Guts closed it behind us. We found access through a chicken wire fence and squeezed through it. On the other side, with nothing else to tie onto, Dan rigged the ropes on some rusty sixty-year-old piping and dropped thirty metres into the darkness. I followed, trembling with nervous anticipation. Patch came down next, carrying most of our gear. He dropped like a rock down the rope with no light, hitting the extractor fan like the Incredible Hulk, and the whole thing shook. We dropped the gear in and squeezed through the fan blades, finding ourselves in the deepest recesses of the

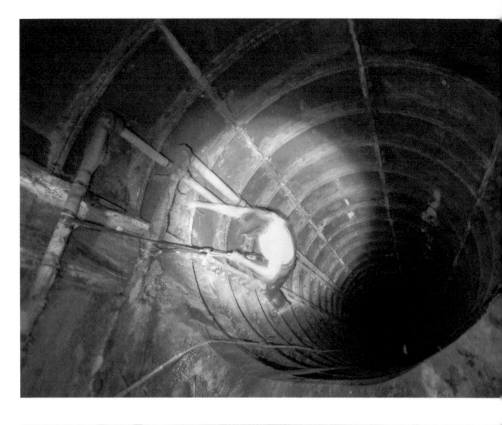

bunker. We scampered up one flight of stairs – and stopped short at a blast door with a square hole in the middle that was too small to squeeze through.

Salisbury looked up and laughed. 'Watch this', he said, as he jumped up and grabbed the edge of some jutting metal. With a quick lift, he was in the airshaft under the first floor. Unbelievable. Ten minutes later, he stuck his head through the hole in the blast door, covered in cobwebs and filth.

He said, 'I think I just set off a PIR' – a passive infrared sensor alarm.

Patch responded, 'Well, I'm not going back up that rope, so open the door, mate.' We heard the wheel screech on the other side and the door swung open.

Once inside, we found that the magnetic reed switch alarm systems on the doors had been disabled prior to our arrival, a technique straight out of Ninjalicious' book *Access All Areas*.[81] We concluded that the PIRs must also have been disabled, based on the fact that the bunker was not teeming with angry police by this point. So it seemed we had free access to an entire bunker full of potentially sensitive documents, though in the end, we all joked about how unexciting most of it actually was.

Just weeks after Julian Assange's WikiLeaks fiasco, when he appeared in a London courtroom for disclosing government secrets, we had gained

entry into a secure file-storage area and had unrestrained access to all the documents it contained. I imagined Assange would have been pleased to know this was happening; his ethos for transparency so closely aligned with ours. The event led to an interesting reflection on what it meant for us as a crew to do something purely for the joy of doing it, purely for the adrenaline rush. For what could be the historical value in seeing a shelter that was architecturally identical to the two others we had already seen, aside from the fact this one held secure files?

Since many people consider urban exploration a victimless crime, I couldn't help but wonder what the eventual consequences would be of Steel Mound finding out that their 'secure' file-storage area had been breached and their alarm systems proven facile. Would they have to tell their clients that there had been a potential document leak? Would they have to inventory every document in the bunker to see if something had been taken (for, surely, what else could be the motivation for such a trespass)? Given the lack of security in the bunker, for all we knew, people have been in their previously, perhaps years before us, as with Kingsway Telephone Exchange, and Steel Mound didn't have a clue.

We laughed about it for weeks, leading Winch, who had been out of town and missed the escapade, to comment, 'This sounds like the hack of 2011 so far.'

Brickman replied with, 'It sounds like a job even the scriptwriters of *Mission Impossible* would have been proud of.'

Patch then quipped, half jokingly, 'Are we even urban explorers anymore?'

When I pressed the crew about the potential consequences of our actions, one explorer laid it out plainly, saying, 'I don't give a shit if seeing that it's been breached causes them anxiety – the fact of the matter is that this company's primary function is secure document storage. You'd think their first priority would have been to secure the fucking bunker!'

By the Spring of 2011, we had infiltrated the Steel Mound file storage, the London Underground, the Kingsway Telephone Exchange, the under-construction 2012 Olympic Stadium, the rooftops of St Paul's Cathedral, the British Museum and almost every major construction project. Between that and the million-hit post about the Mail Rail on Silent UK, security had started tightening up around London.[82] In fact, Patch had found a report online from a consulting firm for Transport for London, advising them of the need for a £240,000 overhaul of security 'following a review of vulnerable access points across the network by London Underground Ltd', where 'the review identified a number of locations where works were required to prevent individuals from gaining unauthorized access

through surreptitious means'.[83] It verified what the Met Police had told the crew at the Mail Rail bust: the Met and British Transport Police knew what we were up to. We imagined they were probably frustrated and stumped by what we were doing, since, unlike graffiti writers, there was little evidence of where we had been except for photos online.

Holidays were a good time for the crew to infiltrate particularly difficult sites, given that most workers took time off then, including security. On Easter, just weeks before the royal wedding, two separate groups went out to explore two locations.

First was the British Museum Tube station, the last on our list of abandoned stations. 'Gary', Patch, Bacchus and Peter had found that by squeezing through a vent shaft into a utility closet, access could be gained to Russell Square station, which was obviously live. By then running down the escalator and across the platforms, through the station, down the Piccadilly line, on to Holborn and then switching through the tickets halls to the Central line tracks – all past dozens of active CCTV cameras – they could make it to British Museum. It was very risky, but those were the stakes. They went for it while Popov waited for them in the car at street level.

Unfortunately, someone at Central Control was actually watching the cameras that day and saw four people running across the platform at Russell Square masked up and dressed in black. Russell Square was probably one of the most-watched stations, since it was between there and King's Cross that one of the 7/7 bombers had detonated their charge. British Transport Police, including an anti-terrorism unit with dogs, swarmed in, arrested everyone and did a bomb sweep of the station, shutting down first service through Russell Square the next morning.[84] Patch wrote to me about it:

> The most hilarious bit was when we were initially arrested and the guy asked us what we were doing. I said just looking around and taking photos, and he was like, 'Bollocks, mate, you're activists. People don't take photos in tunnels.'

At the same time, Dan Salisbury was at Adelaide House, an excellent rooftop for photos over the Thames near London Bridge, when he was spotted by a security guard, who rushed and grabbed him as he tried to climb the hoarding to get out of the site. When the police showed up, the guard claimed that Dan had assaulted him. The police then connected him with the CCTV footage in the Kingsway Telephone Exchange, figured out that he was also connected to the four explorers caught in Aldwych, and the whole story started to unravel.

Within forty-eight hours, multiple explorers had their houses raided on warrants from Crown Court judges. Laptops, cameras, keys, maps, tools and costumes were seized, and CCTV footage matched to specific individuals. Photos and blog posts were linked, aliases unravelled and the whole thing came toppling down.

As we tried to quickly change the passwords on our internal web forum before the police arrived, Ercle joked, 'I find it ironic that, for a group dedicated to finding holes in security, we are struggling so much with our own.' We managed to take down the domain moments before the police forced their way into the front door of the squat in Clapham where Patch and 'Gary' were holding it down. Patch wrote about his end of the experience in an email to all of us from a public computer:

As you may know, myself and some of our friends spent a day at her majesty's pleasure in relation to being caught in the Tube trying to get to the final abandoned station on the list. As a result we've had our homes and our parents' homes turned over and phones, computers, cameras, photographs, negatives, memory cards and various other bits seized by the Major Investigations Team, including photos of Mail Rail and Kingsway Telephone Exchange. We've been bailed and are to surrender at various times on Friday to either be re-arrested/re-bailed in light of new evidence or charged on the spot. Fortunately we realised that with the BTP and City having seized five phones and at least five computers they could easily access the forum if any of us had autologin ticked and he managed to pull the domain name. This wouldn't have happened instantly but the site was unreachable by 11am yesterday when I checked on a friend's computer. As a secondary measure I have made an offsite backup of the server and database then completely wiped both from the hosting account as my FTP is set to autologin on my laptop. I've also changed my passwords for emails, msn, flickr (and removed relevant images) etc., so the only evidence of the places we've been they'll have from me are the photos on my computer and the prints they seized. Unfortunately despite removing most of the incriminating material I fear this won't be totally sufficient to avoid involving more of you in the investigation(s), as every phone seized on Monday probably has texts on it that will at least hint at some of your involvement in the Tube/Kingsway explorations.

I don't really know what to suggest you guys do next, if anything, or if you should even be worrying as much as I am, but I thought I should keep you updated about what I know to at least give you some chance to prepare for a knock at the door. I'm hoping to go and see Dan tonight to find out what happened to him – I haven't had an answer from his phone so assume it has been seized. Our bail conditions include a 2300–0600 curfew and a ban from being in non-public parts of the Tube network so I'll be at the squat every night at least until Friday if anyone wants to come up and chat more about it.

The BTP eventually let all four explorers off with a caution. However, back in court months later, TfL issued an antisocial-behaviour order (ASBO) against the 'Aldwych Four', as the press came to call them.[85]

ASBOs, a brainchild of Tony Blair, are meant to punish people for incidents that would not ordinarily warrant criminal prosecution – they basically allows for a law to be arbitrarily made up for one person who is doing something the state doesn't like but which isn't necessarily a crime. Incredibly, this particular ASBO stipulated that the explorers, who had already accepted cautions, would not be able to speak to each other, speak to anyone else about urban exploration (never defined in the ASBO), undertake exploration or carry any equipment that could be used for exploration after dark. The order would last for ten years.

Under this threat, and with poor legal advice from his court-appointed solicitor, 'Gary' made a deal with TfL to take a two-year ASBO on those conditions. Peter eventually gave up the appeal process due to mounting legal fees and exhaustion after months of being continually re-bailed while the police kept his computer and cameras, his tools for work, and was stuck with the same two-year ASBO.

Weeks later, Patch (who was now out on police bail), Rouge, Scott and Uselesspsychic went back into the Mail Rail and started one of the electric trains. In what Patch described as 'one of the most exhilarating moments of my life', they rode it for four miles until they ran into a track that wasn't set properly and derailed the train. The damage was minor, but by then the police had surrounded the building and all four explorers were arrested.

Scott and Patch told me that, in the police station interview, the investigating officer pulled out ninety-one pages of writing from my blog, attempting to place me at the centre of the group's work. I was able to confirm this when I saw Patch's indictment in a two-inch binder he was meant to look over to prepare his defence. The evidence log read:

MG6C ITEM 7. 91 pages of the website http://www.placehacking.co.uk, describing the acts of photography in abandoned buildings and Tube stations including the Mail Rail.

All four explorers from the Mail Rail arrest ended up at Blackfriars Crown Court, facing quite serious charges of damage to government property and aggravated vehicle taking. I attended their trial. In the courtroom, CCTV footage was played of the explorers riding the train, hanging from the sides, all smiles, fists pumping in the air. Patch was prosecuted for derailing the Mail Rail train. He received a four-month custodial sentence suspended for two years, sixty hours of unpaid work and a fine of £1,000

in compensation to Royal Mail for property damage – though he then beat the ASBO from the Aldwych bust. Throughout the court proceedings, Judge Clark repeatedly referred to me as 'the self-styled doctor'. The investigating officer on the Aldwych case, DC Clear, complimented Patch on our tactics, telling him that we were 'incredibly difficult to catch in the act'. The same investigator later told Scott, 'I normally deal with deaths, muggings and suicides – looking through your photos has been delightful in comparison!'

Salisbury's photos were also on display in Blackfriars Crown Court, as was the CCTV footage of the crew inside the Kingsway Telephone Exchange. It turned out that some keys had gone missing from the Exchange and BT deep-level tunnels, which unlocked a decommissioned wing that had no function. They had been found in Dan's house when it was raided, as had Thames Water and Network Rail uniforms. I testified as a character witness in the case. Luckily for Dan, it was a jury trail, and the jury clearly thought the whole thing was a waste of time. They returned with a not-guilty verdict almost immediately.

By this time the squat was also falling through. It had lasted the summer, but the owners were finally figuring out which papers to file to get everyone out. After our eviction, the group cracked two more squats, including one in Pimlico worth £1.2 million, but we didn't have the numbers anymore to keep someone in them twenty-four hours a day, which was necessary to avoid eviction. Eventually most of the LCC moved away from London, started university or took jobs, and being nocturnal wasn't an easy option anymore. Things settled down, intensities dissipated – by the end of 2011, the LCC was all but dead.[86]

When the news of the court cases was made public, the *London Evening Standard* wrote an incredibly negative article about the group, implying that we had 'broken into' everything we explored.[87] As a result, there was another huge fallout in the wider UK explorer community, almost as vitriolic as after the Burlington incident. Other explorers started calling us the London Criminal Collective, which Patch quite liked. The explorer Sweed wrote on 28 Days Later: 'There's no doubt about what they have achieved but what they have also done is build themselves a pedestal, a pedestal that is way too high and built of crumbling stone.'

Bacchus responded to the post:

As for the activities of LCC . . . Bottom line is they did what no group of explorers, in the ten odd years urban exploration has been going on in the United Kingdom, has ever done. They fucking rinsed the city of Greater London. Tube, Sewer, Pipe Subways, Mail Rail, the lot. The reason it's taken ten years, is because it's by far the hardest. In

sixteen years of exploring, in a variety of different countries, I've never encountered a city as hard to crack as London. But LCC did it . . . as a 'crew' . . . because one person alone couldn't have done it.[88]

At the same time, between the newspaper articles about the bust, our steady three-year stream of blog postings and the success of the *Crack the Surface* film we had produced, which documented our career together, the media had begun paying attention again. I got a cold call from the BBC World Service wanting to do a story about the Mail Rail exploration.[89] We were busier than ever but not doing much exploring, and everyone was getting demoralised. Winch wrote on his blog in September 2011:

The last month has been a drag. Various arrests and police crackdowns have nulled the wonderful spike of accomplishment we've had in the London scene, and with the squat gone, there's an 'end of an era' vibe.

Stories of terrorist alerts in the Tube and the sewers, in both London and New York, have concerned me enough to give the city substructure a wider berth than usual. Many places that we'd previously have waltzed into have been neglected, the love of these spaces tempered by what might happen in the event of serious authoritative intervention.[90]

Philosopher Henri Lefebvre has suggested that the organisation of space is never neutral, but always entangled in complex power arrangements. In contemporary urban environments, an attempt is made to code space to invoke responses that encourage economic growth, often to the detriment of all else.[91] Geographer Tim Edensor points out:

Perhaps it is in the contemporary Western city that . . . tensions are most evident, the site of an ongoing battle between regulatory regimes concerned with strategies of surveillance and aesthetic monitoring, and tacticians who transgress or confound them, who seek out or create realms of surprise, contingency, and misrule.[92]

Although one could see these tacticians, like urban explorers, as opposing dominant narratives, one could also suggest that we just create a different kind of spectacle since we can't make others feel what we felt, even if they can see some of what we saw through our photography.[93]

The nature of subversion, as well as the power of urban exploration, is in its subtlety. Like the Situationist *dérive*, the practice appears to be playful, comical, even pointless, yet it's an indication of a possibility for alternative options. Urban exploration has been described as a type of play that generates *closeness* with the city.[94] It has also been argued that

children have a greater capacity, range or perhaps attunement to the world, before social conditioning begins to slowly constrict the range of their perceived possibilities for engagement.[95] There is obviously a playful element to all these stories, a refusal to give up on childish ambition, the desire to be a real-life Goonie. But exploration of liminal space, and the patience, persistence and creative thinking it requires to hack places also multiply the possibility for affective engagement in relation to people, places and things.[96] Multiplying possibilities, and creating opportunities that are not offered, is always a political act.[97]

Children are born into a world, into a body, with a vast range and potential for affective engagement.[98] However, as the social body begins to condition the individual body, the range of affective possibility narrows according to the range of possibilities accorded by the dominant society, in this case late capitalism and its insistence that relationships and activities be profitable and serve national and economic interests, often at the expense of community and/or individual freedom.[99]

By infiltrating the material social body, the urban body, by entering the metropolitan metabolism and jittering its internal organs, undertaking pointless subversive play in the veins and arteries of the city, we create alternative pathways, little fragments of possibility.

Each fragment created becomes a slow seeping virus that causes the social body to go into spasms and fits when others view the effort and energy invested in what is *clearly* so pointless, and yet so stunningly beautiful and infectious nonetheless. The virus unleashed, when it reveals secrets that seem so incredibly unlikely (i.e., people running through Tube tunnels), is unstoppable in inspiring symptomatic mass panic and joy, registered as World Wide Web hits on our servers in the millions and vitriol in comment boxes. The interest that we receive in the practice, from writers to journalists to students to documentary film-makers, their relentless appetite for more, betrays the desire that urban exploration invokes: a desire for something more than the everyday that eclipses the practice to the point that we were in danger of being consumed by it.[100]

Urban exploration, like parkour, is a call to experience the world in a way that veers from what constitutes normative behaviour but also aligns more closely with childhood as a practice that enriches and redefines our existence, encouraging wonder and the willingness to place hope ahead of fear.[101]

The modern city is becoming more secured and controlled than ever. The here and now is the place and time for subversion. Urban exploration emerges in the midst of a cluster of growing urban interventions developed to (re)seize agency where freedoms appear to be constantly eroding,

circumscribed and surveilled, often enough in the guise of protecting our freedoms.[102] Where our explorations served as an underarticulated critique of the illusory nature of control over and security within that system, the state response, including battering down our doors, seizing our property and attempting to break up the social community we built together, forced us either to give up or become more militant, more political. And given the explorer's constant assertion of the right to personal freedom in the city, it should have been clear from the outset which way it was going to go. Rather than asking permission to be involved in the city, as Marc Explo explains, we just find our own paths to citizenship:

> **When we enter unmonitored spaces, there's no sense of accountability. Being close to infrastructure like that, there are opportunities for wrongdoing. But we don't do harm and through those decisions we actually demonstrate more responsibility than non-tresspassers.**

Urban explorers operate at the vanguard of the exchange beyond critical reflection and into the realm of practice, experimenting with creating new spaces and new ways of being in the world.[103] Explorers crack open the city and expose the joinings, interstices and points of rupture, killing themselves in the process through the necessary exposure to urban toxicity, and celebrate the monstrosities of capital that are accelerating our relationships and potentialities.

The visual, aural and sensual representations created on explorations and temporary urban occupations, created in closed, secret places, bring about new emotional caches that can be tapped into for myth-making practices; practical applications, such as sabotage in the event of authoritarian lockdown; colonisation as temporary free space, including illicit party venues; or utilisation as secure shelter.[104] Reterritorialising those spaces, filling them with imagination, was the real legacy of our work. As a result, the virtual and physical aspects of urban exploration become increasingly inseparable as one network depends on the other. Despite its weavings into the mythologies of the sublime, urban exploration is not an escape from or a transcendence of the physical, but a challenge to the very boundaries of deeply embodied substance dualisms.[105]

Urban exploration stimulates an awareness that the city is more like a sponge than a solid mass of paved streets and architecture, more like a body than a machine. Cities are spikes and sinkholes; the surface is porous. The bloodstream of the city becomes a conduit for shock and wonder in infinite doses. Because overdose is always a possibility, explorers teeter on the brink, doing their edgework, pushing the boundaries in impossible

directions, creating delicious psychological architecture. They come back again and again to the cities they love, their tolerance for exposure to the pain of the meld growing each time, the possibility for transcendence of what is *offered* increasing with each ascent and descent *taken*.

Given that our Golden Age looked like it was on the wane, we had ample time to reflect on what it had meant to be involved in these events and what they might mean for generations of future explorers. Marc, by this point my best friend, suggested that, with all the heat on in London and the LCC dissolved, perhaps it was time to look abroad again. We weren't going to let the busts keep us down. It was time to test our skills in the new world.

Chapter 6

HACKING THE NEW WORLD

'Who wants a world where the guarantee of freedom from starvation means the risk of death from boredom?'

– Raoul Vaneigem

I arrived in Motor City to find Marc passed out in a dingy motel, suffering from severe jet lag. We hired a bright red Dodge Charger (appropriately) and sped downtown, leaving the mess in London behind us. I had recently read that there were over 33,000 derelict building in Detroit.[1] The city had become a Mecca for urban explorers, provocateurs, tacticians and artists around the world in the aughts, much like Berlin in the 1990s after the wall came down and empty industrial space in the East met with cultural capital in the West. Ruination was now a large component of Detroit's

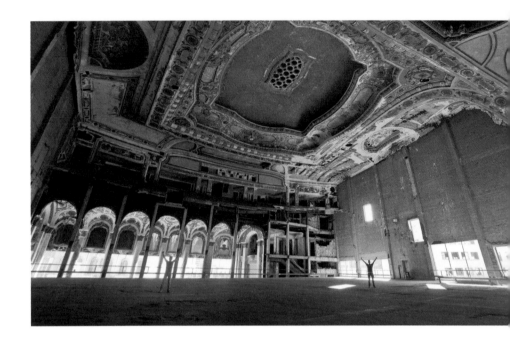

landscape after years of corporate corruption, economic destitution and mass population exodus.

Between 1947 and 1963, manufacturing jobs in Detroit fell by 134,000. By 1967, the city was caught in the grip of riots inspired by rampant arrests where African-American males were blatantly profiled and targeted. After an oil crisis in the 1970s and a growing preference for imported automobiles in the 1980s and 1990s, Detroit became economically ravaged, caught between slow consumer demand and the high wages called for by strong unions. There was also a case of 'white flight' – middle-class white professionals fleeing the city – as racial tensions heated up. The city was a case study in post-industrial abandonment. By 1950, one million people had left Detroit. When we arrived in 2011, it was a 130-square-mile city with only 700,000 residents.

Because of the transformation of our interests through our infiltrations in London and Paris, where ruin fetishists saw photographic opportunities in the suburbs of Detroit, we saw countless possibilities for scaling some of the city's most prominent rooftops, which were hopefully being more or less ignored. We did a recce downtown and, satisfied we had more than enough to tackle, headed to the suburbs to wait for nightfall.

We knocked out the derelict sites of interest on the outskirts of the city pretty rapidly, finding them satisfyingly sketchy, yet feeling increasingly guilty about these 'targets'. We wanted to see the remains of Detroit's

automotive empire; leaving the city without wandering around in the industrial ruins would have been a travesty. But every place we entered was incredibly sombre, either clearly a crack den or homeless shelter, or filled with people wielding cameras and spray cans. Everything was trashed, urban explorers were everywhere, and it was not our city. We took the pictures we wanted to take and saw the places we wanted to see, but we couldn't shake the feeling that we just weren't that interested in dereliction any more.

It was clear, as it had been during the heyday of the LCC, that our explorations were mostly about the experience, and the histories of places had largely become an afterthought. Or it was all jumbled together now in some sort of experiential quagmire that never quite satisfied us in the way it once had. It's part of the inevitable fragmentation of being involved in this practice on a more-than-casual basis. Some of us had moved on to become graffiti artists, squatters or professional photographers. Others had settled down or quietly slipped away. In any case, I don't think any of us could abide the hunger for derelict places for more than a few years; it had to evolve into something with a bit more gravitas. Marc and I drove back to the centre of town as the lights went out in the territory.

At 2 a.m., we climbed on top of an Italian restaurant and squeezed through an open window to ascend the thirty-five-storey Broderick Tower.

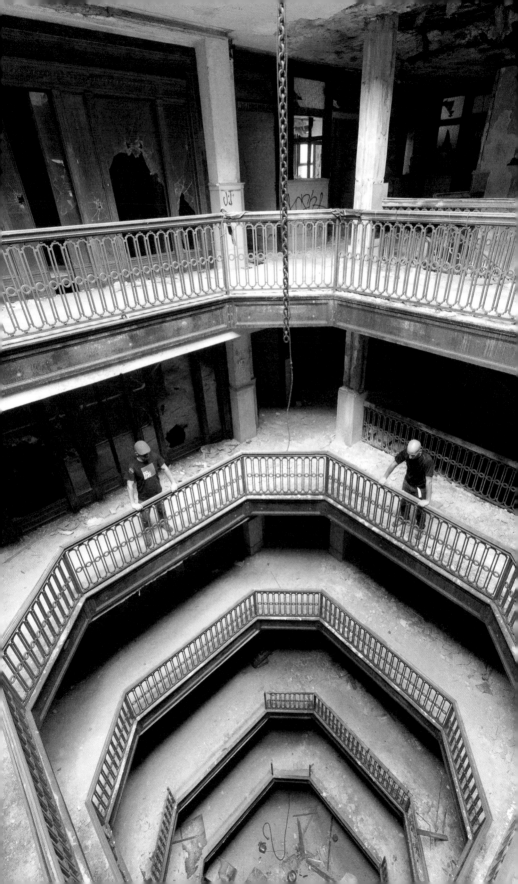

The views were stunning and gave us a new sense of the city as a light, bright, vibrant, beautiful place, in contrast to all the dereliction we had seen that day. Downtown Detroit remained full of life, events, politically active citizens, great places to go out and a plethora of sites ripe for infiltration that were largely ignored by the tight-jeaned, camera-toting dereliction enthusiasts and local explorers alike. These fetishists had failed to get over their adoration for peeling wallpaper in their efforts to replicate the work of Yves Marchand and Romain Meffre, the two most celebrated of Detroit's ruin photographers.[2] We returned to our car satisfied and drove to Michigan Central station, the city's most notable massive derelict icon – not to photograph it, but to roll out our sleeping bags for the night.

As images of decay had become culturally ubiquitous in this city, social backlash had set in. In the decade before we arrived, Detroit had become the epicentre for disputes around the meaning of the urban explorer's images of decay, ruin and dereliction.[3] John Patrick Leary, a scholar of American literature at Michigan State University, pinpointed what he saw as the problem:

> **Ruin photography and ruin film aestheticizes poverty without inquiring of its origins, dramatizes spaces but never seeks out the people that inhabit and transform them, and romanticizes isolated acts of resistance without acknowledging the massive political and social forces aligned against the real transformation, and not just stubborn survival, of the city.[4]**

Part of the concern over the sharp, vibrant, long-exposure photography modern explorers produce is that the pictures are highly stylised, often re-shot dozens of times to 'perfect' them, and look uncomfortably similar to traditional photos of colonial explorers, evoking images of white men sticking flags in soil.[5] Geographer Kathryn Yosoff, writing about polar explorers, notes that 'the "hero shot" is the most extreme example of this in the pornography of explorers' posing and posturing, where the masculine is being built through the pitching of man against, and mastering, the landscape'.[6] But urban explorers are of course aware of that legacy, as we all are, even unconsciously, since the aesthetic has become so culturally coded. What explorers are doing then is both using and re-channelling older aesthetic categories in conjunction with new spaces and technologies to undermine not just the 'security state', but the very lineage embedded in the photo aesthetic – another way of tangling the spectacle in the meld.[7]

Leary is primarily referring to the aesthetic form of the imagery produced from explorations, dissected from the work the image represents or inspires,

the danger being that the isolated, decontextualised images remain a distanced abstraction rather than a process by which the explorers participate in their contributions to the creation of new worlds through their imagery.[8] Leary writes:

> **The ironic appeal of modern ruins lies in the archaeological fantasy of discovery combined with the banality of what is discovered – a nineteen-eighties dentist's office is not implicitly fascinating for anyone who inhabited one in its intact state.[9]**

The solution to the dilemma Leary proposes is that expert control over the 'true' history needs to be established in order to clear out the messy mythologising and misplaced nostalgia. In both cases, effort is being made to pull agency away from the local, popular historian, who may indeed 'get it wrong' or who may wish to care for something of tenuous archaeological, historical or cultural value. These are valid concerns that deserve to be addressed, though it's important that they are counterweighted by giving agency to people who care for places, allowing them to wrap themselves in whatever gives them a sense of place and community.

In regard to the imagery explorers produce, the more troubling aspect, and what Leary never addresses in his manifesto against ruin porn, is the degree to which explorers are taking 'ownership' over sites through their imagery. However, regardless of their motivations, the images explorers produce are about relaying a process of creative encounter that is doing work that moves beside and beyond a simple reading of place, without disrespecting or precluding 'other' readings. So a single image may relay a sense of ownership over a place, a desire to complicate a clean narrative, a longing to capture the aesthetic of decay, as well as a haptic 'reaching out' to an audience.[10] Photography is never merely a mechanical reproduction of a scene within a frame; it is an interpretation of the world.[11]

Marc and I next drove to Chicago where, as in Detroit, we knew no local explorers and, in contrast to Detroit, had few location leads. The city was a slimy glimmer as Marc and I sped in, sleep-deprived, stinky and buzzing from days hurtling down I-94.

We had been hearing rumours from US explorers of an extensive tunnel system in Chicago which London's Mail Rail was modelled on, where an apparently schizophrenic urban explorer called Dr. Chaos had hidden cyanide stolen from the University of Chicago back in the early aughts. It was ostensibly accessible through manhole covers, gated up underground with steel doors that had pins we could pop out with a hammer and screwdriver. So we figured: next stop, Home Depot; we're going underground.

However, those tunnels proved to be more of a challenge than we expected, both because they were difficult to locate using our outdated map (from a 1994 Ninjalicious Infiltration zine)[12] and because Chicago is busy and – unlike London, where people will ignore you doing something naughty, or Paris, where people will ask to come with you – in Chicago people will actually stop in the street at 2 a.m. and ask you why you are prying open a manhole and who you work for. You've got to love nosey Americans! We decided we might have more success in the skyscrapers of the Windy City, given our limited timeframe.

We first hit the Chicago Hilton, where we had been advised by explorers in Minneapolis that the doors from the elevator control rooms to the roof were poppable with a credit card. Within minutes of arriving downtown, we were up the fire escape and on the roof. But the Hilton's rooftop, sexy as it was, left us unsatiated, since it put us eye-level with the torsos of taller buildings. We looked higher and noticed a thunderstorm of epic proportions was coming to meet us. We were going to have to hurry if we wanted to climb the best the Midwest had to offer, because the next day we were meeting up with other explorers rolling in from various cities, and we figured our group would then be too large to undertake any elaborate infiltrations.

The forty-storey Ritz-Carlton Residences had bulbous 360-degree inverted black dome cameras swivelling around, gawping at the piddly four-foot fence surrounding the site. By the time we were standing across the street from it, the rain was coming in from five sides, threatening to breach our bags and assault our fragile cameras. I looked at Marc. He nodded. We ran across the street and gave the camera the finger as we ninja'd the scaffolding and ducked inside.

The main stairwell was easy to find, but the third floor revealed a fat man in a bright vest reading *Maxim* at a desk, facing the wrong way to actually perform the job he was being paid for. We left him to it and hit the crane to bypass an extra layer of third-floor-stair 'security': a plywood plank with a padlock on it. As soon as we swung out onto the crane, we got hammered by the rain again. The thunderstorm had intensified into a full-fledged sensory cacophony, complete with blue forked lighting strikes jabbing in dangerous proximity as our shadowy figures scaled the steel cage towards the clouds.

A few floors up, back off the crane and past the plywood stair barrier, we slunk back to the concrete steps and climbed. After the twentieth floor, it was sheer adrenaline, fear and unquenchable anticipation that kept our legs moving. Add to that the fact that I had somehow broken a rib, we were primarily living off trail mix and fast food and had woken up fourteen

hours earlier in sleeping bags on a misty beach in Gary, Indiana, and you start to get an idea of what we are up against.

Then we heard them: sirens. Everywhere. They converged on our location and the blood drained from Marc's face. Without a blink, he cinched his pack straps, said, 'If I'm getting busted, I'm getting busted on top,' and resumed climbing. We hit the stairs with renewed vigour, every turn cranking up the heat, the angst, the fervour. By the time we got the top, I was locked in a thoroughly embodied stair wobble, my legs only moving in the rhythm they'd become accustomed to over the past ten minutes. My thighs pulsated involuntarily, feeling like they'd been skewered and stuck over a campfire.

Dripping, panting and wrecked, we walked outside on floor forty to a nightmare of epic proportions. The architecture was in the midst of supra-environmental contractions. Rain was cutting through the building sideways, rattling the makeshift suspension system holding the whole thing together. I was terrified that the air ducts, which appeared to be zip-tied to the incomplete ceiling of the top floor, were going to come down on us.

I turned around and was shocked to find Marc was standing on an incomplete ledge, being pummelled by the rain, trying to get a ten-second exposure, defying everything that was happening around us.

And then the rain stopped. And the sirens stopped. We looked over the edge and there was nobody at street level but methamphetamine-addled cab drivers, lost tourists and drunk dudes in loosened ties cruising the Magnificent Mile. It turned out that the sirens had nothing to do with us.

The photos we took that night, of my favourite American city bathed in black cloud and blue light, standing on ledges with lighting strikes crawling down from the clouds into Lake Michigan, the storm slowly creeping away, captured the most beautiful moments we had seen yet in North America. It was an opportunity we easily could have missed if not for our earlier failure, our limited time in the city and our brazenness in the face of a serious Midwestern summer storm.

Cameras repacked, we jogged back down forty floors, bought a beer and popped a hatch in the middle of one of the Chicago River bridges, toasting other explorers who had just finished climbing bridges in New York and were headed to meet us and the Minneapolis crew for an international explorer gathering of epic proportions. Meanwhile, the monsoon renewed itself.

The next day we headed to my family in Elgin, Illinois, had our first hot meal in a week, and slept like dead men.

Though the photos from the top of the Ritz-Carlton are stunning,[13] without the physical drama of getting up there, and without Marc and his

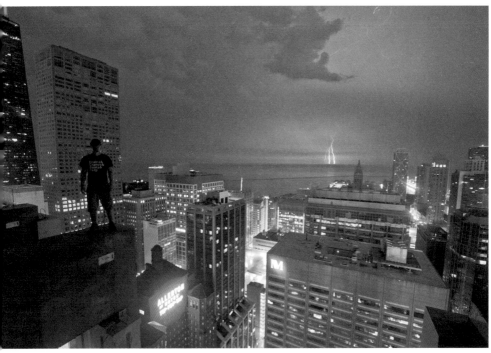

penchant for 'Action!' the frame would be as empty as if it had been snapped in a McDonald's. Explorers share Lefebvre's belief that change can only happen through action in place; activism must be embodied.[14]

Discussions of embodiment frequently incorporate enticing phenomeno-logical discourse, often referencing philosopher Merleau-Ponty's book *The Phenomenology of Perception*. In that text, Merleau-Ponty makes an impassioned argument for the foregrounding of embodied experience, exhorting readers to 'plunge into action'.[15] However, one cannot do this without having some kind of impact on a place, forcing the meld to occur.

It would be easy to see the meld as a temporary fusion of body with city. And in some ways, it is. However, the meld is more process than result; it is a reaching, a branching out, that is in fact always becoming.

The city is never solid; it's always pockmarked with opportunities. The meld does not then rework the city in the image of the explorer as much as it creates new junctions, chains, movements and sensuous dispositions through each exploit. The meld is the city, the human, the camera – living, breathing, working and dying together, inseparable, distinctly communal, tribal. It is the opening of that moment, rather than the space itself, that is, in a sense, 'surreal'. The image that pops into my head, whenever I think of the meld, is from the Ritz-Carlton, standing on that ledge. It is a photo that perfectly relays a moment unfolding.

The next day in Chicago, we met with the crew from Minneapolis/St Paul (MSP) including Chuck, Laura, DJ Craig, Babushka and Alex Printz. The MSP crew is one of the world's largest, and most well-respected urban exploration collectives. Witek, one of Canada's best-known explorers and freight hoppers, also arrived, along with Tyrone from London and Adam from Montreal. The three of them had just left New York City, where they had thoroughly hustled the city's infrastructure. We had a team of ten explorers from four different countries, and we wanted to hit some rooftops on a beautiful sunny Chicago afternoon.

First, Marc and I took everyone back to the rooftop of the Hilton. It proved to be pretty easy to get everyone on top, and once there, we all lay on the hot, squishy tar surface, looking up at taller buildings. One, which looked to be twice the height of the one we were lying on, was covered in mirrored panels. Marc pointed up at it and said, 'What the fuck is *that*? I want to go there.'

What Marc was pointing at was the seventy-two-storey Legacy Tower, a complex of luxury high-rise apartments. As it was a live building, the only way we were going to get in was through international explorer teamwork and a bit of social engineering.

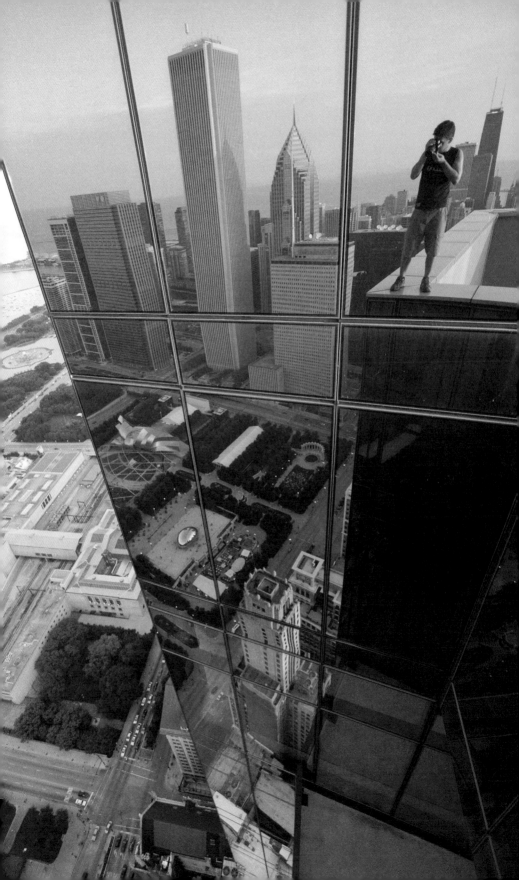

Alex and Laura walked in first and pulled aside the security guards with an errant question, while the other eight of us followed a resident to the lifts, heavily engaged in conversation. We carried on talking as the resident swiped her keycard, then we squeezed into the lift with her. Somebody punched the button for the seventy-first storey and we all went quiet as the resident looked us over. Then we all started laughing and dropped her off on floor forty-four with a wave. After going through the workers' area and lift control rooms, we found that the handle on the locked door to the roof had been installed backwards and could be popped with a credit card. This kind of action pushed at the edge of the UE code of ethics, but no one from the MSP crew batted an eyelid as it got carded open.

On the roof, we decided to wait for sunset so we could watch the city light up from 250 metres. As dusk took hold, with eight of us perched on the ledge, my heart bloomed. It was a spectacular sunset, but I couldn't help feeling guilty that Alex and Laura had missed it. They had sacrificed their personal enjoyment for the benefit of the group.

In our most successful infiltrations of the London Underground, we often had somebody 'on top' to keep an eye on our access point, ferry

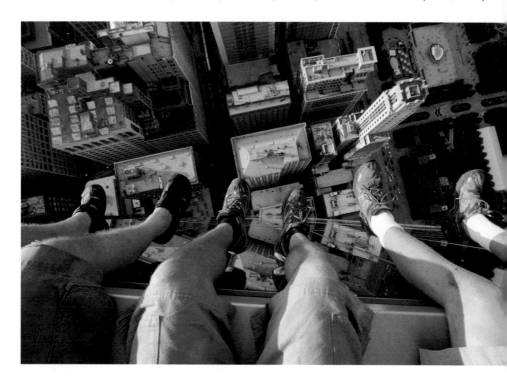

ropes and distract civilians. Both Popov and Dicky had played that important role on major missions. This is an essential part of any successful infiltration crew, and it works well in collaboration. It was good to see we weren't alone in using those skills.

Two days later, I woke up in the basement of Alex's house surrounded by a massive pile of drippy waders, clutching an empty glass which had been full of John and Becca's heavenly homebrew ale the night before. I scratched my head and a host of sand particles dislodged themselves and sprinkled the glass and my sleeping bag. My eyes burned. Witek was drooling on a pillow next to me, dreaming of train engines no doubt, and Marc, as usual, was naked in his sleeping bag, snoring like a baby. I stumbled upstairs to find Mario on the phone, editing maps and listening to heaving dubstep.

After everyone woke up, we slowly made our way over to Chuck's. Her house was full of even more explorers, including Moses Gates, who'd flown in from New York for a yearly party called Spandex. We had finally

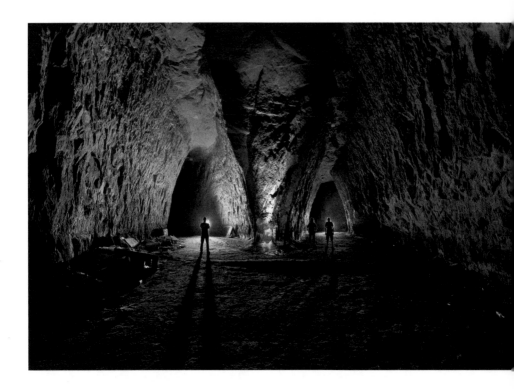

made it to MSP. Now it was time to get busy – the crew had assured us that they were going to put us to work, and Marc wanted to dig.

Minneapolis has some interesting geology. Underneath a bed of limestone, the city is essentially underlaid almost entirely by hard-packed white sandstone that is incredibly easy to excavate. In fact, you can dig it out with your fingers, though handsaws are more effective. In the nineteenth century, while workers were breaking their backs building 'cut and cover' tunnels in London, beneath the cities of Minneapolis and Saint Paul, tunnels could be excavated with ease. Phone systems, sewers, water and gas lines all got buried, each system with its own distinct architectural style.

As a result, a mottled system of tunnels reaches at least five stories deep, stretching for miles and connecting to natural cave systems, some of which were 'sealed' by authorities in the 1960s and 1970s because they were so often used to host illegal parties. We threw a party in one of those caves that the MSP explorers of 1968 would have been proud of, exiting via the sewers through a secret removable panel in the brickwork. The multitude of subterranean features like this led geologist Greg Brick to call MSP a

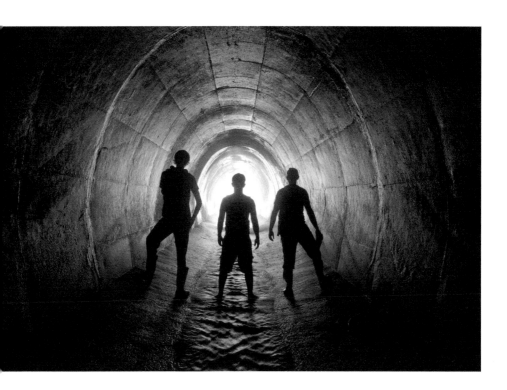

'Swiss-cheese city. And unlike London, these systems are almost always connected to each other in various places, usually illegally.'[16]

These systems were of great interest to the Action Squad, an urban exploration collective organised by Max Action in 1996.[17] As the LCC had in London, the Action Squad had started in MSP's ruins, then moved on to drains, the tightly secured steam tunnel system under the city called 'the Quarry', and then digging out 'sealed' caves. Eventually the media got hold of the stories of the Action Squad. Then an explorer drowned in a drain. The crew ended up fragmenting, with some spending years fighting legal battles and others going metaphorically underground, imposing a media ban and taking down all their blogs. However, as we found, despite not being much talked about online, the subterranean Twin Cities were more active than ever in 2011.

Explorers in MSP constantly rework the city to suit their goals. This can mean anything from clearing a path in order to have a party in a drain to digging tunnels dozens of metres long through the soft sandstone underlying the city to open routes into new cave systems. They work on rotas. Although the LCC was never anywhere near that organised, both of our

crews clearly had the same taste for adventure as we found in Chicago. We all knew that the reason we continued to explore had as much to do with sharing a belief about what kind of world we wanted to live in as it was about finding new places. However, we couldn't overlook the fact that the MSP crew was consistently making incredible discoveries. Their level of organisation, time and effort invested and sheer brilliance of group efforts and accomplishment were unparalleled.

Walking next to a river on a towpath as a cyclist went by, Alex suddenly said, 'This way!' and scrambled up a slope. Six of us followed. He took us to a hole in the side of a cliff, where we descended using a rope tied to a tree. Inside, an extensive cave system stretched for hundred of metres in every direction. We walked much of it, lighting off fireworks in some large chambers, eventually arriving in a small offshoot tunnel filled with buckets, saws, sledges and lanterns. Alex turned to us and said, 'Welcome to the Baby Bottle Dig.'

What they were doing was insane. They had found old maps showing a cave that had been sealed in the 1970s, figured out which known cave was closest to it and started digging a tunnel generally in the right direction. The problem, as Slim Jim pointed out, was that 'these maps are two-dimensional, and we don't have a z-axis, so, you know, we could just come through the ceiling of the cave.'

Alex and Laura showed us how to dig properly, and before we knew it we had an assembly line going: the person digging 'point' pushed dirt out to the people widening walls, who put it in buckets and gave it to the people on break eating pizza and drinking Samuel Adams, where eventually it was dumped in sledges, which got dragged outside. We dug for six hours in frenzied rotation. Alex reckoned we might have gone forward a metre.

Just as the hacker ethic cannot be simplistically reified, categorised or bounded, neither can explorers themselves. While universally shared motivations behind exploration exist, such as friendship or geography, it is impossible to define a coordinated explorer ethos; individuals simply follow their desires and do their own edgework. In MSP, a lot of the edgework was about working the 'point' of a tunnel being dug where it's most likely to collapse and suffocate you in sand.

Two of the most daring MSP explorers we encountered were the infamous Futtslutts: Thelma and Towanda. These two didn't explore by anybody's rules, and they were two of the most accomplished and daring explorers anywhere. In the sewers of Minneapolis, their courage incited Marc and me to charge headlong into a tiny stoop filled with raw black sewage like molasses, packed with cobwebs and little white subterranean spiders, which we fended off with nothing more than a stick and a bottle

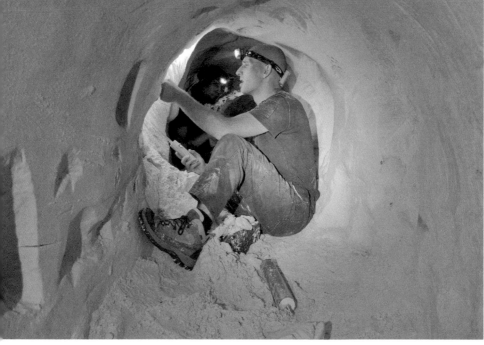

of Andre champagne until the fumes almost took us down. It was a hot meld moment. We found nothing in the tunnel, but through the Futtslutts' radically impractical assault on that den of faeces, another passageway was crossed off the list, which was a celebrated accomplishment.

A lot of the success in MSP came from specialisation. Where the Futt-slutts might form a frontline assault, Alex was behind the scenes drawing up plans, Laura was walking into places in office attire and opening them with ease through the Trojan Horse gambit, Slim Jim was mapping every inch of the process with exacting detail and Chuck was the glue holding it all together. Fulfilment of individual desire fed into group accomplishment.

Urban exploration is often perceived as a relatively solitary activity, something that we accomplish in small groups on the back of research, scoping, surveillance and execution. But, in reality, the urban exploration crews that get the most high-profile locations cracked are the ones that operate not on an ethic of one-upmanship but as a tight-knit group. The Cave Clan learned this a long time ago, and QX, Dsankt and Sergeant Marshall proved it again when they demolished the Paris Metro as a loose infiltration collective. And while it's true that the UK 'scene' was, as Bacchus said, 'all fucked up and weirdly political', the LCC was one of the tightest-knit groups in the city's history, much like the MSP crew, which was a major factor in our success.

However, there is also a downside to a strong group dynamic, as both the LCC and the Action Squad had found. Often a group of people working together to accomplish goals is seen to be a more menacing proposition by authorities, and as a result, their activities are misconstrued as conspi-rational. In MSP, the Action Squad soon became a target for authorities who saw their punk ethos as a threat to the social order, rather than a playful, creative practice. This concern was one of the main objections to the formation and assertion of the LCC as a defined entity in the UK.

Our objective in London of increasingly trying to work social angles as a group, even after the LCC was all but dissolved, was partially inspired by what we saw in MSP. Exploration is about doing exceptional things that challenge and provoke you day after day with a community of close friends. It's not just the places or the process of exploration that makes this worth doing – it's the friendships behind it. We, like the crew in MSP, undertook the research to find out what had been lost to time, and then we went out into the world and found it.

As much fun as we had in MSP, our plans for the trip were to carry on to the West Coast, with one more stop along the way. So Marc, Witek, Tyrone and I hopped on a plane and headed to Vegas where we met up with Emily.

Las Vegas: the American refuge for unscrupulous indulgence, carnal satisfaction and unrestrained capitalism. We often think of the city as a place of luxury, entertainment and freedom, but the libertarian ethos in the middle of the Mojave Desert that has sparked one of the most spectacular free-market systems in the world has an astonishing downside – many people get crushed under the relentless pursuit of cash. There are over 14,000 homeless people in a city of 580,000.[18]

Journalist Matthew O'Brien, author of the book *Beneath the Neon: Life and Death in the Tunnels of Las Vegas*, spent two years interviewing homeless people living in the 350 miles of storm drains under the city as he explored the entirety of the system.[19] Many of these people moved to Vegas with intentions of striking it big in some sort of Mark Twain–inspired hallucination. Matthew ran into more than one person who had blown their life savings on a single hand of cards, lost it all and ended up taking shelter in concrete boxes under the city.

Of course, in a city founded on conservative principles and filled with wealthy landowners, real estate moguls and casino pit-bosses, sympathy for people in unfortunate circumstances is in pretty short supply. No one wants to acknowledge the human casualties of a city that trades on excess,

and those casualties are often literal. Vegas, perched in a flat, hard-packed ancient river valley that is now bone dry most of the year, turns into a place of apocalyptic, terrifying flooding on the rare occasions when it does rain. When this happens, the drains fill to the brim, sweeping away both people and possessions.

O'Brien now runs a non-profit organisation called Shine a Light, devoted to helping the homeless community in the tunnels.[20] Urban explorer Steve Duncan, along with National Public Radio, has done similar work exposing difficult living conditions in the occupied abandoned train tunnels of New York.[21]

Yet these altruistic projects are anomalies and pose a challenge to the urban exploration community: at what point does our exploration cease to be simply an adventure in creative practice and begin to negatively impact those who are less fortunate than us? Is urban exploration truly a victimless crime if we disturb people while exploring? And, perhaps more importantly, at what point might we begin, as Matthew and Steve have,

to move past urban exploration and begin working for the rights of others? Do explorers actually care about that, or just about ticking explored locations off our lists? These were questions we asked ourselves as we delved into the Las Vegas Undercity.

One evening, Marc, Witek, Tyrone, Emily and I parked our truck outside an obvious drain entrance near the Rio Hotel. Under the cheery gaze of Penn and Teller looking down from a massive billboard, we walked down an embankment and into a subterranean storm drain channel under the hotel. No fence-hopping or manhole popping was necessary – in the American West, the individual is responsible for his or her own actions.

A week earlier I had met a guy camped out not far inside the entrance of this tunnel who told me that, if I were going any further, I'd better have a weapon or a few more people with me. Now I called out for him, but got no response. We tiptoed through his living room, which comprised a bed sheet hanging from a ladder rung, wrapped over a couch and placed on plastic milk crates – like a kid's fort. I felt a strong desire to go through the man's things and wondered if the others did too, not that any of us would ever do so.

We walked farther on, and the pipe soon became uniform and unadorned, a simple concrete tube. We followed it for some time before stumbling into what looked like a subterranean graffiti gallery. I climbed a ladder, looked through a grill and realised we were under a construction yard behind Caesar's Palace.

Carrying on, we emerged from the drain into a wide flooded area where an alarm suddenly shrieked. We all ran until the flooded area connected to a parking garage, and then, miraculously, we emerged in the valet parking area for Caesar's Palace, feeling entirely out of place with head-torches on.

The next day, in a different drain, a homeless guy told us, 'Only dumb motherfuckers set off that alarm under Caesar's.' Touché.

It became obvious through our encounters with various people that many were in the drains by choice. They had chosen to stop contributing to the system, chosen to gamble their lives away, chosen meth or heroin over family and stability, and chosen the freedom and danger of living off the grid, scamming tourists and casinos by silver-mining (hunting machines for leftover credits) rather than working a minimum-wage job. They chose to get high in drains until the scorching desert days cooled off, and then crawled out, delighted to run around this desiccated plasticland for another night. In short, it seemed that many people wanted this life in the Las Vegas Undercity. Maybe our pity or guilt as explorers interested in the drains for different reasons was wrongly placed.

Harold, one of the drain dwellers O'Brien encountered during his explorations, told him that moving into the drains was an economic choice: he was saving cash by living for free in drains that were built with tax money he didn't pay into. I couldn't help but wonder if Harold knew something we didn't. Maybe he was braver than us; maybe this was a deeper form of the meld. Maybe homelessness is preferable to the mental vacancy most people inhabit at work every day. The Situationists thought that where material poverty had been eradicated, the biggest threat to life was boredom. Maybe Harold had figured that out and just decided to subvert that whole nightmare before he got there.

The Paris catacombs are perhaps the best European equivalent of what we were encountering in Vegas. In the quarries, humanity has become intricately interwoven into the informal subterranean urban matrix.[22] A symbiotic relationship has been built over nine centuries, during which the populace hacked the closed system open again and again, leading to a consistent rediscovery of a place now layered so thick with history and culture, you can practically taste it in the soil. Cataphiles often do while digging things out.

There was a bizarre political circle being closed in front of us, standing in a Las Vegas storm drain. While in socialist systems people see infra-structural space as belonging to the people, in hyper-capitalist systems these spaces become the last refuge of those who have been crushed under the system. Perhaps it's more often in the middle of that democratic political spectrum where those spaces are completely 'closed', with even the acknowledgment of their existence on some level forbidden.[23]

I kept wondering why, in London and Paris, people *don't* live in ruins and infrastructure. Perhaps it's a fundamental difference in those cities' economic distribution, social programmes or access to charity. Or maybe it's just a matter of pride or social conformity. In any case, the Las Vegas Undercity, the only underground feature of Las Vegas that might interest the intrepid urban explorer, is also, consequently, the true face of a city built on nothing but wealth and decadence, a unique spatial specimen. I suppose, in that light, maybe all visitors should see the Vegas drains; maybe then they would understand the true cost of this wonderland. I'm pretty sure that what we saw is a good indication of what an unfettered free market yields: a catastrophic class divide.

While in Vegas, I chatted with an explorer called Aurelie Curie, who told me she had taken a stroll through the defunct Sahara Casino a few days before. The Sahara, opened in 1952, had shut its doors and was going through a liquidation sale. Aurelie had walked into the sale, wandered though a closed door, taken the stairs to the top and found herself with the full run of a derelict Las Vegas casino. This sounded like a great plan!

We went there soon after and found our way into the old buffet, the kitchens and the stage, where we played with sound equipment and climbed up onto the catwalk.

But the real interest in the Sahara was not the casino, it was the roof. From there we could do a recce on the only mothballed skyscraper in Las Vegas, Fontainebleau. This $2.9 billion, sixty-eight-storey unfinished development was supposed to include almost four thousand rooms. That's a lot of places to hide! The problem was that, to get up there, it looked like we were going to have to dodge security like none we had ever seen.

First we needed to get over the fence on Las Vegas Boulevard, which, unlike most cites, is often busier at 2 a.m. than 2 p.m. Next we had to cross no man's land, an open expanse where three petrol-powered all-terrain vehicles (ATVs) were doing constant sweeps. We could also see about a dozen other guards walking around the site. There were unknown factors: there might be security in the building we couldn't see; we might encounter motion sensors; even the stairwells might be alarmed.

Only one way to find out.

We sat at a small bus stop outside the site at 3 a.m. When traffic on Las Vegas Boulevard lightened up, we pulled ourselves over the fence, using the bus stop as cover from passing traffic. Once on the other side, we saw that two of the ATVs were parked at either end of no man's land, and there was no way across without being seen. However, we'd clocked their patrols from the top of the Sahara and, right on time, they started driving around the base of the skyscraper. As soon as they passed, we scampered into the building.

Inside, we found a stairwell quickly and made our way up ten floors. Then, taking no chances, we exited onto the tenth floor, a stretch of concrete filled with equipment, buckets and dangling wires, and made our way to the second stairwell (there are always at least two in a large building), in case we had been seen going up the first.

Forty minutes later, we were on the sixty-eighth floor. And we had a big problem: the temporary wooden door to the roof had a massive padlock on it.

We tried to squeeze through an unfinished corner to get around it, but we couldn't get our chests through. We walked back towards the other stairwell on floor sixty-eight – and then an air horn shattered the night. In the desert silence, it was the loudest thing imaginable. We dashed behind pillars as three security guards emerged from a lift. The one taking the lead was wearing a straight-billed baseball cap, had a soul patch and was holding a huge fluorescent green can of energy drink. He walked to the middle of the floor and announced, 'You're not even hidden, bro. Just come out from behind the pillar.'

We emerged with our hands outstretched, and there was a modern Old West standoff. On one side, a team of explorers dressed in black with head-torches on, and on the other, three security guards in high-vis gear. Everyone was on alert.

Then the guy with the energy drink said, 'Are you jumpers?'

We looked at him in confusion.

'BASE jumpers, dudes! What's in the backpacks?'

Finally I spoke up. 'Um, no, we're urban explorers. We just wanted to take some photos.'

His eyebrows raised and he said, 'Oh, shit. That's cool, I thought you were jumpers. Come on, I'll take you up.'

The other security guards looked annoyed as he walked us to the service lift, swiped his keycard and we all got in. He introduced himself as Tom, head of security for Fontainebleau.

As we sat on the roof with Tom taking photos, we told him tales of our explorations, and Marc explained that he'd basically come all the way from

France to climb this building. Tom was honoured and told us, 'You guys were fucking hard to catch! We had a guy in the third-storey window with binoculars who saw you come over and get past the ATVs, but when you switched stairwells, you really threw us off. We thought the only chance was to head you off at the roof.'

After about an hour, Tom told us his shift was ending and we had to go. He took us down in the lift and drove us to the front gates, waving us off with memory cards full of photos and one last request: 'If anyone asks, just tell them you got away with it!'

The United States has a reputation for being violent and somewhat authoritarian. We thought this would especially be the case in Las Vegas, where security is big business. However, Tom taught us that a single person with common sense can make all the difference. It's a shame that in London the BTP seemed determined to and make explorers' lives as difficult as possible for simply being curious and wanting a little adventure.

We stopped back by Fontainebleu the next day with a bag full of energy drinks and a note for Tom that said, 'Thanks for being so cool about things. We'll be back to test your security again next year.' And with that, after a few weeks of Las Vegas desert drainage systems, derelict casinos and stalled-out skyscrapers, we were on the I-15 towards Los Angeles.

On the long drive through the desert, we discussed different forms of policing spaces and came to the conclusion that the UK is in many ways far more authoritarian and violent than the United States; it's just hidden behind a veneer of British reserve and a general willingness to accept the status quo.

Not all our explorations were entirely benign. However, the inconvenience caused by a few people sneaking into the sewers, tunnels and construction sites of cities, even if a lock is picked or an alarm temporarily disabled, is negligible. Urban explorers do no more damage than, for instance, skateboarders 'waxing' a curb or a street artist stencilling characters onto sterile walls; and the rewards, in the form of an imaginative, desirous citizenry, searching for places where unusual things can happen, are well worth the trade-offs if we are truly interested in cultivating creative cities.[24]

I think Tom probably did similar mental calculations when he understood what we were doing at Fontainebleu. We also (unwittingly) helped him find the weak point in his security. It was a win/win. This was a sharp contrast to the situation in London, where the police, explorers and taxpayers are all suffering as a result of the endless investigations and targeting of urban subversionists. Even the judges and juries find the whole thing ludicrous. The only people who seem to benefit from the quagmire are lawyers.

Explorers, like 'white hat' computer hackers, assist in strengthening security by exposing systems' weaknesses through benign exploration, before a group or individual with more malicious intentions does the same.* It's clear from the reactions of authorities we encountered through our explorations that the 'problem' with what explorers do is not that it is illegal but that, in capitalist terms, it's pointless and therefore highly suspect, or that it embarrasses the forces of security, order and control. However, while neoliberal agents may be confused or frustrated by urban exploration, it is much more a celebration than a condemnation of capital and spectacle. It's an anti-spectacle that runs alongside the main act, weaving a double helix. Perhaps in the United States people are more understanding of someone having the gall to play by their own rules.

Capital investment is the catalyst both for sensibly sterile spaces of economic production and for spatial fluidity (some would say forced mobility), as well as leftover, forgotten and (often unintentionally) disused spaces. Both types of sites are the inevitable result of endless 'development' and the inexorable quest to increase profit margins, bottom lines and shareholder value.[25]

Explorers understand the role monetary investment plays in creating both new constructions and ruins, and, where preceding movements connected to my notion of place hacking might condemn capitalism for creating sterile space and seek to turn streets into battlefields in an effort to overthrow the dominant social order,[26] urban explorers celebrate capitalism for both its successes and its failures, rejoicing over the construction of new skyscrapers as well as the economic crises that empty them. Both construction and destruction, intertwined forces, are spaces of opportunity, open to the usufruct hack any time, any day.

I was anxious to get to California to see how what I had learned in the past few years had changed my relationship to the place where I grew up. I also hadn't seen my family in a very long time, focused as I was on dashing through Tube stations in London and sleeping in derps in Europe.

We breezed through Primm, Nevada; past Baker, California; and into the high desert of the Golden State. We stopped in Yermo to build a massive fire in the Mojave, climb around in some old colemanite mines at Calico

* 'Black hat', 'grey hat' and 'white hat' are terms borrowed from computer hacking, applied to place hackers. Black-hat hackers may cause damage to gain access to places and have little regard for the 'community', white-hat hackers may work with security to fix their security flaws, with grey hats somewhere in between.

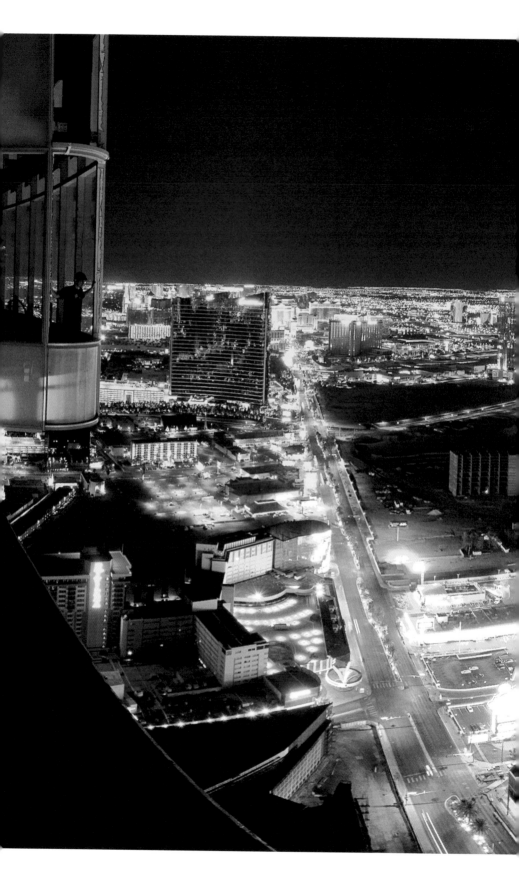

Ghost Town, and shoot bottles with an AR-15 rifle that kept jamming, the banana clip loaded with cheap ammo from Wal-Mart.

I'd spent a large chunk of my teenage years driving around in the desert and sleeping next to open bonfires under the stars. Since California coastal cities are where most of the 38-million-person population is, many forget that 25 percent of the state is desert. One of the unique features of the landscape is that it's a relatively arid environment. Without water, rust can't form, and things don't decay very quickly. As a result, the Mojave is a great place to store broken-down equipment and electronics. We found out that there was a massive boneyard filled with hundreds of 'retired' planes, beautifully preserved in the dry Mojave air 100 miles from LA. We wanted desperately to get in there and look around.

The problem was that the boneyard was connected to an active military base. We needed a creative solution to this problem, or we were more likely to end up in a military prison than a 747 Jumbo Jet. So we laid maps out on the truck bonnet and pinned down the corners with cans of Tecate, committing the layout of the perimeter fence and surrounding desert to memory.

The next day, we arrived outside Victorville, California. We rolled up to the perimeter fence around George Air Force Base (the Southern California

Logistics Airport) and spotted a security truck. We tailed them, staying far enough back not to be noticed but keeping them in view. Tyrone and Witek sat on the tailgate looking for holes in the perimeter fence or a place where soil erosion had left an opening underneath.

Unfortunately, it was not only sealed tight, but the fence appeared to have been buried more than a few feet underground. The barbed wire was also well maintained. Everybody agreed that the security here was intimidating. But every system has a weak point, and we finally found it: a fence corner where you could use the barbed-wire supports to pull yourself over. It was far from easy, but it would work. Luckily, the military security patrol didn't spot us, and we were able to crack their security routine as well: two rounds per hour at twenty and forty minutes past the hour. We went to a twenty-four-hour Denny's and waited until 2 a.m.

The problem with exploring in the desert is, firstly, that you have to drive there and, secondly, that you have to park your empty rig in a blatantly obvious place, given that there are no trees or other cover to speak of.* It was ironic, given our experiences in London, that our biggest problem here was a lack of walls and buildings to hide behind. More often than not, the security architecture of the city is what makes it easier to explore. The most unassailable security is actually an open field and a tweeker with a dog.

The only inhabited space within ten miles was the military base itself and we really didn't like the idea of having our truck found while we were in the boneyard. We decided to park in a burnt-out methamphetamine lab roughly two miles from the access point – essentially just jamming the truck between two building husks and praying for the best. Then we set off across the desert on foot with our camera gear.

As we neared the gate, security was doing its patrol, right on time. We saw the headlights and crouched behind some knee-high sage bushes, scooting around the bush as they went past, like a Scooby-Doo caricature. When they had gone, we ran like hell to the fence, threw some borrowed bathroom towels over the barbed wire and clambered over. On the other side, we ran for the first plane we saw, a massive British Airways 747. The truck keys worked to pop the hatch behind the landing gear, and up we went. Inside, the plane was sticky and hot, but intact. The windows were blacked-out, but we sat at the controls anyways, wrenching back the flight stick with yells of 'Buckle in, boys, we're going down!'

There were numerous planes of all sorts – lear jets, FedEx delivery planes, little short-flight hoppers and massive military cargo aircraft. It was

* Well, there are Joshua trees but, like cacti, they really don't provide any cover.

a vast playground and a long night. We went in six or seven planes and photographed dozens. At some point we realised there was a security patrol inside the fence as well, and we had to hide in landing gear a few times while they drove by. It was a complex process exploring the bone-yard, and we wouldn't have had it any other way; as we knew, more often than not harder hacks yielded better rewards.

We were nearing the final stop of our US trip, looping around to my brother Pip's house in Canyon Lake, California. When we arrived, he pulled out a $200 bottle of tequila to celebrate. Then he took out maps and fire-arms and gave us two hot leads before taking us for a spin around the lake in his pimped-out 4x4 golf cart and sending us on our merry way.

Tip one was that, in the mountains near Big Bear, there were a series of radio towers we could climb to get proper David Lynch–esque skyline shots of the Inland Empire. Tip two was that there was an abandoned water park in nearby Redlands called Pharaoh's Lost Kingdom. Both sounded like great opportunities for some last adventures before we were back at LAX and on a plane to London.

The radio tower did indeed turn out to have incredible views. As a bonus, when we pulled up to it, there was a herd of local kids gearing up

to climb it as well. We shared our beer with them and then all climbed the tower together. We left satisfied, having never seen the Inland Empire at that scale before. After the successful climb, we were pumped to sneak into the abandoned water park – which didn't exactly go as planned.

When we arrived at Pharaoh's Lost Kingdom, it was clear that the abandoned areas of the park had been knocked down and the ground salted, all evidence of that failure erased from history. What remained standing was very much active. However, it was two in the morning, we'd had a

few beers up on the tower and it was our last adventure in the States, so we decided to run through the sprinklers and hop the fence anyway.

Inside, we climbed the first waterslide, and from there we could see the night guard off in the distance talking to a girl in a car. Easy. We climbed down the slides, which were surprisingly unslippery without water, then grabbed some inner tubes off a big pile and floated around in the pools, relaxing in the warm desert air while our shirts wicked up the shimmering, chlorine-infused pool water. Then we snuck a bit farther into the park and hit the jackpot – a snack booth with an open window. I slid through and found a fridge full of energy drinks, a nacho cheese dispenser and a Slurpee machine. Breakfast served! With packs full of fresh beverages, and a few hot photos to tell the tale, we headed back to the car.

By the time we returned to London, due to the arrests, people being on bail, the ASBOs, work and family obligations, as well as general loss of interest, most of the explorers we knew had taken some time off, and new explorers were taking the lead. Guerrilla Exploring (GE) and Hermes, with whom we had sometimes collaborated (they called it competition), had also done Tube stations, Mail Rail and most of the skyscrapers in the city, and they were making plans to see the last disused station in the system. Filo Pastry and I, having already planned on making another attempt at British Museum station, asked to link up for the journey. It would be the last journey into the Tube I ever made.

It was a long walk that night down the Piccadilly line after a harrowing entry into the Tube network that involved a homemade ladder. I had missed the smell, the warmth, of being in the Tube at night. And it was as sketchy as ever. We were going to have to cross two live stations, right in front of the cameras, and do a nearly three-mile walk. The risks, with the ghosts of previous Aldwych arrests still haunting the system, were not insignificant.

Standing at the edge of the King's Cross platform on the Piccadilly line, GE turned to us and said, 'Everyone ready? We need to gun it.' The gate swung out and, as he wrote on his blog, 'we all ran like crazy things' past eight, ten, possibly twelve cameras, ski masks stuck to our faces with sweat.[27] We made it to the other side without event.[28] Then, halfway to Russell Square, the lights in the tunnels came on.

GE turned to us and calmly said, 'That's it, guys, they saw us. We're fucked.' He wrote later, 'I ran as fast I could muster [to the next] platform ... and half expected to have been rugby-tackled by some cops coming out of one of the exits. However, we made it back into the tunnel. The lights on and hopefully the power off, we ran down the middle of the tunnel between the live and non-live tracks.' All I could think during the

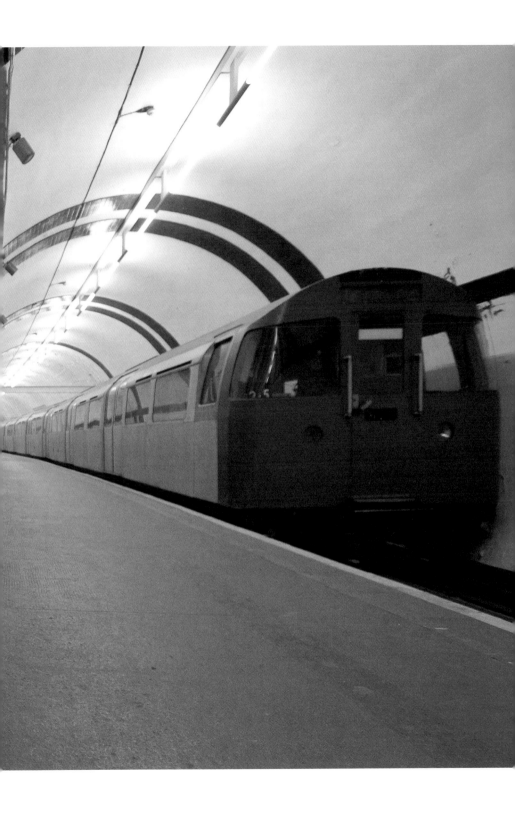

whole run was that this was it, the end of the story. When this had happened to the 'Aldwych Four' a few months earlier, they all ended up in cells. But where my British friends got cautions and ASBOs, I would surely suffer graver consequences as a 'foreigner'.

We ran for a very long time. By the time I reached the Holborn junction, a stitch in my side was unbearable. There were two options here. The first was to take the disused platform towards the dead Piccadilly branch to Aldwych. The other was to take the live platform to the ticket office, switch to the Central line and charge towards British Museum. Knowing that the BTP were following our progress ticking off stations after the busts, and that they had likely surrounded all of these stations and were monitoring CCTV very closely, I opted to head towards Aldwych, the fastest way out of the system. I had never seen Aldwych myself, so it seemed like that would be a fine accomplishment for the night in any case. I figured everyone else would feel the same.

But when I arrived at the Holborn junction to turn left, GE was standing there waiting. I asked him what he was doing. He looked me straight in the eye and said, 'Brad, there's only one station left on the list. I'm going, whether or not it means arrest. Someone has to do it.' I said nothing and shook his hand, shocked into silence by the audacity of the moment. He told me later that I didn't just shake *his* hand, I 'shook the hand of someone who represented all London Tube explorers.' It was the finest edgework I had ever seen.

It turned out that the lights had nothing to do with us; they had come on because some graffiti artists were also in the system farther north and had been spotted, seemingly at the exact moment we were running across the King's Cross platform. So it turned out that I could have seen British Museum and completed the set for the LCC. But I didn't. I ran all the way to Aldwych, as did Filo Pastry and Hermes. I took a few shaky handheld photos of the train parked on the platform before heading to the nearest portal out of the Tube to find the street eerily quiet.

Still thinking the police were on their way, I carried on running to a dark alley, where I stuffed my memory cards in a plant pot, burned the track maps and threw the charred remains in the sewer, washed the Tube dust off my hands in a rain puddle, covered myself with beer from a bin, and slumped down in a corner like a drunk, waiting for sirens that never came.

And so in the midst of the various court proceedings, British Museum station was explored and the list completed by an explorer who loved this city as much as we did but never considered himself part of the LCC. The Tube was done.

* * *

Months passed, and Marc and I had lost almost all interest in exploring. While he was off caving in Yorkshire, I was branching out, trying to find something to be interested in again, looking for the edge honed running to Aldwych. I feared nothing would ever live up to it.

After a long planning session in Helen Carlton's studio in Hartlepool at the end of 2012, Lucy Sparrow, Helen, Witek and I gathered our gear together. Then, at 2 a.m., we hit the road towards Gateshead with a car full of ropes, a bow and arrow, cameras, flasks of hot chocolate, some warm clothes and a lot of wool. With winter rolling hard into Britain, Lucy wanted to put a scarf on the Angel of the North, a twenty-metre free-standing metal sculpture, to 'keep him warm'.

Getting up the wing of the Angel was trickier then we anticipated. It turns out that shooting an arrow from a bow with fishing line tied to it in 30 mph gusts, near-freezing temperatures and light rain is not as easy as it looks in films. But after a few attempts, Helen cleared the wing, and Witek went running to snatch the dangling arrow from the air and stake it into the ground. Then, using the fishing line as a lead, snapping a few, re-doing it and finally layering three lines together to take the weight, we yanked the rope over and began rigging.

Witek quickly wrapped the ropes around the statue's feet and tied off a few quick knots. At this point, we began to hear traffic noise increasing and realised the sun was coming up – we had taken far longer than

expected, and time was running out. The Angel, seen by 90,000 people each day (one person every second!), is not a location you want to be silhouetted on top in the morning light on an illegal rigging. We had to move fast. Helen quickly pulled on her harness, hooked in her chest ascender and foot loop and started climbing.

From the top of the wing, Helen called us on her mobile to say that she was very exposed and did not feel entirely safe climbing around the head to drop the second half of the scarf, having nowhere to clip into safely.

We decided, rather than having her take an unnecessary risk, to drape the scarf over one shoulder and wrap it around the body of the Angel like a Tibetan monk's robe. With the knitwork in place, Helen jumped off the wing and descended down the rope to safety in front of a dismayed early morning dog-walker. Standing at the bottom looking up, the size of the Angel became even more impressive – it made Lucy's massive scarf, which had filled half the car, look like a piece of string.

We later heard on the news that local people had come out to watch the removal of the scarf, and many had taken pieces of it home to keep, clearly delighted by the project. Two weeks later, I received a bill from the Gateshead City Council: a £168 'scarf removal fee'. The local council heard my name mentioned on the news, Googled me, decided the whole thing was my idea and sent an invoice to my publicly available address at the University of Oxford. I responded in a letter, explaining to them that spending £168 of the council's money to make people smile was worth the investment. I never heard from them again.

It was only days after the 'Cold Angel' project that I started to feel the itch again. What once would have satisfied me for weeks now only made me crave more adventure. I was beginning to understand why many people in the community 'aged out' of urban exploration. It wasn't about growing out of it or even about not physically being able to do what you once did – it was about not being able to find your edge anymore.

Losing the edge is about the risk/reward ratio shifting. For instance, where going into the Tube at great risk was worth the effort while trying to complete the set, once the set was done the reward value lowered to the point where the risk wasn't worth going in the Tube anymore. Thinking back to the explorers' desire to be the first to find epics, it occurred to me that was less about claiming superiority over being 'first' and more about taking big risks for big rewards in the process of doing so. I imagine cavers or mountain climbers, for instance, might actually feel the same way. Everybody just wants to work their own edge, and when you can't find it anymore, you move on. If you don't, your once exhilarating interest becomes as mundane as an office job.

Chapter 7

CROWDS AND CUFFS

'Man, whom we now know to respond predictably to social forces, is therefore himself the ultimate artistic medium.'

– Bill Wasik

In April 2012, we learned that the Shard was going to 'top out', reaching its vertical pinnacle. Several explorers made plans to simultaneously release images of our infiltration of the skyscraper on blogs, images that had been collected over the course of multiple trips there in 2011. Given that twenty or thirty explorers had climbed it, and some people had already leaked isolated images, we didn't put much energy into it. I plucked some text from my now-completed PhD thesis, sandwiched it between some photos and posted it.

The post went viral almost immediately. The link was being retweeted at a rate I had never experienced. Within an hour, my server had been overloaded, and my blog crashed after about 13,000 hits. Marc and Witek, who were staying with me, watched with amazement as the post, as well

as one on Silent UK, caught fire and emails started flooding in. And then the phone started to ring.

The first call was from the *Daily Telegraph*, who politely informed me that they had downloaded photos from my blog and were going to run a story. I objected, and the journalist told me, 'Look, the editor knows this is news and it's already online. We're moving on this.' Realising they were going to run the story whether I liked it or not, I told them that they were going to need to pay me for the use of my images, remembering an instance the year before where the *Daily Mail* had ripped off Site's photos from the top of St Paul's Cathedral and he ended up having to take them to court. They agreed to pay for the images on one condition: I do an interview with them explaining why we had done it.

I was fairly sure the geography department at Royal Holloway, University of London, who supported and funded my research, would be pleased to see some press coverage of my work. There had been a lot of discussion while I was in the PhD programme about increasing the social impact and reach of research, making research more publicly accessible, giving researchers media training and disseminating research beyond the academy.[1] However, that had been theoretical, and this was real. I was sitting on the kitchen counter in my flat in Clapham at 11 p.m., the phone was ringing off the hook, I'd graduated several months previously and there was no one to consult. The pressure from the media was enormous, and a decision had to be made immediately.

I consulted with explorers who happened to be sprawled out on my floor with takeaway and beer waiting to go hit the city. After watching me try to wrangle the reporter and wrestle with the potential benefits and complications of these institutional questions, they were finding the whole situation pretty hilarious.

Marc said, 'Well, if anyone is qualified to explain our various bizarre motivations it's you. Go for it.'

We called Peter. He said, 'Look mate, if you don't talk to them they're going to say we broke in and all that. Just get out there and do damage control.'

I called the *Telegraph* back and agreed to an interview.

For the next six hours, long into the evening, one paper after another called: the *Guardian*, the *Daily Mail*, the *Independent*, *The Times*, the *Sun*, the *Daily Mirror*, and then *Forbes*, the Huffington Post, *Le Monde*, the *Atlantic Cities* and *Metro International*. I probably should have told them that the story had already been given to another paper, and that I would not speak to any more journalists. But I was worried, given the questions they were asking, that they would try to paint us as vandals or make my research

look like a waste of time and money. So I put my education to use, making sure to shift the conversation away from issues of trespass, insurance and liability, interjecting notions of creativity, civic engagement, popular history and artistic reinterpretation, and noted that explorers were working to create more democratic relationships to space in the context of an often dehumanising global capitalist system.[2]

When they asked whether we broke into this location or that one, I told them that wasn't part of what most explorers do, although we were very good at bypassing security and had been doing so for years. They also asked more ridiculous questions, like whether we were aiding terrorists. It was incredible where they were willing to go, just jabbing from any direction to provoke a response; it was all pretty feral. By midnight, I had also received calls from BBC London, Channel 4, Sky News and the ITV *Daybreak* show, which wanted two of us 'on the couch at 6 a.m.' I was nauseated and terrified. I called around and asked if anyone wanted to come on TV with me, and the only person who agreed, I think due to hearing the terror in my voice, was Helen. She spent £140 on a cab to London from Hartlepool, arriving at 3 a.m. We slept for two hours, passed out in empty takeaway boxes with the phone mercifully off.

At 5 a.m. a silver Mercedes pulled up in front my ramshackle one-room South London studio. Witek tried to give me a swig of beer to quell my nerves, and I vomited immediately. This was a whole different kind of edgework, far more nerve-wracking than climbing a skyscraper. Helen and I walked out into the cold morning and were briskly chauffeured to the ITV studio, where a woman with a clipboard and a microphone attached to her head put us through hair and makeup and then sat us in a waiting room. Time passed more slowly than I ever could have imagined.

Finally the clipboard lady told us we were 'on in five'. We were walked into the studio, where we encountered a mob of camera operators, stern overlookers and scurrying interns, all watching the show from behind the wiring. During a commercial break, we were taken to the couch and introduced to the hosts, who seemed genuinely interested and cheery enough.

Then someone yelled, 'And we're back on in 5 ... 4 ... 3 ...' As the hosts turned to us, their entire demeanour changed. I knew we were in for a battle and was glad to have Helen sitting next to me.

In the end, the interview went well enough, except for one point where I said, 'Technically everything we do is illegal', which is true in the United States but not in the United Kingdom. I backed out of the statement by assuring the hosts and viewers that 'trespassing in the UK is not a criminal offence', but in the months following, that quote would be taken out of context.

We returned from the show, worn and weary, and the phone calls from news agencies, superfans, creepy stalkers, independent film-makers and students wanting to do 'projects on UrbEx' were endless. My phone was constantly dead, and every time I plugged it in, it would ring again. I had to disable my voicemail. My email inbox was positively bulging.

As soon as I had a moment to breathe, I began to realise the true reach of this story. The photos had been printed, stolen, reposted and reblogged so many times I could no longer keep track of them.

Two related and valuable things emerged during this time. First, the media, probably because of so many stories that year about the Occupy movement and the proposed changes in UK squatting laws, were quite happy to let me talk about the politics of space in London. When they described scaling the Shard as 'climbing an urban Everest', I told them it was more like sacking Olympus. The context was the imposition of a particular form of verticality that has been thrust upon us, inescapable almost everywhere in the city.

The conceptual barriers to places in our cities is brought about by a process of engineered exclusion. While horizontal sprawl tangibly affects us, we often feel out of touch with vertical sprawl because tall buildings are built for bankers, bosses, businessmen, advertisers, marketers, media and, increasingly, 'tech people' – precisely the groups that create and maintain the spectacle.

In the case of the Shard, apartments on floors fifty-three to sixty-five sold for between £3 and £5 million each, creating what Reuters describes as the world's most unequal neighbourhood for housing prices.[3] While concessions are sometimes made to the general population, such as the inclusion of public viewing platforms on the Shard, they are for those willing to pay up to £30 for the privilege. The platforms also have a separate entrance to ensure that visitors can't access the rest of the building, and a stringent set of rules for entry, including requirements to present government identification, pass through an electronic body-scanner and have any baggage or personal items scanned before entry.[4] It's clear that these vertical spaces, though inescapably part of the urban landscape, are not for most of us.[5] I'm glad I climbed it the easy way – with a large rucksack full of camera equipment and no ID at 2 a.m.

Increasingly, the vertical city is about security from the insecurities of street level.[6] The relentless construction of skyscrapers and the closure of access to subterranean areas is increasing tensions between surface, supra-surface and sub-surface space.[7] When the photos of our explorations of the Shard, and many other places were released, we made all those vertical tensions visible, changing the material–spatial awareness of the people living in every city we

had infiltrated. This is the inherent political power behind place hacking: rendering the city more legible, more tangible, for everyone.

The second important thing to emerge from the media circus was that the engagement with papers and local news opened opportunities to elevate the discussion about what we had done. It helped us move away from depictions of UE as a quirky, passing subcultural practice to discuss the practice in the broader context of exploration. The only real divergence from earlier forms of exploration, I argued, is that urban explorers are interested in the hidden world not in distant lands but right here, veiled behind economics, rather than geography and exoticism.

Urban exploration seemed like something new, due to the sudden flurry of media coverage, and I constantly reasserted that it was not. The desire to explore the environment in which we live is hard-wired into us as curious, passionate, inquisitive beings – and it always has been. Whether we are scaling snowy peaks, diving to new depths in the sea, excavating prehistoric pit-houses or wiggling through vent shafts into train tunnels, the desire to explore is part of us. Wherever doors are closed, we will find a way through. Wherever history is buried, we will uncover it. Wherever architecture is exclusionary, we will liberate it.

I am openly embarrassed about many of the things that came out of that three-month media blitz. A great deal of the reportage was wrong or wrongly attributed (usually a problem stemming from journalists rushing to get the story out), painted us in bad light and placed me, unfairly, at the centre of the London exploring community. Our collective capacity was consistently undermined, no matter how much I tried to expand the coverage. This is always an inherent risk in ethnographic work – when you finally publish it, you can become the de facto spokesperson for the entire community.[8]

However, all the attention also allowed us to begin public discussions about the significance of our activities and proved our capacity not only to undertake urban explorations in what were supposed to be impossible places, but also to use our collective achievements as a platform to make the world a more exciting, adventurous and participatory place, undermining the deadly trio of apathy, distraction and boredom that so often makes up modern life.

The world is understood not through images but in the relationships between images that have the power to affect action. The further those images travel, the higher their capacity to cause reaction and change. Having my photographs appear in newspapers all over the country inspired and incensed a lot of people. Many urban explorers also condemned the LCC (which by that point had long dissolved, due to our fledgling ambitions, diverging interests

and legal problems). These explorers saw the practice as intramural play; it was a terrain for private games, not to be shared.[9] Many of them genuinely wanted our practice to remain on the margins, a selfish, egotistical navel-gazing adrenaline squeeze. I didn't, and felt I had the right to an opinion as someone deeply invested in this practice.

There were three primary objections from the UE community to the media engagement. First, I was accused of speaking for others. As an ethnographer, although talking about my research was part of my work, I tried to be very careful to not do this, always qualifying interviews by stating that I was only giving my opinion as a researcher. But, of course, my disclaimers were often cut out of final broadcasts. I was always in danger of being approached to speak on behalf of others, and I was not prepared to deal with that.

The second objection was that many sites were being sealed as a result of the increased public exposure. If we ignore the fact that most explorers put photos online and would prefer, I assume, to have people see them, the concern is that once the people who own buildings know explorers are accessing them, they will upgrade camera systems, hire more security guards, and fix fences. Keeping in mind that most construction projects have a limited budget for security and are pretty unlikely to invest large amounts of money on expensive infrared tracking cameras or, far more expensively, more guards on the ground, this argument in not overly convincing.

As a case in point, mere weeks after the media storm, London explorers happily walked into the construction site at 20 Fenchurch Street, the thirty-six-storey Walkie-Talkie building, through a fence laying on the ground, and climbed around on the cranes. We even met Guerrilla Exploring in the stairwell with a guitar, just going up for an jam session – security really could not have been much more casual. If the security culture does change, it is unlikely to be because of any particular media moment; it will be because of the increasing interest in urban exploring generally, and that would have happened without my going on TV and connecting urban exploration to notions of creativity and public space.

It is also worth considering the ways in which these construction companies might use the photos and media coverage to their advantage to attract funding for 'hot projects' and actually might *not care* about keeping us out. As a case in point, the PR department from the Legacy Tower in Chicago actually emailed me with a request to add a link to their website in my post. Which I happily did. Which brings me to the third, and most interesting, argument levelled against me – that I was codifying the practice of urban exploration, which would lead to its commodification.

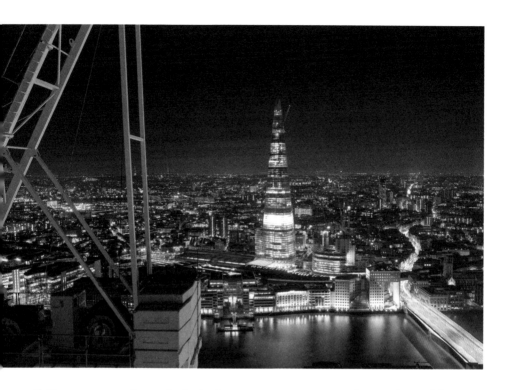

If the purpose of spectacle is to encourage consumption and provide distraction (especially from injustice), urban exploration is meant to be more a call to action than an alternative distraction. Images, once posted online, have their own life – they become resonance machines that inspire others to repost, rework, condemn and share them. The affective force of releasing the images into the wild is unknown; one can only surmise what the response might be. Often you couldn't have guessed it.

I got the weirdest calls – from Ripley's Believe It or Not, from a company selling insoles for shoes who wanted me to promote them as great for walking in ruins, and from an energy drinks company that wanted to 'sponsor' us by offering a limitless supply of high-octane liquids. Marc assured me that this was a good investment for them, as the drinks would kill us in two years anyway.

This relationship between exploration, resistance and capitalism became a flash point for discussion within the community. Interestingly, though the larger community of explorers claimed over and over not to be political or against capitalism, they were very quick to condemn anything they perceived as capitalist exploitation or 'selling out'. Whether that was genuine hypocrisy or they were just confused, I never found out. Thinking back

to moments at Burlington, Clapham Common and the Shard, one thing that became quickly apparent was that the notion of urban explorers being a leaderless community of rule-breakers was a farce – it's full of jocks and bullies just like any other community.

The response from the public to the media attention, in contrast to that of the community, was overwhelmingly positive. The reactions people exhibited concretised what I'd been saying the whole time: that the work we were doing was the kind of release millions of people were looking for – a sign that the city was not as controlled as it appeared, and that a spirit of adventure was still alive out there in the world.

Due to explorers' obvious preoccupation with visual media technologies, the practice would seem to be an easy target for those who insist that it is just about taking photos. Images, whether still or moving, are more than representations; they always contain, in the words of Roland Barthes, 'the *punctum*, conceived as its affective force, irreducible to transmission of knowledge'.[10] Images embody an affective politics and are themselves a politics of possibility. The politics here have to do with the way the images generate surprise or curiosity, which then causes people to reconsider the relationship they have, and can have, to the modern city.

Of all the public comments the stories about our work received, three really stuck with me. Each one points towards the imaginary spaces opened up by urban explorers' imagery and stories, as well as the LCC's field-tested capacity to reconfigure access to the geographies of urban space alongside concomitant changes in people's everyday lives and imaginations.

The first comment was from a banker, who wrote, 'Mate, I have worked at London Bridge for years and watched that building getting built from day one. I looked up at it all the time and not once did I try to imagine what it might look like from the top down. Now every morning I look up and my palms sweat and it makes me smile. Cheers for that!' The second was from a mother of four who wrote, 'I came across your site after reading on the BBC news site about the Shard urbex . . . I loved the story and I am glad that there are guys like you out there in the world.' The third, which came in via my blog, said, 'Hey, thanks for doing cool stuff like this so homebodies like me can live vicariously through you as we sit at home with our four kids and wife.'[11]

Comments like these showed me that people related to our explorations beyond accomplishment and representations. We had created a world people were inhabiting and engaging with passionately. It logically followed that we were also affecting people's behaviour, catalysing creativity.

The experiences we have in the city, and the discoveries we make, deserve to be shared precisely because of comments like these. People are overworked, overtired, bored and apathetic. They are frustrated with the government, corporations, banks and their jobs. Our explorations pull them out of that their routine and show them a vertical urban realm where the impossible can be made possible, both above and below ground.

In another interesting turn, due to all the new attention, people started rediscovering old explorations on my blog. One post in particular, about exploring an abandoned low-security prison called Boron in the Mojave Desert, triggered responses from ex-inmates, workers and their family members, some of whom then reconnected out in the world.[12] It was exciting to see my photos and stories from a solo urban exploration on a lazy Sunday trigger that. Those stories, like the ones in this book, reveal a life behind the scenes, something more active than appearance, the point of departure where experiences become tales and are rewoven into the narratives of people's lives.

If urban exploration is ever to have the capacity to be more than art for art's sake, it must move from an internal diologue to engage with other artists, hackers, explorers and political activists. The only way to forge broader coalitions and get people talking about the politics of closed space and the control of narratives over our histories is to use the same techno-cultural media circuitry that is constantly entangling and distracting everyone. The danger here is that if you try to change the system from the inside, often what becomes changed is you. Many of those who objected to this media engagement did so with the best of intentions. I think, though many explorers fail to recognise it, that what people are actually afraid of when they voice frustration over 'selling out' is that urban exploration will be sapped of its political weight before it has had a chance to make a significant mark on the world. I hope this book has gone some way towards alleviating those fears.

As much as urban exploration, as a movement, is changed through media engagement, these interactions also changed the media, as well as the hearts and minds of those who interacted with it, perhaps challenging them to engage more fully, more diversely, in the worlds we are building together.

In any case, twisted and complex as this all was, the story was not yet over.

On 17 August 2012, after undertaking a month-long participatory video research project in Cambodia on domestic violence, I flew back home to London. As the plane pulled into the terminal and the little *ding!* went off

that causes everyone to stand up and start opening the overhead compart-
ments, an announcement came over the intercom. It said, 'Everyone please
return to your seats. The police are boarding the plane.' We all sat back
down. I quickly sent out a tweet that said, 'Just landed at Heathrow and
told police are boarding the plane. Welcome home.' Three officers came
down the aisle, the one in front muttering, '42K, 42K, 42K . . .' They
stopped in front of me.

'Dr Garrett.'

'Yes?'

'You're under arrest. You need to come with us.'

The friendly couple sitting next to me, with whom I had been happily
chatting away during the flight, looked shocked as I was cuffed and
dragged down the aisle.

British Transport Police had arrested me, I was informed, to collect
evidence for an investigation regarding criminal damage, burglary and
assisting or encouraging an offence in relation to Clapham Common secure
file storage, where Steel Mound had reported a break-in.

I was taken to passport control in handcuffs, where I was questioned
by the United Kingdom Border Agency (UKBA) about where I had been,
what I had been doing in Cambodia, why I was entering the UK and where
I was staying. I told them I had been doing a research project, lived in
Clapham and was starting a new job at the University of Oxford in two
months. I had a valid work visa. The officer holding my arm as I was
questioned turned to the others and said, 'Hear that, boys? He lives in
Clapham.'

I was told I was being denied entry to the UK, as I was 'a person liable
to be detained'. We then moved to a back room, where my fingerprints,
DNA and photo were taken. During this process, the police then informed
me that I was being additionally arrested for criminal damage at the
disused Down Street Tube station. The UKBA then took my passport, trap-
ping me in the country until 'the investigation is concluded and your
request to enter the United Kingdom can be reassessed'.

I was put in the back of a holding van, my hands still cuffed behind
my back, and driven to BTP headquarters. On the drive, I met DC Cormack,
the investigating officer, who would become a central character in my life
for the next year. When we arrived at headquarters, my handcuffs were
removed and I was asked to sign some papers. While this was happening,
the police were going through my luggage and putting most of my posses-
sions into BTP evidence bags.

They then took my fingerprints again and asked for the PIN to my
phone. I declined, saying that I would like to talk to my legal council before

making any decisions. I also explained that I was exhausted and, well, foreign – I didn't really know what I was obliged to do under UK law. The only British law I knew well (for obvious reasons) was trespass law. They told me it might be a while before I could talk to anyone, as they had arrested three more people as part of the same investigation and were busy with interviews.

They gave me one phone call before putting me in a holding cell, and I called Marc, whose phone was off. I left a message for him and to try to locate Matthew Power, a writer for *GQ*, whom I was supposed to have met at the airport. Little did I know that, at about at that time, Power was standing outside my flat, where the BTP had taken down my front door with a battering ram and confiscated everything I owned that could hold data, including computers, hard drives, notebooks, disks, phones and camera equipment.

They left me in the cell for eight hours, with a book and pen and paper at my request, returning twice to ask for my phone's PIN. Late in the afternoon, they walked me to an interview room where, after twelve hours on a plane and eight hours in the cell, DC Cormack and a thick-necked colleague wanted to 'ask me some questions'. I declined to comment for almost two hours while they asked me if I was an urban explorer, if I could explain what urban exploration was, if I was the one who wrote my thesis, if I lived in Clapham and if I had ever done criminal damage in order to gain access to a building. They also asked me who certain people were and whether I was also known as the Goblinmerchant. They asked me about my blog, Twitter feed, YouTube videos and Facebook page. They asked if I was the leader of the LCC. They pulled out a copy of my thesis and went through it in great detail, asking whether I had 'gone beyond urban exploration' and 'become a criminal'. They read long passages of my thesis aloud and described them as 'evocative' and 'very condemning'. At one point when DC Cormack was changing the tapes, he said, 'I have to say off the record, Bradley, that this is really great stuff, I mean, I'm just doing my job here, but I would like to buy you a pint when this is all over. These photos are amazing and the writing is beautiful, really great stuff, but we can't have you telling everyone about going in the Tube after hours.'

I was released onto the streets exhausted. Most of my possessions were gone, including my passport and phone. Despite the fact that I had not been charged with a crime, my newly acquired immigration lawyer later gravely informed me from a payphone, 'You are a ghost now. You officially do not exist.'[13] It was clear that British Transport Police had arrested me on the plane to force me through passport control in handcuffs, knowing this would jeopardise my status with the UKBA.

By 9 p.m., I was back at Marc's, where he and Luca were drinking bourbon on the roof with Matthew Power, the *GQ* journalist. When I got there, Power gave me a hug and told me, 'This is the best start to a story I've ever had!'

I later met many people who had their houses raided, possessions seized indefinitely and ASBOs applied by BTP and TfL. In the run-up to the 2012 Olympics, in fact, BTP had carried out dozens of raids on the homes of graffiti artists, some of whom had stopped painting more than a decade earlier. One of the artists, Ser, had even done work for Adidas, a 2012 Olympic sponsor.[14] A representative from the Green and Black Cross, a grassroots legal advisory service for activists, who were helping me understand my legal situation, told me that authorities in London routinely 'use police bail as a deterrent punishment' without charge.

Thinking back to Barthes' notion of the 'photographic *punctum*' – the capacity that each photo has to relay feeling beyond representation – you may wish to flip back through the images in this book with a renewed sense of the costs of each one, the risk involved every time we went out, the price we paid. While urban explorers do not face all the same difficulties as more traditional explorers, the crisis of a failed expedition can have lasting repercussions on the body, on the community, on personal freedom. As a researcher and friend, I felt it important to follow my project participants wherever they went, and I did, time after time, risking deportation and the potential loss of the life I had built in the UK. I did this for myself and to embody my philosophy, believing that the only way to truly understand another culture is to live it.

Of course, I am not the first researcher to have a brush with the law, but it's interesting to note that it seems to be becoming more frequent as the regulatory regimes of neoliberalism creep into the academy. In 1993, Rik Scarce, a sociologist at Skidmore College, was incarcerated for not revealing information about his project participants, animal rights activists who had broken into a research laboratory. He describes his experiences in his book *Contempt of Court: A Scholar's Battle for Free Speech from Behind Bars*.[15]

Naomi Adiv was in the middle of a project about walking the Amtrak Capital Corridor rail line between the San Francisco Bay Area and Sacramento in the United States when Union Pacific railway police showed up at her university and pulled her out of class to tell her she could not carry on walking the tracks. What they were actually interested in, of course, was getting her to stop *telling people* she was walking the tracks. Media exposure of her project probably provoked the situation. She writes on Boing Boing:

The rail project was shut down just two days after it was posted on Boing Boing, and I think this brings up some interesting questions about research and publishing on the internet. The first, and most obvious, is that this project was going on for months before anyone at Union Pacific (UP) ever found out about it. Furthermore, I saw and talked to a bunch of UP maintenance people while I was out walking and they didn't stop me. This isn't to incriminate them or say that they are doing a bad job, but that people are out there all the time, and the fundamental difference here is that I am publishing my findings. The second is an ethical concern: I have now attracted a lot of attention to this space that I find so special precisely because it is marginal. Does this endanger its marginal quality?[16]

Adiv's case, like mine, is an interesting one in the context of increased university endorsement of public research and media engagement. If these projects are any indication of the trajectory of those engagements, social researchers will soon be spending as much time defending their research on the Internet, fighting court battles or languishing in jail cells as they will conducting their research.

Scott DeMuth, another researcher interested in liberation struggles and social movements, also interviewed animal rights activists as part of his research. When a federal grand jury investigating the Animal Liberation Front subpoenaed DeMuth and tried to coerce him into divulging the names of activists he had interviewed during his research, DeMuth refused. He then served six months in a federal penitentiary for 'conspiracy to commit animal enterprise terrorism in violation of the Animal Enterprise Protection Act'.

Scott Jaschik, editor of *Inside Higher Education*, says of the Demuth case:

The American Sociological Association's code of ethics ... specifically stresses the importance of discretion when working with people. The introduction to its section on confidentiality reads: 'Sociologists have an obligation to ensure that confidential information is protected. They do so to ensure the integrity of research and the open communication with research participants and to protect sensitive information obtained in research, teaching, practice, and service.' The ethics code stresses that this obligation extends even when 'there is no legal protection or privilege to do so'.[17]

I found out months later that we were also being investigated in the United States by the National Counterterrorism Center, which had produced a flyer citing my websites, Steve Duncan's Undercity and also Silent UK, suggesting we 'frequently post photographs, video footage, and diagrams online that could be used by terrorists to remotely identify

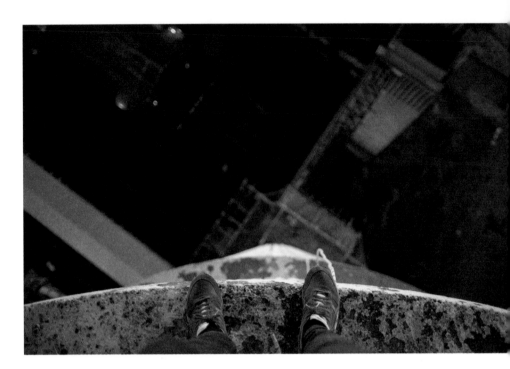

and surveil potential targets'. The flyer cheerfully urges that 'suspicious UE activity should be reported to the nearest State and Major Area Fusion Center and to the local FBI Joint Terrorism Task Force'. The public response to the flyer, much like my response to such directives in the UK, was incredulity. One online commenter suggested, 'Trying to stop people from being curious is a waste of time. No matter how many you arrest, on however suspicious grounds, there will always be more. Here's an idea – why don't you take the poor slobs who've been assigned to tail a bunch of young nerds and put them on projects that actually prevent terrorism?'[18] What the authorities in London, and increasingly the rest of the world following the security precedent being set here, fail to understand is that trust in police and governments and belief in community is not something that can be institutionalised – it has to be earned and built together.[19]

I had to make difficult decisions during my research about what would I would participate in, what I would share online, what I would write about. I balanced those things between what the community wanted, what my university wanted and what I wanted. Often I had to make those decisions in a very short time. There's no template for how to do research like this. It really depends on the people you're working with, and for this reason,

I had to construct theories of how to do fieldwork on the fly, in the moment.[20] Sometimes these choices backfired, but it's important that we tie these thoughts into the notion of becoming over being, and process over product, that I have stressed throughout the book and that are outlined geographer David Pinder:

> The kinds of experimentation that are the hallmark of much creative cultural practice, and their willingness to take risks with different forms, media and performative practices, are significant in this regard, not for laying down a path to be followed, which would be strewn with pitfalls for those lacking training in those fields, but rather for encouraging reflection on modes of presenting, writing and pedagogy . . . and on the technologies through which cities are made visible as cities.[21]

It was the combination of what we all did as a group, including our engagement with the media and various police interventions, that made London what it was during that time.

EPILOGUE

'Well, if it were easy, kid, everybody would do it.'
– James Coughlin, *The Town*

If you could go exploring anywhere, in any city, where would you go? You might answer, 'I'd love to wander around the abandoned nuclear fallout zone around Chernobyl and the Pripyat ghost town', or 'I would be interested in walking the sewers in Vienna where they filmed *The Third Man.*' Perhaps, standing on Tottenham Court Road in London, you have looked up and thought, 'I'd like to see the view from the top of Centre Point.' All of these things are possible. However, each one carries different costs and sets of restrictions based on the physical makeup and the social context of the city.

To get to Chernobyl, you will need to pay more than £300 for a tour where guys with Geiger counters will herd you along the same known, and ostensibly least dangerous, dark path through the area that thousands of other tourists have taken. In Vienna, after signing a two-page waiver regarding safety precautions and rules and paying €7, helmeted tour

operators with gas detectors will use projection and light technology to give you an audiovisual tour inside a 'safe' sewer chamber with a distanced platform viewing. If you would like to have a party at the top of Centre Point, you can either get a job with the Confederation of British Industry or the Chinese oil company Petrochina, or hire the viewing gallery for a group of thirteen to sixty people after applying for membership, where aspiring members will be 'assessed' by a panel that includes English actor Stephen Fry. If you've got cash or fame or know the right people, you might just get in.

Alternatively, when you arrive in Chernobyl, you could pay off a guard in Vodka or cash to let you sneak off on your own and walk at your own pace, seeing parts of the site few tourist ever have. If you're caught, you may end up lighter in the pocket, or you might acquire a heavier dose of radiation than you'd prefer, but you'll have seen it. Or, when you get to Vienna, you could open a manhole in the middle of the night with two friends. You can take turns playing the roles of Harry Lime, Holly Martins and Major Calloway, running in the sewage all night, no gas detector required. And then, if you wanted to see the view from the top of Centre Pointe, well, why stop at the expensive viewing gallery? Why not pose instead as an electrical contractor and get your friends straight to the roof after hacking the lift controls? If it's warm out, why not even camp on the roof overnight?

I am not suggesting that one way of experiencing a place is superior to another. Indeed, many people would prefer to take a safe tour or sit in a climate-controlled viewing platform with a cocktail. But just as many people, I would venture to guess, would opt for adventure, given the choice, or would be happy to let others make that decision for themselves. Sadly, it is increasingly not a choice we are given. As a result, the urban explorer must cut a new path. The explorer reclaims rights to the city that are not on offer. They take control of heritage not interpreted, making the city a reflection of their own desires, rather than the expectations of others.

By 2013, Patch was still cracking new locations, as was Guerrilla Exploring. New London explorers kept the scene going. OliverT was one of those who came to notice quickly, eventually doing things we never dared to, like climbing the Olympic 'gondola' cable car pylons with Alex, right after Hermes. Later, Dicky, Hermes and OliverT climbed the Crystal Palace radio transmitter. The Special Needs Crew from Manchester also started making forays into London, moving through locations quickly and hitting things before we could, like the forty-eight-storey Cheesegrater skyscraper on Leadenhall Street. Kingsway Telephone exchange was explored again. Alex

accessed the new National Grid excavations, eventually paving the way for us to reach the tunnel-boring machines. Sticking my fingers into the soft earth where the drill bit had just pulled out fresh subterranean London was a moment that filled me with joy. I was there, participating in the unravelling of new infrastructure being ripped through the heart of our city that might serve my children and grandchildren one day. It made me wonder whether Dickens and Hollingshead had similar thoughts when watching the sewers being dug out 150 years earlier.

Despite the best efforts of the British Transport Police to make our lives miserable and fragment our community, the Tube continued to be explored. Even Crossrail, the new seventy-three-mile transportation system stretching forty metres below the city, was cracked, traced and recorded. In a few years, explorers will ride trains past the spot where they hid in the dark, sneaking past twenty-four-hour Network Rail workforces. But these are not my stories to tell.

It's important that I mention those adventures though, because they are the beginnings of new branches, new tales of urban exploration. The LCC accomplished a great deal in our Golden Age, but I don't want to give the impression that exploration in the city was an event that happened and is now over. Exploration of London, and of cities all over the world, is happening all the time, even as you read this. Explorers will continue to branch out and create new possibilities for edgework and meld moments, both old and new. The £4.2 billion London Tideway Tunnel (Super Sewer) construction, for instance, will certainly be hacked, as will, one day, the system of secret military citadels under Whitehall that connect the city's most politically powerful architecture, hidden behind a door in the underground that the LCC approached but never breached.

What I experienced with the London explorers was more than a bizarre subcultural hobby or passing fad. What the group built together was a deeply bonded community of people committed to a very specific set of goals built on the desire to see places that very few people ever had – places that were right under all of our feet in the city. The amount of research and effort required to access many of these places rivals the great explorations of the twentieth century – we just had different considerations at stake.

In this way, urban exploration is connected to earlier forms of exploration that have been taking place since prehistoric times, perhaps pointing to a neural desire for discovery. But it also speaks in a unique way to this specific period in time. These explorations have different political implications in this age. Perhaps those fluctuating inferences say less about urban explorers and more about the state of purportedly representative

democratic societies where civil liberties appear to be rapidly dwindling. It is interesting that, back in 2003, Liz and Ninjalicious wrote the following:

> **Allowing the darkening threat of future terrorist attack or indeed of our increasingly scarce civil rights to deter our curiosity or intimidate us away from expressing our deep appreciation for the hidden and neglected bits of our urban landscapes would be the greatest crime of all. Continuing to support considerate exploration and questioning authority in productive, benevolent, and visible ways will allow us to represent ourselves as what we really are: people who love our cities, not those who wish to destroy them.[1]**

It is perplexing, given that we purportedly live in an open, free and transparent democracy in the UK, that curiosity about, and exploration of, the spaces around us should be reacted to with such militancy. Photographers in general have been treated with great suspicion and intolerance in recent years.[2] As Moses pointed out to me, it's bizarre that, while exploration (and photography) of the 'wilderness' is seen as a noble and productive use of people's time, exploration of the urban is seen as threatening. This is yet another example of the weary modernist binary of in place/out of place.[3]

Urban exploration blurs the boundaries between nature and culture where, as environmental historian William Cronon tells us, '*Wild*ness (as opposed to wilderness) can be found anywhere; in the seemingly tame fields and woodlots of Massachusetts, in the cracks of a Manhattan sidewalk, even in the cells of our own bodies.'[4] Urban exploration is a search for experiences located at the porous, live intersections between bodies and places in (re)discovered locations. It creates distal tendrils of affect that reach out to form new hybrid assemblages. In creating relationships of meaning in off-limits locales, urban explorers understand that meaning can be neither purely conceptual nor purely spatial. Meaning is generated in the space between things. Whether all the effort invested has reworked that binary at all by showing people that the urban environment can and should be explored, whether it was worth the effort invested and price paid, remains to be seen. As does the question of whether the media will succeed in dulling the edges we have created through co-option until they no longer cut new paths.

Like most contemporary urban explorers, Team B began with an interest in abandoned buildings and industrial ruins. We quickly felt satisfied that we had seen some of the most interesting, enticing and resonant derelict sites in greater London and then ventured into Europe to continue the process of discovery, eventually pushing ourselves to our existential, embodied and emotional breaking points by sleeping in ruins for weeks on

end, overindulging in urban toxicity and searching for the most visceral connections to historic places we could create.

After exploring the Burlington government bunker in Wiltshire, a site of immense historical value only recently declassified, the group began breaking not only social convention but also community regulation, playing by our own rules until the consolidation with Team A at Marc Explo's twenty-ninth birthday party on top of King's Reach Tower. Re-forged as the London Consolidation Crew, we began climbing the city's most notable construction projects together. We explored the majority of London's drainage systems, including what used to be the Fleet, Westbourne, Effra and Tyburn rivers, now sewer networks adorned with the beautiful brickwork of Victorian engineer Joseph Bazalgette and the builders who made his plans a reality, all of whom the group began to feel particularly connected to across two centuries. We were becoming increasingly melded into the fabric of the city, enraptured and inspired not only by the Victorian creations and imagery, but by our strong conviction of the value of public space and belief in community.

As we then moved from one component of infrastructure (sewers) to others (bunkers, utility and transportation networks), the group began to experience a collective upswing in both tolerance for adrenaline and risk and a deeper desire to experience the most unique and hidden materialities of London. The goal we had previously held – to see sites – morphed into a desire to understand the flow of interconnected systems, and to chase desire and affect in places where our bodies were probing (and exceeding) tolerance limits, doing delicate edgework. Our photography practice changed with us, becoming more about movement, flow and action, rather than strict documentation.

As a loosely defined urban exploration collective that often extended beyond the LCC, we pushed the boundaries of London urban exploration to a point never before seen, sneaking into the London Underground on a mission to relocate and photograph every disused Tube station, work that tested the limits of our abilities to explore and to escape capture. With the Mail Rail, Kingsway Telephone Exchange, British Museum, the Shard, St Paul's and countless other locations, we continued our work, proving that any space was open to the place hacker.

However, as I have shown, where I may point to overarching imperatives and motivations, it is problematic to attempt to reify a coordinated explorer ethos even within our specific group of explorers. Individuals simply followed their own desires, did their own edgework, each connected to the city in the ways he or she saw fit, creating an arboreal structure through individual meld moments.

By 2012, after authoritarian crackdowns, mistakes, community rifts, changing desires and life situations, the LCC was fractured. But we re-formed for our adventures into the United States, fed by the energy of other crews and different situations. We returned to London to find that there were now new explorers hacking the city, learning from our successes and failures.

As we saw via our engagement with bodywork and urban hybridity, death is always part of the meld, creating fertile ground for new growth. Ruins decay and collapse and are experienced by the explorer as a space of different time, leading to new imaginations. Infrastructure and new construction are also part of the meld, emergent blocks of sensation where we were moved to think about the viscerally intense processes that create new formations in the world.

The kind of knowledge and experiences that urban explorers seek and find, hidden in plain sight, is exciting, empowering and ultimately has less to do with fetishising the aesthetics of decay or embarrassing forces of social control, and more to do with creating a new type of relationship with place, one not offered but taken. Urban exploration is an effort to connect in a meaningful way to a world rendered increasingly mundane by commercial interests and an endless state of 'heightened' security.

If authorities choose to interpret our actions in an overzealous way, we ultimately have little control over that. But the recent civil unrest and global occupation movements in cities all over the world clearly belie a deep societal dissatisfaction, one I think urban explorers are also a product of and that their actions speak back to. The official rhetoric of fear has risen to absurd levels, where urban exploration is considered a criminal activity. The public can then see how the propaganda of fear is being used to distract them from the real problems we face in the world. The absurdity of the accusations does not expose us; it exposes the accusers.

I remain hopeful that, now that connections have been made, we will draw on the models built by explorers like Duncan Campbell, Julia Solis, Predator, Ninjalicious, John Law, Steve Duncan and Moses Gates to imbue the practice with the power to effect meaningful change in the world by exposing government secrets, learning more about the history of our cities, participating in their inner workings and ultimately creating more democratic and transparent environments – not to just inhabit but to care for.

While, as a crew, we clearly pushed some boundaries past their breaking points, urban infiltrators everywhere raise an interesting challenge

regarding the right to venture into public architecture in their cities. Where late modernity has buried these systems in an attempt to present a frictionless interface that is to remain unseen, unquestioned and taken for granted, urban explorers, as active participatory citizens, are asserting the right to know how these things work, where they exist and what they connect to.

Through the LCC's ever-shifting bodywork built on a foundation of fracturing motivational multiplicity, changing photography practice and increasing meld moments, we ourselves became the ghosts of time we were originally chasing. In fact, in a sense, the LCC never actually existed. That is to say, no one was ever 'in' or 'out'; it was simply a group of people who came together for a series of incredible events, spikes in time where affect rose and dissipated, spilling out into the city, where it was sometimes picked up and reworked. Membership was loose; some people left, others entered, new assemblages were built for a particular duration (both personal and collective). The whole nature of the 'consolidation', as silly as it may have sounded as a group name (certainly nowhere near as sexy as, say, the Jinx Crew, Cave Clan or Suicide Club), was that it wasn't exclusionary. The LCC always retained its arboreal structure, with branches dying and reforming all the time.

Part of the reason the London scene was so enticing to everyone during the Golden Age was because no one could really apprehend what was taking place. It was a period when accumulated frustration and desire became unleashed on the city in a furious wave, fuelled by a collective of close friends. Questions about what urban exploration was and would become, who else would get involved, why it was happening, what its boundaries were, and when and where it would end were still being probed. Some of those answers are in this book.

The urban exploration community deserves to be problematised for its lack of socio-political contextualisation or self-reflection, or for the failure on the part of individual participants to interrogate their own desires to capture, collect, protect and control information and locations, in contrast to the open-source ethic they espouse. There are also obvious openings for critique in regard to urban exploration's historical precedents, such as fetishism for dereliction and group smugness, which can lead to exclusionary practices and powerful but contentious uses of imagery.

However, urban exploration is also an important grounded process that renders the city legible, transparent and within reach for a wide range of people who feel excluded from its production and maintenance. It is a practice that costs nothing but produces a great deal. Urban exploration

reveals the potential to expose latent possibilities locked behind smooth glass, metal and stone. It reveals new worlds above and below us, portals to other feelings and modalities, alternative landscapes and hidden places behind doors, through fences and under manhole covers we pass every day.

While I am cautious about overemphasising the significance of urban exploration as a social practice, given the relatively small size of the movement and its desire for insularity, I hope to have demonstrated throughout this book that explorers are doing important work that goes beyond the production of slick media spectacles. The movement has coalesced not because of camera technology or Internet facilitation but because so many people feel a need to connect with each other, and with the world, in ways not mediated by social, economic and cultural conditioning. Explorers do the work of opening closed systems, propriety systems, systems of corporations and government (which are often one and the same), poking holes in the urban security fabric, levelling and democratising place wherever it is closed off by forces ensuring safe banality. That process of opening up is not limited to place, for as I have shown, places are also constituted socially.

Through the lens of my fifteen minutes of fame for being connected to the UE 'scene', we were able to think about the ways in which explorer imagery has the capacity to go beyond a simple representation to create new assemblages and blocks of sensation that shocked and inspired. We saw how the creation of those assemblages affected our community, the public that engaged with our work and the police who felt an ever-increasing need, the more visible we became, to stop us. This was not because we were breaking the law; it was because we were creating a more interesting spectacle than the state, causing people to pay more attention to what was around them and to start asking questions.

However, the attempt to quash alterative narratives in a capitalist society, in contrast to an authoritarian one, is always two-pronged: it includes both suppression and absorption. While the authorities have largely failed to stop us, the media is still working diligently to de-tooth urban exploration by buying us out. Now that we have used their channels to broadcast our messages, it's important that we slip the net and re-form as something equally inspiring and hard to pin down, and then reform again from another angle.

Under the broad banner of place hacking, a term that eventually came to encompass the full range of alternative urban projects our crew undertook, including urban exploration, infiltration, illegal parties, squatting, illicit art installations and generally accomplishing whatever the group had the

desire to pursue regardless of social expectation or legal constraint, it is worth turning to the anthropologists Coleman and Golub when they suggest:

> Hacking [is] a constant arms race between those with the knowledge and power to erect barriers and those with the equal power, knowledge and especially desire to disarm them.[5]

Through infiltrating the urban environment, explorers assert an equal right to power, space, history, investment, development and knowledge. Despite the fact that this age ended with arrests, police raids and seemingly endless court battles, regret is rarely expressed. As Patch told me:

> I have lived a life few people dream of and even fewer would aspire to. So what if people think I'm a cunt? So what if I end up with a criminal record? So what if it costs me my driver's license, job or court fees? Do you think for a minute that when I'm seventy and in a wheelchair I'm going to look back and think, 'Damn, I really wish I hadn't driven the Mail Rail train or seen Brompton Road station'? Not for an instant. I have loved every second of this, even the busts.

The attentiveness to time and space is evident in everything urban explorers do, from the appreciation of sites of temporal slippage in ruin space to the awareness of the fact that everything they undertake, be it an exploration of a bunker or spending the summer in a squat, is temporary. The photography of these temporary spatial reappropriations is an attempt to relay those transitory moments to others, to create a visual mark of this time and place, with reference to what came before, what will come after and how it is all connected through us. The life of the urban explorer is flavoured by the awareness of the past and future, but it is always, first and foremost, about the here and now, about the possibilities of the present. Coleman and Golub again:

> The morality encoded in this form of hacker practice thus values the process of piercing through locks, disarming security, accessing the inaccessible, eliminating barriers, and reaching the pot of gold behind the locked door – knowing full well that barriers will always come back in some form.[6]

Flipping through our photos with Helen one day, I asked her why she originally got involved in urban exploration. She gave me a simple answer: 'Mental and physical barriers are there to be pushed.' Where I feel a compulsion to unpack the background, theory and motivation behind this practice,

most explorers are content to explore because they can, connecting simply to what they know to be true. Explorers of all sorts have been doing so since long before a researcher, film-maker or photographer was there to document it. The desire to explore is inside all of us to some degree, and many people can't, or won't, suppress it at the behest of social expectation.

Nine months after my arrest, still stuck in Britain, I met with Marc Explo for a pint at the Falcon in Clapham, one of our regular spots for plotting and planning. I told him I felt, looking back, that I was quite lucky to have met Team B when I did, and that I had been able to integrate myself into the culture of urban exploration as I had done.

He responded, 'Brad, you didn't integrate yourself into the culture; you created the culture so that you would have something to study.' That comment haunted me for weeks. Although I think most of what happened would have happened with or without me, there is no doubt that it would have happened in a different way. It's even possible that if I had not started this research, there would have been no LCC.

Whatever my involvement triggered, I believe it's a vital component of my ethnographic work to acknowledge its role in the rise and fall of Team B and the LCC. These communities are the most exceptional people I have ever encountered. I will never live down the trouble my publications got people into, including myself, but I was relieved when Site, reflecting on everything that happened, wrote to me:

> In my eyes the LCC stopped that naive, egotastic explorer mindset and actually opened up a lot of people to go explore with other people . . . So as much as a lot of people hate on thinking up a 'crew name', I think it was a general idea and joke that probably got out of hand, but I think it brought a hell of a lot of people together who probably never would have spoken to each other.

Although the end of these tales of urban exploration is not exactly cheerful, this research remains a celebration of urban exploration as a vibrant community creation and populist practice, echoed by hundreds of other community-building processes taking place all over the world. I believe that when we look back on this period, we will realise we were involved in nothing less than a cultural renaissance, where people began to take control of their rights to their cities, again, many times, not necessarily through force but in more playfully subversive ways in the midst of failing economies, ineffective partisan governments and the erosion of democratic ideals as the very existence of public space continues to slide unopposed into private hands.

These movements and interventions, seemingly isolated from one another, indeed even at times hostile to one another, are nonetheless working to undermine singular, authoritative narratives over space through the creation of new relationships to places, recoded for the world to see. Urban exploration, as one of these practices, reconfigures places in ways that can be shocking, beautiful, confusing and bizarre, but ultimately bear a particularly rare authenticity in these militarised, Orwellian cities we reside in. The spaces explorers find, open and create spring from something profoundly human and social, a process of creation seeded from a visceral right to define places on our own terms, not in opposition to but regardless of social expectation.

Given the array of events that unfolded during the years I was a part of this movement, and how deeply this research was and is embedded in me, any prediction I could proffer about the future of the practice will likely fail. As we've seen, these things have a history of backfiring. However, there certainly seems to be a rapidly growing interest in urban exploration, which might be promising or foreboding. We, of course, contributed to that and will receive part of the blame if there is a significant crackdown on or co-option of the practice. However, a line of history has been etched based on what London explorers accomplished from 2008 to 2012.

This Golden Age of London urban exploration will always be our legacy, and I feel privileged to have been chosen as the scribe for the tribe. What other legacies we may have left behind, what accomplishments and experiences are not contained within these pages, I will leave to your imagination. And what tales of urban exploration future generations will tell, I leave to them.

ENDNOTES

DISCLAIMER

Readers interested in understanding the motivations behind the protection of project participants when working on a sensitive subject should consult Patricia A. Adler and Peter Adler, 'Ethical Issues in Self-Censorship: Ethnographic Research on Sensitive Topics', in Claire M. Renzetti and Raymond M. Lee, eds, *Researching Sensitive Topics* (Newbury Park, CA: Sage, 1993), and Raymond M. Lee, *Doing Research on Sensitive Topics* (Thousand Oaks, CA: Sage, 1993).

PROLOGUE

1 Tim Edensor, 'Staging Tourism: Tourists as Performers', *Annals of Tourism Research* 27: 2 (April 2000); Peter Adey, 'Facing Airport Security: Affect, Biopolitics, and the Preemptive Securitisation of the Mobile Body', *Environment and Planning D: Society and Space* 27: 2 (2009).

1. THE UE SCENE

1 Ninjalicious, *Access All Areas: A User's Guide to the Art of Urban Exploration* (Canada: Infilpress, 2005), p. 3.
2 Geoff Manaugh and Troy Paiva, *Night Visions: The Art of Urban Exploration* (San Francisco: Chronicle Books, 2008), p. 9.
3 Jamie Peck and Adam Tickell, 'Neoliberalisation of the City', *Antipode* 34: 3 (2002).

4 Bradley L. Garrett, 'Assaying History: Creating Temporal Junctions through Urban Exploration,' *Environment and Planning D: Society and Space* 29: 6 (2011).

5 For similar examples of these tactics, see Iain Borden, *Skateboarding, Space and the City: Architecture and the Body* (Oxford: Berg, 2001); Stephen Saville, 'Playing with Fear: Parkour and the Mobility of Emotion', *Social & Cultural Geography* 9: 8 (2008); Stephen Lyng, 'Edgework: A Social Psychological Analysis of Voluntary Risk Taking', *American Journal of Sociology* 95: 4 (1990); and Sarah G. Cant, '"The Tug of Danger with the Magnetism of Mystery": Descents into the Comprehensive Poetic-Sensuous Appeal of Caves', *Tourist Studies* 3: 1 (2003).

6 Alan Rapp, 'The Esoteric City: Urban Exploration and the Reclamation of the Built Environment', *Architecture* (2010).

7 Michel Foucault and Paul Rabinow, *The Foucault Reader* (London: Vintage, 1984); Jean-Paul Sartre and Wade Baskin, *Of Human Freedom* (New York: Philosophical Library, 1967); Maurice Merleau-Ponty, *Phenomenology of Perception* (London: Routledge, 1962).

8 Hayden Lorimer, 'Cultural Geography: Non-Representational Conditions and Concerns', *Progress in Human Geography* 32: 4 (2008).

9 Stephen Lyng, 'Crime, Edgework and Corporeal Transaction', *Political Theory* 8: 3 (2004); Lazar Knustmann, *La culture en clandestins: L'UX* (Paris: Hazan, 2009).

10 William E. Connolly, *Neuropolitics: Thinking, Culture, Speed* (Minneapolis, MN: University of Minnesota Press, 2002), cited in Harriet Hawkins (2012), 'Geography and Art: An Expanding Field: Site, the Body and Practice', *Progress in Human Geography* 37: 1 (2013).

11 'The Winchester', at thewinch.net/?p=1724.

12 'Sleepy City', at sleepycity.net.

13 See Bradley L. Garrett, 'Cracking the Paris Carrières: Corporal Terror and Illicit Encounter under the City of Light', *Acme: An International E-Journal for Critical Geographies* 10: 2 (2011).

14 'You Have to Choose', at vimeo.com/13702117.

15 RomanyWG, *Beauty in Decay* (Durham, NC: Carpet Bombing Culture, 2010), np. See also Cécile Martha and Jean Griffet, 'Le BASE-jump, le Jeu le Plus Sérieux du Monde', *Ethnologie française* 36 (2006).

16 'No Promise of Safety', at thelazyrando.wordpress.com/2011/03/27/no-promise-of-safety.

17 Steve Graham and Simon Marvin, *Splintering Urbanism: Networked Infrastructures, Technological Mobilities and the Urban Condition* (London: Routledge, 2001), p. 206.

18 Francisco R. Klauser, 'Splintering Spheres of Security: Peter Sloterdijk and the Contemporary Fortress City', *Environment and Planning D: Society and Space* 28: 2 (2010).

19 Stephen Graham, 'Olympics 2012 Security: Welcome to Lockdown London', *Guardian*, 12 March 2012; Adam Higginbotham, 'Deception Is Futile When Big Brother's Lie Detector Turns Its Eyes on You', *Wired*, 17 January 2013.

20 Anna Minton, *Ground Control: Fear and Happiness in the Twenty-First-Century City* (London: Penguin, 2012).

21 Guy Debord, *The Society of the Spectacle* (London: Rebel Press, 2006), p. 14.

22 N. J. Thrift, 'Lifeworld Inc. – and What to Do About It', *Environment and Planning D: Society and Space* 29: 1 (2011), p. 16.

23 See Elizabeth R. Straughan, 'Touched by Water: The Body in Scuba Diving', *Emotion, Space and Society* 5: 1 (February 2012); Gordon Waitt and Lauren Cook, 'Leaving Nothing but Ripples on the Water: Performing Ecotourism Natures', *Social & Cultural Geography* 8: 4 (2007).

24 Moses Gates, *Hidden Cities: Travels to the Secret Corners of the World's Great Metropolises – A Memoir of Urban Exploration* (New York: Tarcher, 2013).

25 Emily Gowers, 'The Anatomy of Rome from Capitol to Cloaca', *Journal of Roman Studies* 85 (1995). See also Greg A. Brick, *Subterranean Twin Cities* (Minneapolis, MN: University of Minnesota Press, 2009).

26 John Hollingshead, *Underground London* (London: Kessinger, 2009 [1862]); Charles Dickens, *All the Year Round* (London, 1861).

27 Whipplesnaith, *The Night Climbers of Cambridge* (Cambridge: Oleander Press, 2007 [1937]).

28 See Tom Whipple, 'Confessions of a Night Climber', *Times*, 2 November 2007.

29 Tom Wells, 'Deck the Halls with, er, 150ft-high Santa Hats', *Sun*, 4 December 2009.

30 Patrick Sawer, 'Cambridge University's 1958 Car on Roof Prank Secrets Revealed', *Telegraph*, 28 June 2008.

31 Jon Lackman, 'The New French Hacker-Artist Underground', *Wired*, 20 January 2012.

32 Steven Jones, *The Tribes of Burning Man: How an Experimental City in the Desert Is Shaping the New American Counterculture* (San Francisco: CCC Publishing, 2011).

33 Geoff Manaugh, *The Bldg Blog Book* (San Francisco: Chronicle, 2009).

34 D. Wershler-Henry, 'Urban Life: Usufruct in the City', *Globe and Mail* (2005), quoted in Steven High and David W. Lewis, *Corporate Wasteland* (Ithaca, NY: Cornell University Press, 2007), p. 42.

35 Ashley Fantz and Atika Shubert, 'Wikileaks "Anonymous" Hackers: "We Will Fight"', CNN, 10 December 2010.

36 Lucy Osborne, 'Urban Explorers Enter London's Landmarks', *Evening Standard*, 10 November 2011.

37 David Pinder, 'Old Paris No More: Geographies of Spectacle and Anti-Spectacle', *Antipode* 32: 4 (October 2000).

38 Quentin Stevens, *The Ludic City: Exploring the Potetial of Public Spaces* (London: Routledge, 2007).

39 Michael Scott, 'Hacking the Material World', *Wired* 1: 3 (July/August 1993).

40 E. Gabriella Coleman and Alex Golub, 'Hacker Practice: Moral Genres and the Cultural Articulation of Liberalism', *Anthropological Theory* 8: 3 (September 2008).

41 Jonas Löwgren, 'Origins of hacker culture(s)', 2000, at webzone.k3.mah.se/ k3jolo/HackerCultures/origins.htm.

42 Eric S. Raymond, *The New Hacker's Dictionary* (Cambridge, MA: MIT Press, 1996), p. 310.

43 'The London Underground', at sleepycity.net/posts/247/The_London_Underground.

44 James Nestor, 'The Art of Urban Exploration', *San Francisco Chronicle*, 16 August 2007.

45 There are about 10,000 registered users, according to Davenport (2011), and Zero, 'The Anger Tunnel', *Drainor Magazine* (2009) suggests there are probably about 3,000 active in the UK.

46 High and Lewis, *Corporate Wasteland*; Luke Bennett, 'Bunkerology – A Case Study in the Theory and Practice of Urban Exploration', *Environment and Planning D: Society and Space* 29: 3 (2011).

47 George Herbert Mead, *Mind, Self, and Society* (Chicago, IL: University of Chicago Press, 1934).

48 High and Lewis, *Corporate Wasteland*, p. 63.

49 Similar to the work of Willis and Jefferson on 'hippie culture' in 'The Cultural Meaning of Drug Use', in Stuart Hall and Tony Jefferson, eds, *Resistance through Rituals: Youth Subcultures in Post-War Britain* (London: Routledge, 2006).

50 Charles Arthur and Josh Halliday, 'Lulzsec Leak: Is This the Beginning of the End for the Hackers?', *Guardian* 24 June 2011.

51 My first attempt at contacting the community was posted on 17 November 2008. The thread can be found at uer.ca/forum_showthread_archive.asp?fid=1& threadid=61723&currpage=1&pp#post18.

52 Watch the encounter, 'Getting Busted by the West Park Asylum', at youtube. com/watch?v=A4-u46BjYYI.

2. THE RUINS OF HISTORY

1 Dylan Trigg, *The Aesthetics of Decay: Nothingness, Nostaligia and the Absence of Reason* (New York: Peter Lang, 2006).

2 Fredric Jameson, *A Singular Modernity: Essays on the Ontology of the Present* (London: Verso, 2002), p. 215.

3 Brian Dillon, 'Fragments from a History of Ruin', *Cabinet Magazine* 20 (2005/06);

Caitlin DeSilvey and Tim Edensor, 'Reckoning with Ruins', *Progress in Human Geography*, 27 November 2012.

4 Rose Macaulay, *Pleasure of Ruins* (New York: Walker & Co., 1964), p. xvii.

5 Jo Frances Maddern, 'Spectres of Migration and the Ghosts of Ellis Island', *Cultural Geographies* 15: 3 (July 2008).

6 Derrida's topography is discussed in M. Crang and P.S. Travlou, 'The City and Topologies of Memory', *Environment and Planning D: Society and Space* 19: 2 (2001).

7 Ann Reynolds, *Robert Smithson: Learning from New Jersey and Elsewhere* (Cambridge, MA: MIT Press, 2002), p. 264.

8 Manaugh, *Bldg Blog Book*; Jack Flam, ed., *Robert Smithson: The Collected Writings* (Berkeley, CA: University of California Press), p. 107.

9 Jane Bennett, 'The Force of Things: Steps toward an Ecology of Matter', *Political Theory* 32: 3 (2004), and *Vibrant Matter: A Political Ecology of Things* (Durham, NC: Duke University Press, 2010).

10 Luke Bennett, 'Bunkerology – A Case Study in the Theory and Practice of Urban Exploration', *Environment and Planning D: Society and Space* 29: 3 (2011).

11 RomanyWG, *Beauty in Decay*.

12 Caitlin DeSilvey, 'Observed Decay: Telling Stories with Mutable Things', *Journal of Material Culture* 11: 3 (November 2006).

13 Raphael Samuel, *Theatres of Memory* (London: Verso, 1994), p. 3.

14 Bradley L. Garrett, 'Drowned Memories: The Submerged Places of the Winnemem Wintu', *Archaeologies* 6: 2 (August 2010).

15 J.B. Jackson, *The Necessity for Ruins, and Other Topics* (Amherst, MA: University of Massachusetts Press, 1980), p. 4.

16 Ruth Milkman, *Farwell to the Factory: Auto Workers in the Late Twentieth Century* (Berkeley, CA: University of California Press, 1997).

17 Hayden Lorimer, 'Telling Small Stories: Spaces of Knowledge and the Practice of Geography', *Transactions of the Institute of British Geographers* 28: 2 (2003).

18 Michel de Certeau, *The Practice of Everyday Life* (Berkeley, CA: University of California Press, 1984), p. 108.

19 'English Heritage', at english-heritage.org.uk/about.

20 'National Park Service', at nps.gov/history/about.htm.

21 Doreen Massey, 'Global Sense of Place', in Doreen Massey, ed., *Space, Place and Gender* (Minneapolis, MN: University of Minnesota Press, 1994).

22 Rupert Costo and Jeanette H. Costo, *Missions of California: A Legacy of Genocide* (Riverside, CA: Indian History Press, 1987).

23 Dydia DeLyser, 'Authenticity on the Ground: Engaging the Past in a California Ghost Town', *Annals of the Association of American Geographers* 89: 4 (December 1999), p. 617.

24 Tim Edensor, 'Sensing the Ruin', *Senses and Society* 2: 2 (2007); C.L. Witmore, 'Four Archaeological Engagements with Place: Mediating Bodily Experience through Peripatetic Video', *Visual Anthropology Review* 20, 2 (2005); Caitlin DeSilvey, 'Salvage Memory: Constellating Material Histories on a Hardscrabble Homestead', *Cultural Geographies* 14: 3 (July 2007).

25 RomanyWG, *Beauty in Decay*.

26 Max Pensky, 'Memory, Catastrophe, Destruction', *City: Analysis of Urban Trends, Culture, Theory, Policy, Action* 9: 2 (2005); Barbara Bender, *Stonehenge: Making Space* (Oxford: Berg, 1998); Andreas Huyssen, *Present Pasts: Urban Palimpsests and the Politics of Memory* (Stanford, CA: Stanford University Press, 2003).

27 Cindi Katz, *Growing up Global: Economic Restructuring and Children's Everyday Lives* (Minneapolis, MN: University of Minnesota Press, 2004); Julian Jonker and Karen E. Till, 'Mapping and Excavating Spectral Traces in Post-Apartheid Cape Town', *Memory Studies* 2: 3 (September 2009), p. 307.

28 Caitlin DeSilvey, 'Art and Archive: Memory-Work on a Montana Homestead', *Journal of Historical Geography* 33: 4 (October 2007), p. 878.

29 Bennett, *Vibrant Matter*.

30 Blakeslee, quoted in Rapp, 'Esoteric City'.

31 Jackson, *Necessity for Ruins*, pp. 94–5.

32 Samuel, *Theatres of Memory*, p. 8.

33 Le Corbusier, *The City of To-Morrow and Its Planning* (Mineola, NY: Dover Publications, 1987), pp. 50–1.

34 Gay Hawkins and Stephen Muecke, *Culture and Waste: The Creation and Destruction of Value* (Plymouth: Rowman & Littlefield, 2003).

35 Manaugh and Paiva, *Night Visions*, p. 7.

36 Julian Holloway and James Kneale, 'Locating Haunting: A Ghost-Hunter's Guide', *Cultural Geographies* 15: 3 (July 2008); Tim Edensor, 'The Ghosts of Industrial Ruins: Ordering and Disordering Memory in Excessive Space', *Environment and Planning D: Society and Space* 23: 6 (2005), p. 834; Crang and Travlou, 'The City and Topologies of Memory', p. 463.

37 High and Lewis, *Corporate Wasteland*.

38 Tom Vanderbilt, *Survival City: Adventures among the Ruins of Atomic America* (New York: Princeton Architectural Press, 2002), p. 20. See also Cornelius Holtorf, *From Stonehenge to Las Vegas: Archaeology as Popular Culture* (Walnut Creek, CA: Altamira Press, 2005).

3. CAPTURING TRANSITION

1 Caitlin DeSilvey, 'Making Sense of Transience: An Anticipatory History', *Cultural Geographies* 19: 1 (2012).

2 Bradley L. Garrett, 'Urban Explorers: Quests for Myth, Mystery and Meaning', *Geography Compass* 4: 10 (2010).

3 Richard Godwin, 'Secrets of an Urbex Mission', *London Evening Standard*, 15 March 2010.

4 Trigg, *Aesthetics of Decay*; Michael Roth, 'Irresistible Decay: Ruins Reclaimed', in Michael Roth, Claire Lyons and Charles Merewether, eds, *Irresistible Decay: Ruins Reclaimed* (Los Angeles: Getty Research Institute for the History of Art and the Humanities), p. 8.

5 Steve Pile, *Real Cities: Modernity, Space, and the Phantasmagorias of City Life* (London/Thousand Oaks, CA: Sage, 2005), p. 29.

6 See Albert Speer, *Inside the Third Reich* (London: Simon & Schuster, 1970).

7 Karl Haushofer, *Weltpolitik Von Heute* (Berlin: Zeitgeschichte, 1934), pp. 259, 211, quoted in Hell 201, Naomi Stead, 'The Value of Ruins: Allegories of Destruction in Benjamin and Speer', *Form/Work: An Interdisciplinary Journal of the Built Environment*, October 2003; Walead Beshty and Eric Schwab, 'Stumped', *Cabinet Magazine* 20 (Winter 2005/06).

8 Alan Berger and Dorion Sagan, 'A Brief History of the Future', *Cabinet* 22 (Summer 2006).

9 Rapp, 'Esoteric City', p. 20. See also Walter Benjamin, *The Origin of German Tragic Drama* (London: Verso, 2003).

10 Stead, 'Value of Ruins'.

11 Michael Anton, Bradley L. Garrett, Alison Hess, Ellie Miles and Terri Moreau, 'London's Olympic Waterscape: Capturing Transition', *International Journal of Heritage Studies* 19: 2 (2013).

12 Friedrich Nietzsche, *The Use and Abuse of History* (New York: Cosimo Classics, 2006), p. 21.

13 Brian Dillon, 'Decline and Fall', *Freize Magazine* 130 (April 2010).

14 Ninjalicious, 'The End Is Nigh, but I'm Probing On', *Infiltration* (1997).

15 Paul Dobraszczyk, 'Petrified Ruin: Chernobyl, Pripyat and the Death of the City', *City: Analysis of Urban Trends, Culture, Theory, Policy, Action* 14: 4 (2010), p. 372; Susan Sontag, 'The Imagination of Disaster', in Sean Redmond, *Liquid Metal: The Science Fiction Film Reader* (New York: Wallflower Press, 2005), p. 52.

16 Dobraszczyk, 'Petrified Ruin'; Mike Davis, *Dead Cities, and Other Tales* (New York: New Press, 2004).

17 W.G. Sebald and Michael Hulse, *The Rings of Saturn* (New York: New Directions, 2002). See also Robert Macfarlane's film *Untrue Island*, at guardian.co.uk/books/video/2012/jul/09/robert-macfarlane-untrue-island-orford-ness-video.

18 Jonathan Veitch, 'Dr Strangelove's Cabinet of Wonder: Sifting through the Atomic Ruins at the Nevada Test Site', in Julia Hell and Andreas Schönle, eds, *Ruins of Modernity* (London: Duke University Press, 2010).

19 RomanyWG, *Beauty in Decay II: Urbex* (Durham, NC: Carpet Bombing Culture, 2012).

20 Raymond Kurzweil, *The Singularity Is Near* (New York: Penguin, 2006).

21 Christopher Lasch, *The Culture of Narcissism* (New York: Norton, 1991); Kai T. Erikson, *Everything in Its Path: Destruction of Community in the Buffalo Creek Flood* (New York: Simon & Schuster, 1976).

22 Eric Lusito, *After the Wall: Traces of the Soviet Empire* (Stockport: Dewey Lewis, 2009).

23 Karen E. Till, 'Staging the Past: Landscape Designs, Cultural Identity and Erinnerungspolitik at Berlin's Neue Wache', *Cultural Geographies* 6: 3 (July 1999).

24 Trigg, *Aesthetics of Decay*.

25 Matthew O'Brien, *Beneath the Neon: Life and Death in the Tunnels of Las Vegas* (Las Vegas, NV: Huntington Press, 2007).

26 Susan Buck-Morss, *The Dialectics of Seeing: Walter Benjamin and the Arcades Project* (Cambridge, MA: MIT Press, 1991), p. 164.

27 Walter Benjamin, *The Arcades Project* (Cambridge, MA: Harvard University Press, 1999).

28 Pile, *Real Cities*.

29 Jefferson Cowie and Joseph Heathcott, eds, *Beyond the Ruins: The Meanings of Deindustrialization* (Ithaca, NY: Cornell University Press, 2003), p. 15. See also Milkman, *Farewell to the Factory* (1997).

30 DeSilvey, 'Making Sense of Transience'.

31 Lucy R. Lippard, *The Lure of the Local: Senses of Place in a Multicentered Society* (New York: New Press, 1997), pp. 5–6.

32 Steinmetz (2010), 'Colonial Meloncholy and Fordist Nostalgia: The Ruinscapes of Namibia and Detroit', in Hell and Schönle, *Ruins of Modernity*, p. 317.

33 DeSilvey and Edensor, 'Reckoning with Ruins'.

34 David Schweickart, *After Capitalism* (New York: Rowman & Littlefield, 2011).

4. THE RISE OF THE INFILTRATION CREW

1 Rapp, 'Esoteric City'.

2 Adam Barnard (2004), 'The Legacy of the Situationist International: The Production of Situations of Creative Resistance', *Capital & Class* 28: 84 (Winter 2004).

3 A. Bonnett, 'Situationism, Geography, and Poststructuralism', *Environment and Planning D: Society and Space* 7: 2 (1989).

4 Ninjalicious, *Access All Areas*, p. 123.

5 '28 Days Later', at 28dayslater.co.uk/forums/showthread.php?t=66190, accessed 11 November 2011; thread deleted as of January 2012.

6 'Infiltrating the Ministry of Defence', at placehacking.co.uk/2010/12/05/infiltrating-ministry-defense.

7 Stephen Lyng, *Edgework: The Sociology of Risk-Taking'* (London: Routledge, 2004).

8 For video footage of the party, see vimeo.com/17033526.

9 'Reach for the Skies', at vimeo.com/17033526.

10 Neil Lewis (2000), 'The Climbing Body, Nature and the Experience of Modernity', *Body & Society* 6: 3–4 (November 2000).

11 Maria Kaika and Erik Swyngedouw, 'Fetishizing the Modern City: The Phantasmagoria of Urban Technological Networks', *International Journal of Urban and Regional Research* 24: 1 (2000), p. 121; S.D.N. Graham and N. Thrift, 'Out of Order: Understanding Repair and Maintenance', *Theory, Culture & Society* 24: 3 (2007).

12 Dylan Trigg (2005), 'Ninjalicious 1973–2005', *Side Effects*.

13 Ninjalicious, 'On Viewing Holes', *Infiltration*, 13: 2 (1999).

14 David Pinder, *Visions of the City: Utopianism, Power and Politics in Twentieth-Century Urbanism* (Edinburgh: Edinburgh University Press, 2005), p. 149, quoted in Luke Dickens, 'Placing Post-Graffiti: The Journey of the Peckham Rock', *Cultural Geographies* 14: 4 (October 2008).

15 Peter Adey, 'Vertical Security in the Megacity: Legibility, Mobility and Aerial Politics', *Theory, Culture & Society* 27: 6 (2010); Stuart Elden, 'Secure the Volume: Vertical Geopolitics and the Depth of Power', *Political Geography* 34 (May 2013).

16 Minton, *Ground Control*.

17 You can see the photo at guardian.co.uk/artanddesign/2012/sep/21/urban-exploration-bradley-garrett-photography.

18 Eva Weber, dir., *The Solitary Life of Cranes*, Channel 4, 2008.

19 Henri Lefebvre, *Rhythmanalysis: Space, Time, and Everyday Life*, transl. Stuart Elden and Gerald Moore (London: Continuum, 2004).

20 Phil Hubbard, 'The Geographies of "Going Out": Emotion and Embodiment in the Evening Economy', in Joyce Davidson, Mick Smith and Liz Bondi, eds, *Emotional Geographies* (Aldershot: Ashgate, 2005), pp. xiii, 258.

21 Larry Cahill and James L. McGaugh, 'Mechanisms of Emotional Arousal and Lasting Declarative Memory', *Trends in Neurosciences* 21: 7 (1998).

22 Following Lyng, *Edgework: The Sociology of Risk-Taking*.

23 David Pinder, '"Old Paris Is No More": Geographies of Spectacle and Anti-Spectacle', *Antipode* 32: 4 (2000).

24 James Donald McRae (2008), 'Play City Life: Henri Lefebvre, Urban Exploration and Re-Imagined Possibilities for Urban Life', unpublished master's thesis, Department of Geography, Queen's University, Kingston, Ontario, Canada, p. 168.

25 *Nocturnes*, at nocturn.es.

26 Hunter S. Thompson, *The Great Shark Hunt: Strange Tales from a Strange Time* (New York: Simon & Schuster, 2003), p. 530.

27 Lyng, 'Edgework'; Riley Olstead, 'Gender, Space and Fear: A Study of Women's Edgework', *Emotion, Space and Society* 4: 2 (May 2011); Robert Fletcher, 'Living on the Edge: The Appeal of Risk Sports for the Professional Middle Class', *Sociology of Sport Journal* 25: 3 (September 2008).

28 In 2009, Downfallen, a prominent London urban explorer and BASE jumper, fell to his death while BASE jumping in Switzerland (see skyscrapernews. com/news.php?ref=2414). The next year a thirteen-year-old Swedish boy fell into an underground canal in Stockholm (see oursisthefury.com/2010/ the-fall-of-urban-exploration). Then, in 2010, the explorer Solomon fell to his death from a hotel balcony in Thailand (see guardian.co.uk/world/2010/aug/26/ urban-explorer-hotel-death-fall).

29 'No Promise of Safety', at nopromiseofsafety.com.

30 William Gurstelle, 'Take Smart Risks', *Wired*, 21 September 2009.

31 Katherine Hayles, *How We Became Posthuman: Virtual Bodies in Cybernetics, Literature, and Informatics* (Chicago, IL: University of Chicago Press, 1999), p. 290.

32 Dickens, 'Placing Post-Graffiti'; Oli Mould, 'Parkour, the City, the Event', *Environment and Planning D: Society and Space* 27: 4 (2009); Saville, 'Playing with Fear'; Borden, *Skateboarding, Space and the City*.

33 Tim Cresswell, *In Place/Out of Place: Geography, Ideology, and Transgression* (Minneapolis, MN: University of Minnesota Press, 1996).

34 Christopher Stanley, 'Teenage Kicks: Urban Narratives of Dissent Not Deviance', *Crime, Law and Social Change* 23: 2 (1995).

35 Foucault and Rabinow, *Foucault Reader*, p. 47.

36 Lyng, 'Edgework'.

37 Ibid.

38 See Samuel Z. Klausner (1968), 'The Intermingling of Pain and Pleasure: The Stress Seeking Personality in Its Social Context', in Klausner, ed., *Why Men Take Chances* (Garden City, NY: Anchor), p. 156.

39 Saville, 'Playing with Fear', p. 891.

40 Stephen Lyng, 'Crime, Edgework and Corporeal Transaction', *Theoretical Criminology* 8: 3 (August 2004).

41 Jeff Ferrell and Clinton R. Sanders, 'Toward a Cultural Criminology', in Ferrell and Sanders, eds, *Cultural Criminology* (Boston, MA: Northeastern University Press, 1996).

42 Sartre quoted in Robin Wright, *Dreams and Shadows: The Future of the Middle East* (New York: Penguin, 2009), p. 98.

43 Rapp, 'Esoteric City', pp. 1–58.

44 Predator, 'Approach: A Sprawling Manifesto on the Art of Drain Exploring', at infiltration.org/observations-approach.html.

45 Luke Dickens, '"Finders keepers": Performing the Street, the Gallery and the Spaces In-Between', *Liminalities: A Journal of Performance Studies* 4: 1 (2008).

46 Matthew Holehouse, 'Base Jumper Films Himself Parachuting off The Shard Four Times', *Telegraph*, 13 April 2012.
47 Oli Mould and Bradley L. Garrett, 'Urban Subversions: Comptemporary Pasttimes in Global Cities', RGS-IBG Annual Conference, London, 2011.
48 Bill Wasik, 'My Crowd: Or, Phase 5', *Harper's Magazine*, March 2006.
49 Rebecca Solnit, *Wanderlust: A History of Walking* (London: Verso, 2000).
50 Trevor Paglen and A.C. Thompson, *Torture Taxi: On the Trail of the CIA's Rendition Flights* (New York: Melville House, 2006).
51 Trevor Paglen, 'Late September at an Undisclosed Location in the Nevada Desert', *Cultural Geographies* 13: 2 (April 2006).

5. GRAILS OF THE UNDERGROUND

1 Paul Dobraszczyk, 'Sewers, Wood Engraving and the Sublime: Picturing London's Main Drainage System in the Illustrated London News, 1859–62', *Victorian Periodicals Review* 38: 4 (2005).
2 Manaugh, *Bldg Blog Book*; Zero, 'Anger Tunnel'.
3 Bertrand Russell, *Mysticism and Logic, and Other Essays* (London: George Allen & Unwin, 1918), p. 22, quoted in Mike Crang, '*Tristes Entropique*: Steel, Ships and Time Images for Late Modernity', in Gillian Rose and Divya P. Tolia-Kelly, eds, *Visuality/Materiality: Images, Objects and Practices* (Farnham: Ashgate, 2012).
4 Peter Ackroyd, *London Under* (London: Chato & Windus, 2011), pp. 89–90, 79–80.
5 G.C. Cook, 'Construction of London's Victorian Sewers: The Vital Role of Joseph Bazalgette', *Postgraduate Medical Journal* 77 (2001).
6 Kaika and Swyngedouw, 'Fetishizing the Modern City', p. 125.
7 Fiona Rule, *London's Labyrinth* (Hersham: Ian Allen Publishing, 2012), p. 27.
8 Ibid., pp. 36–7.
9 Henry Mayhew, *London Labour and the London Poor* (Oxford: Oxford University Press, 2010 [1861]), pp. 185–6.
10 Hollingshead, *Underground London*, p. 4.
11 David L. Pyke, *Subterranean Cities: The World beneath Paris and London, 1800–1945* (Ithica, NY: Cornell University Press, 2005), p. 229; Alain Corbin, *Le Miasme et la Jonquille* (Paris: Flammarion, 1998).
12 Harriet Hawkins, 'Geography and Art. An Expanding Field: Site, the Body and Practice', *Progress in Human Geography*, 18 April 2012.
13 G.C. Cook, 'Construction of London's Victorian Sewers', quoted in Manaugh, *Bldg Blog Book*, p. 63.
14 Petr Gibas, 'Uncanny Underground: Absences, Ghosts and the Rhythmed Everyday of the Prague Metro', *Cultural Geographies*, October 2012.

15 Hollingshead, *Underground London*, p. 62.

16 Ackroyd, *London Under*.

17 David Cornish (2013), 'Crossrail Unearths "Black Death" Burial Ground', 15 March 2013.

18 'Underground', in Nigel Thrift and Steve Pile, eds, *The City A–Z: Urban Fragments* (London: Routledge, 2000), p. 271.

19 L.B. Deyo and David Leibowitz, *Invisible Frontier: Exploring the Tunnels, Ruins, and Rooftops of Hidden New York* (New York: Three Rivers Press, 2003), p. 213.

20 The manifesto can be viewed at infiltration.org/observations-approach.html.

21 Ninjalicious, *Access All Areas*, p. 3.

22 McRae, 'Play City Life', p. 17.

23 Matthew Gandy, 'Rethinking Urban Metabolism: Water, Space and the Modern City', *City: Analysis of Urban Trends, Culture, Theory, Policy, Action* 8: 3 (December 2004); Kaika and Swyngedouw, 'Fetishizing the Modern City'; Graham and Marvin, *Splintering Urbanism*; S.D.N. Graham and N. Thrift, 'Out of Order: Understanding Repair and Maintenance', *Theory, Culture & Society* 24: 3 (2007).

24 Richard Sennett, 'Qaunt: The Public Realm', available at richardsennett.com/site/ SENN/Templates/General2.aspx?pageid=16.

25 Matthew Gandy, 'Cyborg Urbanization: Complexity and Monstrosity in the Contemporary City', *International Journal of Urban and Regional Research* 29: 1 (2005), p. 28.

26 Jon Calame and Esther Charlesworth, *Divided Cities: Belfast, Beirut, Jerusalem, Mostar, and Nicosia* (Philadelphia: University of Pennsylvania Press, 2012), p. 121.

27 David Pinder, 'Arts of Urban Exploration', *Cultural Geographies* 12: 4 (2005), p. 399.

28 L. Sandercock, 'Towards Cosmopolis: Utopia as Construction Site', in Susan S. Fainstein and Scott Cambell, eds, *Readings in Planning Theory*, 3rd edn (London: Wiley-Blackwell, 2003), p. 403.

29 Cresswell, *In Place/Out of Place*, p. 22.

30 Hollingshead, *Underground London*, p. 60.

31 Rapp, 'Esoteric City', p. 45.

32 Julia Solis, *New York Underground: The Anatomy of a City* (New York: Routledge, 2005), p. 3.

33 Charles Baudelaire, 'Le Cygne', *Fleurs du mal* / 'Flowers of Evil', at fleursdumal. org/poem/220.

34 Matthew Gandy, 'The Paris Sewers and the Rationalization of Urban Space *Transactions of the Institute of British Geographers* 24: 1 (1999).

35 Rapp, 'Esoteric City', p. 34.

36 Guy Debord, 'Report on the Construction of Situations and on the International Situationist Tendency's Conditions of Organization and Action' (1957), transl. Ken Knabb, in Ken Knabb, ed., *Situationist International Anthology* (Berkeley, CA: Bureau of Public Secrets, 1981), p. 25.

37 Gandy, 'Paris Sewers'.

38 Hollingshead, *Underground London*.

38 Kaika and Swyngedouw, 'Fetishizing the Modern City', p. 134.

40 Tseira Maruani and Irit Amit-Cohen, 'Open Space Planning Models: A Review of Approaches and Methods', *Landscape and Urban Planning* 81: 1–2 (2007).

41 Borden, *Skateboarding, Space and the City*.

42 Neil Shea (2011), 'Under Paris', *National Geographic*, February 2011.

43 Kathleen Stewart, 'Atmospheric Attunements', *Environment and Planning D: Society and Space* 29: 3 (2011).

44 Edensor, 'Ghosts of Industrial Ruins', pp. 23, 6.

45 'That Parisien Loop', at thewinch.net/?p=2856.

46 Garrett, 'Cracking the Paris Carrières'.

47 'Demolition of the Paris Metro', at sleepycity.net/posts/252/Demolition_of_the_Paris_Metro.

48 'Into the Belly of the Beast', atn adventuretwo.net/stories/into-the-belly-of-the-beast.

49 Gibas, 'Uncanny Underground', p. 3.

50 J.E. Connor, *London's Disused Underground Stations* (St Leonards on Sea: Capital Transport, 2008); Joe Brown, *London Railway Atlas* (Surrey: Ian Allen, 2009).

51 Connor, *London's Disused Underground Stations*, pp. 28–33.

52 Ibid.

53 *Lizzi Dun' Know*, at vimeo.com/35907845.

54 Kathryn Yusoff, 'Visualizing Antarctica as a Place in Time: From the Geological Sublime to Real Time', *Space and Culture* 8: 4 (2005), p. 218.

55 Gibas, 'Uncanny Underground', p. 12.

56 Ibid.

57 Mark Townsend, 'Underground Rave Culture', *Guardian*, 7 November 2010.

58 '"Robust" Security Plan for Royal Wedding', at tvnz.co.nz/royal-wedding/robust-security-plan-4143132.

59 Duncan Campbell, *War Plan UK: The Truth about Civil Defence in Britain* (London: Burnett, 1982).

60 Ibid.

61 Duncan Campbell, 'A Christmas Party for the Moles', *New Statesman*, 19 December 1980.

62 Some photos available at web.archive.org/web/20050422114116/http://www.iptvreports.mcmail.com/Tunneltrip.htm.

63 Alan Latham and Derek P. McCormack, 'Thinking with Images in Non-Representational Cities: Vignettes from Berlin', *Area* 41: 3 (September 2009), p. 253.

64 David Heap, *Potholing: Beneath the Northern Pennines* (London: Routledge & Kegan Paul, 1964), p. 22, cited in Cant, '"Tug of Danger"', p. 71.

65 Lyng, *Edgework*, p. 362.

66 'The Stinger – June 2010', at thewinch.net/?p=849.

67 David Batty, ' "Urban explorer" Dies after Falling from Thai Hotel Balcony', *Guardian*, 26 August 2010; James Newman, 'RIP Downfallen', at skyscrapernews.com/news.php?ref=2414; Herón Márquez Estrada, 'Man Dies, Another Rescued in Drama along Mississippi River', *StarTribune* (Minneapolis), 26 April 2009.

68 Ian Buchanan, 'The Problem of the Body in Deleuze and Guattari, or, What Can a Body Do?', *Body and Society* 3: 3 (September 1997).

69 Newman, 'RIP Downfallen'.

70 Richard Sennett, *Flesh and Stone: The Body and the City in Western Civilization* (London: Faber, 1996), p. 15; David Howes, 'Architecture of the Senses', Sense of the City exhibition catalogue (Montreal: Canadian Centre for Architecture, 2005), p. 3, citing Sennett (1996), p. 1. See also James C. Scott, *Seeing Like a State: How Certain Schemes to Improve the Human Condition Have Failed* (New Haven, CT: Yale University Press, 1998).

71 Saville, 'Playing with Fear', p. 893.

72 Edensor, p. 227.

73 David Conradson, 'Experiential Economies of Stillness: The Place of Retreat in Contemporary Britain', in Alison Williams, ed., *Therapeutic Landscapes: Geographies of Health* (Aldershot: Ashgate, 2007), p. 33.

74 E. Virginia Demos, 'An Affect Revolution: Silvan Tompkin's Affect Theory', in E. Virginia Demos, ed., *Exploring Affect: The Selected Writings of Silvan S. Tompkins* (Cambridge: Cambridge University Press, 1995).

75 Lyng, *Edgework*.

76 Rachel Pain and Susan J. Smith, *Fear: Critical Geopolitics and Everyday Life* (Aldershot: Ashgate, 2008); Yi-fu Tuan, *Landscapes of Fear* (New York: Pantheon Books, 1979).

77 Lyng, *Edgework*, p. 368.

78 Gilles Deleuze and Félix Guattari, *A Thousand Plateaus: Capitalism and Schizophrenia* (London: Athlone Press, 1988), p. 347.

79 Lyng, *Edgework*, p. 860.

80 Ninjalicious, *Access All Areas*, pp. 126–7.

81 'Olympic Sized Ambitions', at adventureworldwide.net/stories/olympic-sized-ambitions; 'St Paul's Cathedral', at partoftheplan.org/2011/06/st-pauls-cathedral.html.

82 'London Underground Security', theclancygroup.co.uk/casestudies/52.

83 'Central London Security Alert Shuts The Mall', *BBC News*, 16 May 2011; Justin Davenport, 'Terror Alert at 7/7 Tube Station Blamed on Four Urban Explorers', *London Evening Standard*, 3 May 2011.

84 Adrian Craddock, 'Underground Ghost Station Explorers Spook the Security Services', *Guardian*, 24 February 2012.

85 Derek P. McCormack, 'Thinking-Spaces for Research Creation', *Inflexions* 1 (May 2008), p. 8.

86 Osborne, 'Urban Explorers Enter London Landmarks'.

87 28dayslater.co.uk/forums/showthread.php?t=66190, accessed November 2011; thread removed as of January 2012.

88 'En Fotos: Viaje a Uno de los Secretos Mejor Guardados de Londres', *BBC Mundo*, 3 May 2011.

89 'NEO Bankside', at thewinch.net/?p=2949.

90 Henri Lefebvre, *The Production of Space* (London: Wiley-Blackwell, 1991).

91 Edensor, citing de Certeau, *Practice of Everyday Life*.

92 Bonnett, 'Situationism, Geography, and Poststructuralism', p. 135.

93 McRae, 'Play City Life', p. 130.

94 Owain Jones, 'Before the Dark of Reason: Some Ethical and Epistemological Considerations on the Otherness of Children', *Ethics, Place and Environment* 4: 2 (2001); Stuart C. Aitken, *Putting Children in Their Place* (Washington, DC: Association of American Geographers, 1994).

95 Buchanan, 'Problem of the Body'.

96 Editorial, *Transgressions: A Journal of Urban Exploration* 2: 3 (1996), p. 7.

97 Kathleen Stewart, *Ordinary Affects* (Durham, NC: Duke University Press, 2007).

98 Erling Kagge, *Philosophy for Polar Explorers: What They Don't Teach You in School*, transl. Kenneth Steven (London: Pushkin Press, 2005).

99 McRae, 'Play City Life', p. 158.

100 Saville, 'Playing with Fear', p. 909.

101 Pile, *Real Cities*, p. 8.

102 Paglen, 'Late September'.

103 Hakim Bey, *TAZ: The Temporary Autonomous Zone* (Williamsburg, Brooklyn: Autonomedia, 1985).

104 Giorgio Hadi Curti, 'The Ghost in the City and a Landscape of Life: A Reading of Difference in Shirow and Oshii's Ghost in the Shell', *Environment and Planning D: Society and Space* 26: 1 (2008), p. 95.

6. HACKING THE NEW WORLD

1 Bill McGraw, 'Life in the Ruins of Detroit', *History Workshop Journal* 63: 1 (2007).

2 Yves Marchand and Romain Meffre, *The Ruins of Detroit* (London: Steidl, 2010).

3 Nate Millington, 'Post-Industrial Imaginaries: Nature, Representation and Ruin in Detroit, Michigan', *International Journal of Urban and Regional Research* 37: 1 (January 2013); Yablonsky, 'Artist in Residence', *New York Times*, 2010.

4 John Patrick Leary, 'Detroitism', *Guernica*, 15 January 2011.

5 Mary Louise Pratt, *Imperial Eyes: Travel Writing and Transculturation* (London: Routledge, 1992).

6 Yusoff, 'Visualizing Antarctica', p. 225.

7 Imre Szeman and Maria Whiteman, 'The Big Picture: On the Politics of Contemporary Photography', *Third Text* 23: 5 (2009), quoted in Crang, '*Tristes Entropique*'.

8 McCormack 'Thinking-Spaces', p. 3.

9 Leary, 'Detroitism'.

10 Kevin Hetherington, 'Spatial Textures: Place, Touch, and Praesentia', *Environment and Planning A* 35: 11 (1937).

11 Jacques Rancière, 'Notes on the Photographic Image', *Radical Philosophy* 156 (July/August 2009), p. 8.

12 Ninjalicious, 'Chicago Tunnel Company', *Infiltration* 12.

13 High and Lewis, *Corporate Wasteland*.

14 McRae, 'Play City Life', p. 78.

15 Merleau-Ponty, *Phenomenology of Perception*.

16 Brick, *Subterranean Twin Cities*, p. 7.

17 'Action Squad', at actionsquad.org.

18 Adam Burke, 'Sucked Into the Tunnels Beneath Las Vegas', National Public Radio, 4 December 2008.

19 Matthew O'Brien, *Beneath the Neon: Life and Death in the Tunnels of Las Vegas* (Las Vegas, NV: Huntington Press, 2007).

20 Matthew O'Brien, 'Shine a Light', at beneaththeneon.com/shine-a-light.asp.

21 Jacki Lyden, 'Into the Tunnels: Exploring the Underside of NYC', National Public Radio, 2 January 2011. See also Jennifer Toth, *The Mole People: Life in the Tunnels beneath New York City* (Chicago, IL: Chicago Review Press, 1993).

22 Lackman, 'New French Hacker-Artist Underground'.

23 David Harvey, 'Neoliberalism as Creative Destruction', *Annals of the American Academy of Political and Social Science* 610 (2007), p. 1.

24 Andy C. Pratt, 'Creative Cities: The Cultural Industries and the Creative Class', *Geografiska Annaler: Series B, Human Geography* 90: 2 (June 2008).

25 Tim Edensor, *Industrial Ruins: Space, Aesthetics, and Materiality* (Oxford: Berg, 2005), p. 4.

26 Jeffrey S. Juris, 'Practicing Militant Ethnography within Movements against Corporate Globalization', at periferiesurbanes.org/wp-content/uploads/2011/06/JURIS2007PracticingMilitantEthnography.pdf (2010).

27 'GES154 – British Museum Abandoned Station, London', at guerrillaexploring. com/gesite/public_html/index.php?option=com_content&view=article&id=226: ges154-brtsh-museum-tube&catid=52:metro&Itemid=67.

28 The run across the platform, 'With Nerves of Steel', can be viewed at youtube. com/watch?v=RKneXhGuZfU.

7. CROWDS AND CUFFS

1 See Rachel Pain, Mike Kesby and Kye Askins, 'Geographies of Impact: Power, Participation and Potential', *Area* 43: 2 (June 2011); Tom Slater, 'Impacted Geographers: A Response to Pain, Kesby and Askins', *Area* 44: 1 (March 2012).

2 David Pinder, 'Urban Interventions: Art, Politics and Pedagogy', *International Journal of Urban and Regional Research* 32: 3 (September 2008).

3 Tom Bill, 'London "Shard" Homes Create Record Price Gap', Reuters, 12 April 2012.

4 'The View from the Shard: Plan Your Visit', at theviewfromtheshard.com/#plan-your-visit/visitor-information.

5 Bradley L. Garrett, 'Scaling the Shard', *Domus* 960 (July/August 2012).

6 P. Adey, 'Vertical Security in the Megacity: Legibility, Mobility and Aerial Politics', *Theory, Culture and Society* 27: 6 (November 2010), p. 58.

7 Stephen Graham and Lucy Hewitt, 'Getting Off the Ground: On the Politics of Urban Verticality', *Progress in Human Geography* 9 (April 2012).

8 Matthew Power, 'Excuse Us While We Kiss the Sky', *GQ*, March 2013.

9 Wasik, 'My Crowd', p. 65.

10 Rancière, 'Notes on the Photographic Image', p. 9.

11 There are more than 130 other comments on that blog post (placehacking. co.uk/2012/04/07/climbing-shard-glass), along with the many others in newspapers and blog articles around the web.

12 Bradley L. Garrett, 'Fiberglass and Tumbleweeds', at placehacking.co.uk/2010/ 04/07/fiberglass-and-tumble-weeds-boron-fcp (7 April 2010).

13 Erika Sigvardsdotter, 'Presenting Absent Bodies: Undocumented Persons Coping and Resisting in Sweden', *Cultural Geographies*, 21 November 2012.

14 David Allen Green, 'A round-up of retired graffiti artists for the London Olympics?', *New Statesman*, 18 July 2012; Anon., 'Graffiti Raids across London as Police Sanitise City Ready for Olympics', atthelondonvandal.com/2012/07/ graffiti-raids-across-london-as-police-sanitise-city-ready-for-olympics.

15 Rik Scarce, 'A Law to Protect Scholars', at skidmore.edu/newsitems/features/ chronicle081205.htm (12 August 2005).

16 David Pescovitz, 'Beating the Bounds Railwalk Project Shut Down', at boingboing.net/2008/03/10/beating-the-bounds-r.html (10 March 2008).

17 'ASA Code of Ethics', at asanet.org/images/asa/docs/pdf/Ethics Code.pdf; Jaschik, 'Protecting His Sources', *Inside Higher Ed.*, 4 December 2009.

18 '(U//FOUO) National Counterterrorism Center: Urban Exploration Offers Insight into Critical Infrastructure Vulnerabilities', at publicintelligence.net/nctc-urban-exploration (19 November 2012).

19 Jane Jacobs, *The Death and Life of Great American Cities* (New York: Random House, 1961).

20 Lisette Josephides, 'Representing the Anthropologist's Predicament', in Allison James, Jenny Hockey and Andrew Dawson, eds, *After Writing Culture: Epistemology and Praxis in Contemporary Anthropology* (London: Routledge, 1997), p. 32, cited in Sarah Pink, *Doing Visual Ethnography: Images, Media and Representation in Research* (Manchester: Manchester University Press, 2001), p. 4.

21 Pinder, 'Urban Interventions', p 734.

EPILOGUE

1 'Suspicious Behaviour', *Infiltration* 2 (2003).

2 See Stephanie Simon, 'Suspicious Encounters: Ordinary Preemption and the Securitization of Photography', *Security Dialogue* 43: 2 (2012).

3 Cresswell, *In Place/Out of Place*.

4 Hetherington, 'Spatial Textures'.

5 Coleman and Golub, 'Hacker Practice', p. 263.

6 Ibid.

GLOSSARY

abseiling – Also called rappelling, a controlled descent down a vertical drop using a rope.

access/access details – The means by which one gains entry to a location. Access details are shared carefully.

admin – The administration building of a derelict hospital or asylum.

anorak – Someone obsessed with a niche interest, such as train stock variations.

ARTS – Abandoned Rapid Transit Stations/Systems.

asylum seeker – An explorer who primarily explores abandoned asylums.

backcabbing – Riding in the back cab of a train.

backlighting – A photographic technique in which something (usually a person) blocks light in front of a camera to create a photo that 'pops' in the dark. In drains, this is sometimes called a 'Otter shot', after, an elusive and prolific explorer.

bait – Acting in a way that is provocative or exposes one's position, therefore baiting police or security (e.g., 'She just kicked that door open – that's so bait').

BASE jumping – Using a packed parachute to jump from fixed objects, often illegally. The acronym stands for the four categories of objects from which one can jump: buildings, antennae, spans and earth.

blagging – Talking one's way into a place/out or a bust (*see* Bust).

bricked up – An opening that has been blocked or cemented, often with bricks or breezeblocks (*see* Sealed).

BTP – The British Transport Police, national police force for the railways, which includes the London Underground (Tube).

buildering – Using rock-climbing techniques to scale a building; a play on 'bouldering'.

bust(ed) – 1. Getting caught. 2. Doing something (i.e. we busted that location).

carded – Sliding a credit card in between a door handle latch plate and frame over a lock to pop it open.

catacombs (of Paris) – 280km of disused quarries under Paris that are colloquially known as the Paris catacombs or catas.

cataphiles – People who spend a great deal of time in the Paris catacombs. Though they are 'urban explorers' in a broad sense, many would eschew that label.

chimney climbing – Scaling a building by wedging yourself between two walls and inching up using opposing pressures with your hands, knees, feet and back.

chimping – Looking through digital photos just taken, an activity often punctuated by 'chimp' sounds, e.g. *Ooh-ooh!*

City – The police force with the square mile of the City of London, run by the City of London Corporation.

cracking (a location) – Opening and entering a place that no explorer (and likely few other people) have ever seen.

crash bar – The bar on the backside of a door that unlocks it. These must be installed for health and safety reasons, though sometimes opening them triggers an alarm.

cubed location – A place where one exploration connects to another and then another (e.g., a tunnel goes into the basement of a building, where you can then climb to the roof [*see* Squared location]).

derp – 1. A derelict place, non-infrastructural. 2. Somewhere a bit dull/stripped out.

dirty shot – A photograph taken with the lens wide open and the electronic gain (ISO) bumped up, which captures action in low light but looks grainy and raw.

drains – A generic terms used for sewers, stormdrains and combined systems.

drainer/drainor – An explorer who is primarily interested in sewers and stormdrains.

DSLR – A Digital Single Lens Reflex camera, the preferred photographic equipment for most urban explorers.

edgework – Undertaking a life-threatening risk for no reason other than to feel 'the edge'.

epic(s) – An exploration of a very high calibre and/or a never-before-seen site (*see* holy grail).

fail – 1. A failure or failed exploration. 2. The failure of the secca or cop to catch you (*see* Secca).

first service – The first trains to run in the morning.

the fresh – Poo. Also used to describe the feeling of being in the sewer or 'in the fresh'.

Golden Age – The years of urban exploration in London between 2008 and 2012. Other cities (such as Minneapolis, New York and Manchester) have different Golden Ages.

group shot – A photograph of everyone participating in an exploration.

HDR – High Dynamic Range, a photographic technique that layers three or more

shots to create a surreal or fantasy visual aesthetic. Most explorers have a strong opinion either for or against the use of HDR.

Heras – The name of a fence manufacturer, usually used in reference to a type of loose fence that, though easy to disassemble, is noisy to climb.

hero shot – A highly stylised photo of an urban explorer looking smug about an accomplishment in a location.

high-vis – A high-visibility vest, often worn by construction and rail workers (*see* Over-camouflage).

hoarding – Wooden boards placed around a site as a temporary wall to secure it.

holy grail – An exploration that requires deep research, effort and often teamwork, with a commensurate high reward at the end.

hot (location) – A location that has been written about online or that explorers were recently caught in. It's best to stay out of a hot location until it cools down.

infiltration – A trespass on a live site (one that is not derelict or that has workers in it).

J. Bizzle – Joseph Bazalgette, architect of the London sewer system.

key – A found/borrowed/copied key, drain key or triangle key (for lifts); also (flippantly) a crowbar.

Layup – Where trains are parked.

lift surfing – Standing on the roof of a lift box while it is moving.

light painting – Illuminating a dark place during a long-exposure photograph.

mask up – Putting on or pulling up facemasks, usually to run by a camera or security personnel.

meet/meet-up/pissup – A mass meeting of urban explorers.

Met – The Metropolitan Police, responsible for law enforcement in greater London, excluding the 'square mile' of the City of London [*see* City].

ninja/ninjors – An explorer skilled at climbing, often sent in solo to open doors from the inside.

no man's land – The area between the outer security fence and a building, usually where security patrols walk (*see* Secca).

noob – A new/inexperienced explorer.

overt camouflage – Using transparency as opposed to stealth, often utilising a costume, to look as if you belong in a place/doing a certain activity (*see* High-vis).

people shot/action shot – A photograph focussed on people exploring, rather than the place being explored.

picked – A place explorers have used lockpicks to gain entry into.

PIR – Passive InfraRed sensor alarm, set off by motion through its beam.

the point – The farthest point of excavation in a tunnel, where a collapse is most likely. Explorers do edgework by 'working the point' (*see* edgework).

portal – Where an infrastructure system (i.e., the Metro) goes from underground to aboveground.

prohobo/probo/urban camping – Sleeping in abandoned places with expensive kit.

recce – Reconnaissance/scouting/scoping out the way inside a place before exploring it and/or clocking security patrols.

rinsed – A location or place (perhaps as large as a city) perhaps thought to have been thoroughly explored.

rooftopping – Gaining access to the roof of a building for the view.

rope in/drop in/rope access – An abseil entry using ropes and harnesses (*see* abseiling).

ruin porn – A fetish for the exploration and photography of dereliction.

secca – Security guard.

sealed – Somewhere that is, or has become, inaccessible (*see* bricked up).

snipping – Cutting through a fence/lock.

squared location – A location which connects to another (e.g., entering a tunnel which then connects to a drain) (*see* cubed location).

SRT (kit) – Single Rope Technique is a set of methods and equipment used to descend and ascend a rope.

stoop – A small sewer pipe that is filthy and painful to traverse. Also the name of a well-known London drain explorer.

swag – Material artefacts removed from a site.

tankcatting – Smashing/breaking into a site through a door or lock.

the third – The third rail that provides power to electric trains (for instance in the London Tube and Paris Metro).

TOADS – Temporary, Obsolete, Abandoned and Derelict Spaces.

top(ped) out – When a skyscraper reaches its highest point.

trackies – Rail line workers.

Trojan horse exploit – When an explorer enters a building through the front door, possibly in office attire, and then finds a way to let everyone else in (*see* blagging).

trolling – Purposefully antagonizing other people online to provoke outrage, for instance by posting 'secret' access details (*see* acess details).

tweeker – A methamphetamine user. Copper thieves and security guards in derelict buildings are sometimes tweekers.

urban exploration/UrbEx/UE – Recreational urban trespass.

usufruct – A legal concept that affords people the right to use and enjoy property owned by someone else, provided it is not changed or damaged in any way.

walk-in – A site that requires little or no effort to access.

wonky – Off-kilter, usually referring to a badly framed photo.

Xmas – A period of time when security is almost non-existent, when epic sites get cracked and busted (*see* epic, cracked, busted).

INDEX